ART OF THE CRÈCHE

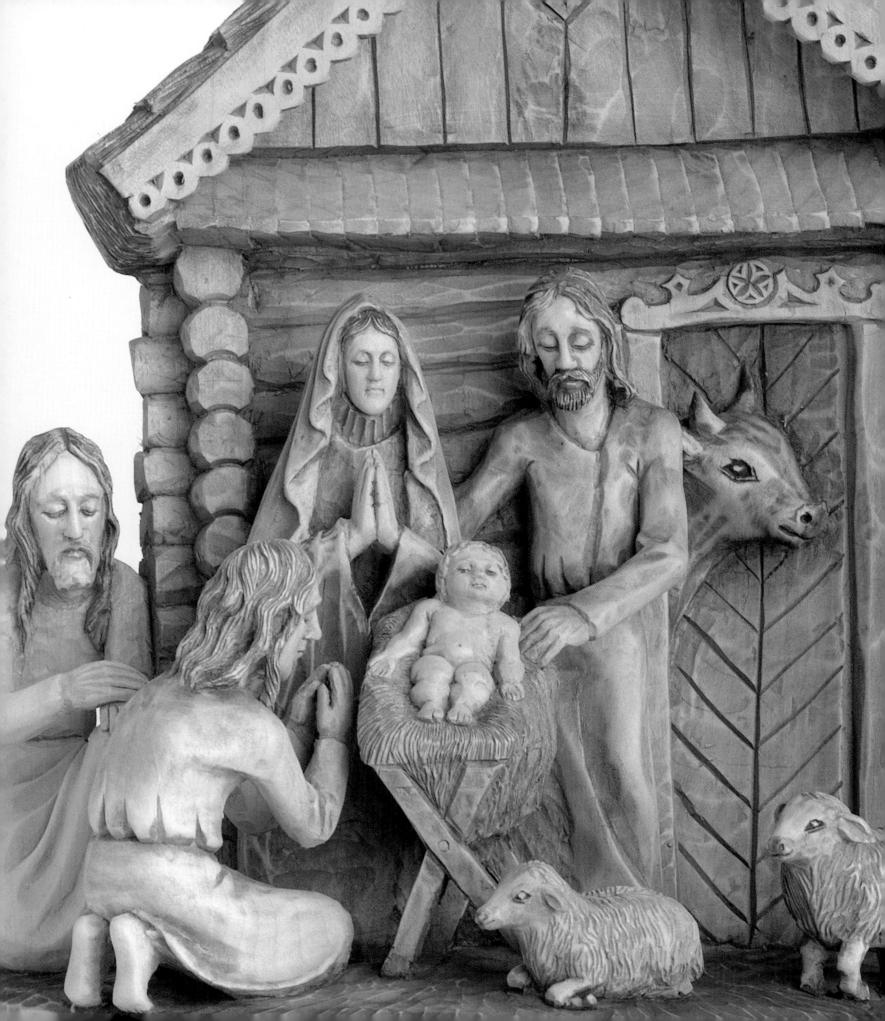

ART OF THE CRÈCHE

NATIVITIES FROM AROUND THE WORLD

JAMES L. GOVAΠ

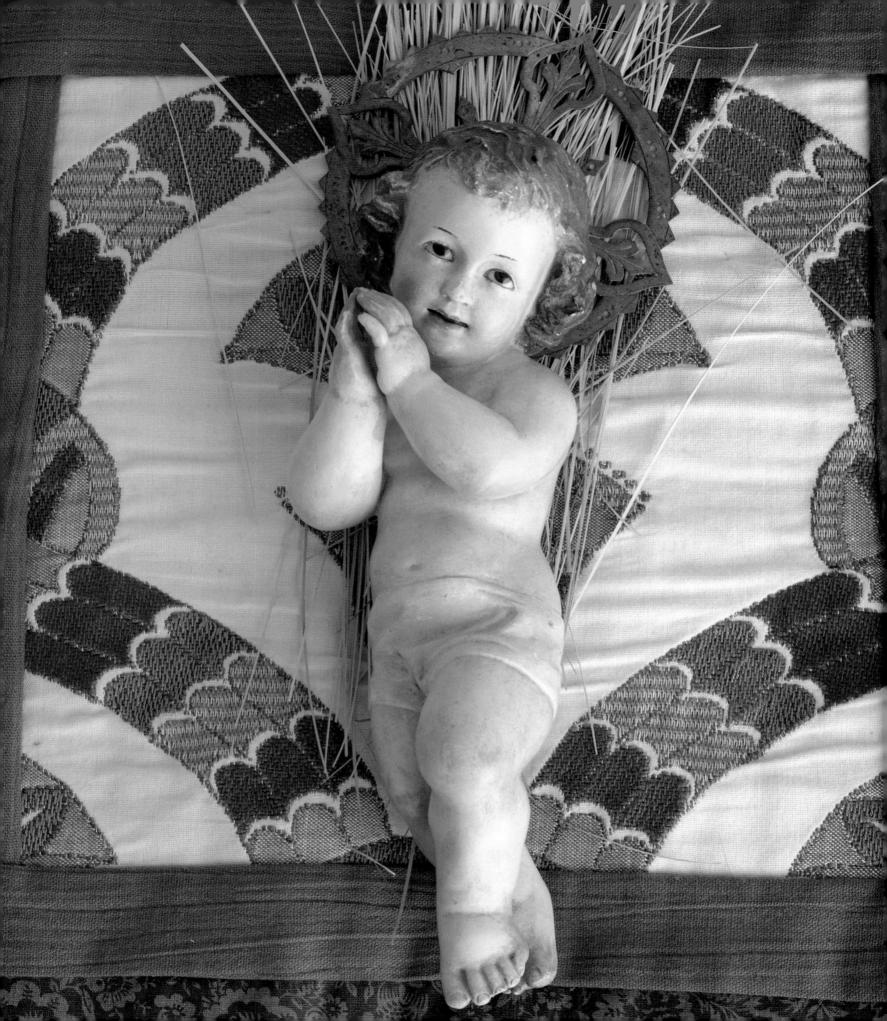

Emilia Longobardo Govan (1937-2000)

I dedicate this book to Emilia, my loving wife and friend of thirty-eight years and the caring mother of our two sons, Michael and Stephen. Emilia was an avid partner in building our family's collection of crèches. A radiant individual, she reflected an openness to life and people that made her an instant friend to many who met her. She was an extremely talented person who, during an accomplished career, was a college teacher, a citizen leader, a manager in the legislative and executive branches of the U.S. Government, a lawyer, and a consultant. For her citizen leadership in transportation and environmental issues, she was recognized as a Washingtonian of the Year in 1974, and for her professional achievements in the fields of energy and environment, she was awarded an honorary Doctor of Laws degree by her alma mater, St. Joseph's College of New York, in 1992. She would have been pleased to know that our collection of crèches was to be shared with so many.

A COLLECTOR'S JOURNEY COLLECTING STORIES 8

SIGH & SYMBOL
NATIVITY, INCARNATION, AND EUCHARIST
17

What Child is This?
THE EVOLUTION OF ARTISTIC EXPRESSION
29

O COME, ALL YE FAİTHFUL CRÈCHES IN TIME AND PLACE 47

ROBED IN GLORY
COSTUMES
59

HEAVER & ΠΑΤURE ABOURD
FLORA AND FAUNA
67

A JOYFUL MOISE
MUSICAL EXPRESSIONS
85

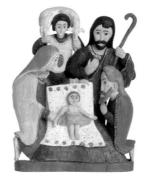

Gifts of the Magi expressions of homage 95

Tradition & Innovation creating crèches 103

SEASON OF GIVING
ACTS OF GENEROSITY
123

ALL IN THE FAMILY
FAMILY LEGACIES
141

MAKING A DIFFERENCE CRÈCHES AS INSTRUMENTS OF SOCIAL CHANGE 161

A WORLD OF CRÈCHES
SEEING OURSELVES
173

ACKNOWLEDGMENTS 205

FURTHER READING 207

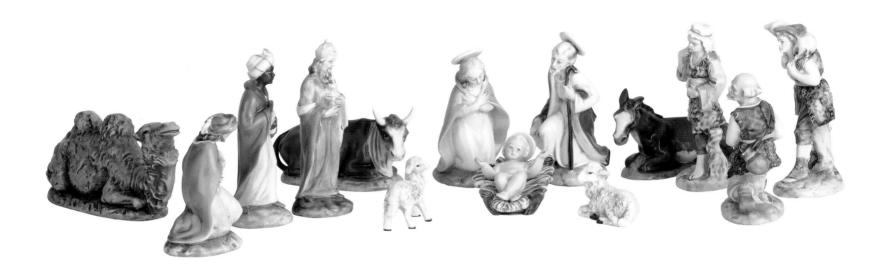

A COLLECTOR'S JOURNEY

COLLECTING STORIES

hristmas abounds with traditions. For centuries, people have performed plays, painted, composed music, and sculpted to tell the story of Christ's birth. One of the most enduring of these customs involves the nativity scene, or "crèche." The crèche (a French term meaning "crib") is the portrayal of the Nativity through figurines of people and animals, often set in a stable, a Classical ruin, or even among large village scenes. The diversity of the nativities created by artists and artisans, and their universal appeal, are the primary subjects of this book.

My late wife, Emilia, and I began our collection in the 1970s. As the collection grew, so did our interest in the historical development and scope of the tradition, and the experience of collecting became for us a journey. As we searched for nativities, we reached out to the corners of the world to find them not only in our travels but also through the marvel of modern communications. We engaged museum curators, merchants, missionaries, friends (many of them working abroad), and the artists themselves. The richness of the social context was an unexpected joy. We encountered many interesting people, if only briefly, and gained insights into many cultures.

While the collection bears the family name, it is really the product of many people. In one year, for example, we received crèches from each of four former professional colleagues working in Africa; a Catholic priest in Arizona who had located a Navajo carver; a New Zealand carver I knew only through e-mail contact; and some dear family friends working in Hungary. At times, Emilia and I saw ourselves as simply the caretakers of a wonderful collection created by so many others.

The collection consists of more than 450 crèches from over a hundred countries. It reflects the relatively recent spread of the tradition, since all but a few were made within the last thirty years. It includes only three crèches made before 1960. Some older examples, such as the Neapolitan *presepi* (literally "cribs") of the seventeenth and eighteenth centuries, are so prized that only museums and a few fortunate private collectors possess them.

Beyond expressing the personal joy of developing the collection in this book, my intent is to present the crèches with two parallel themes. The first is illustrated by the emphasis on crèches with indigenous presentations. This represents, for me, how genuinely and deeply the Nativity story has been accepted by people and their cultures the world over. They see themselves as part of the story. So we have crèches with figures in local dress set among scenes with familiar animals and plants. Gifts for the Christ Child are often those that are important, or perhaps simply common, in the artists' or artisans' cultures. Musical praise for the Infant may

> OPPOSITE: UNKNOWN ARTIST, ITALY

be reflected in instruments known to them. At the same time, there is a theme that demonstrates how crèches create bonds within and among different cultures. One of these bonds is the giving of crèches. Many of the pieces in the collection are gifts: from people I know, but also from people I've never met. Another sign of coming together is seen within families that devote themselves, some over generations, to creating crèches. And as the tradition spreads around the world, increasingly people are linked—Christian and non-Christian, those with means and those without—by artisans making crèches to earn a living. The art of the crèche symbolizes the cultural diversity and richness of the world just as it symbolizes a common humanity among all peoples.

THE REWARDING ART OF COLLECTING

Collecting is far more than acquiring objects. It embraces not only the search for the objects, but also the research into their individual histories and backgrounds, the appreciation of their particular attributes, and often there is an interesting and rewarding social context. Emilia and I found all this and more: building the collection yielded pleasure, learning, and social enrichment.

The richness of our experience encouraged me to present the collection in this volume with some description of the way in which it came about and grew. This intention was reinforced by the reactions of many people who have seen portions of the collection exhibited. They were often fascinated to learn about how the crèches were obtained, their cultural contexts, and their artists. Thus, in this book, I present what I call the journey of collecting, which includes highlights of all these elements.

Emilia and I did not begin with a plan to build a collection of crèches. We were drawn to the idea after acquiring three over a period of several years. The first was a traditional Italian scene acquired for Christmas shortly after we were married in 1962. The second, bought a few years later, was a whimsical Portuguese scene. The third, obtained in 1974, was a slightly abstract American crèche. While looking at the figurines from this American set in a shop, we discussed how imaginatively and differently artists (or artisans) of various cultures created the appealing scene. One of us—I do not recall which—asked what we would do with three crèches. The other replied, "Well, we might collect them." So we decided, twelve years after acquiring the Italian set, to begin our collection.

Three main influences prompted us. First was a shared Catholic faith that gave the Nativity of Christ a special meaning for us. Second was our

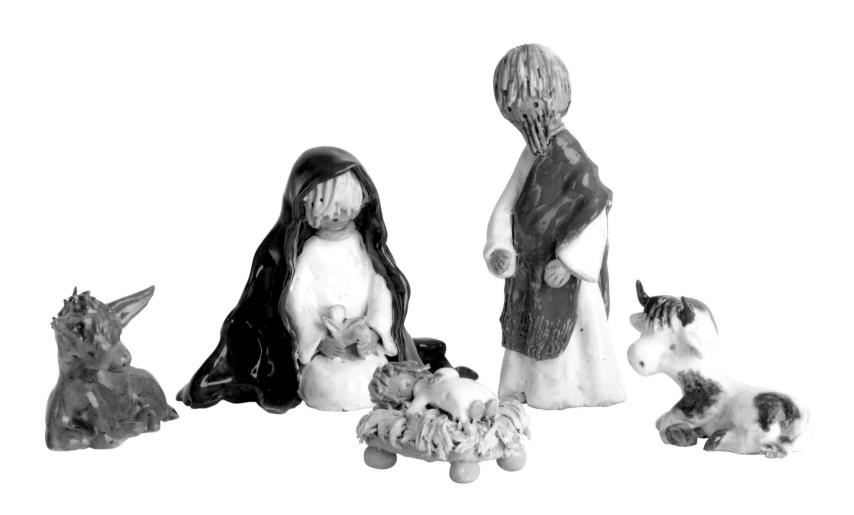

> UNKNOWN ARTIST, PORTUGAL

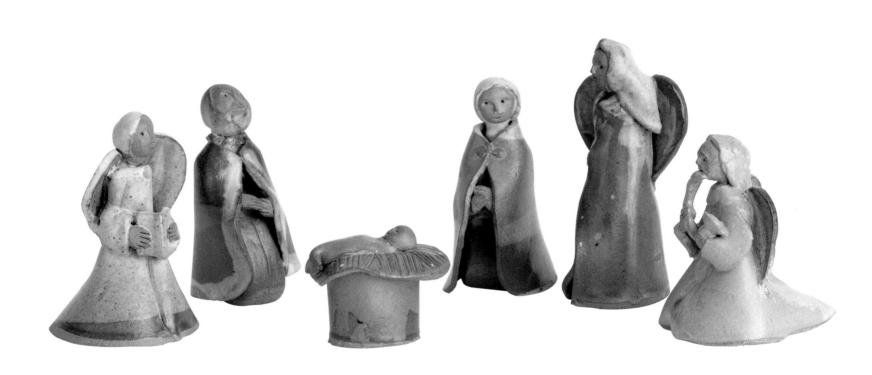

> CHARDAVOYNE POTTERY, NEW YORK, UNITED STATES

strong and eclectic interest in art (for me, especially folk art). Third was a fascination with cultural diversity. Both Emilia and I had immigrant backgrounds. She grew up in an Italian section of Brooklyn. Her parents came from Procida, a small island in the Bay of Naples. I grew up in a neighborhood of Eastern European immigrants that included my Lithuanian grandparents. I was eventually drawn to a career in international affairs.

FROM COLLECTION to Exhibition

The character of the collection evolved over time. It developed slowly at the beginning. By the early 1980s, there were only twenty-five crèches: the demands of our work and family life allowed us little time to focus on collecting. We also had limited means or time for travel. While initially we wanted to seek out nativities from diverse cultures to reflect the universality of the tradition, a critical focus was also to acquire pieces that were fine examples of art. We passed up many crèches that were readily available in shops each Christmas in our determination to be selective.

During the 1980s, we became interested in learning about the historical development of the crèche tradition. I began to search out books and articles, and we gathered materials on folk art and related cultural traditions. By the late 1980s, the collection had grown to roughly one hundred pieces. I became more committed to documenting them, learning as much as possible about how they were made and the individuals who made them. Depending on how the nativities were acquired, the amount of information available varied from non-existent to abundant. In some cases, I was lucky enough to have detailed conversations with the makers themselves. By then, we also had more opportunities to travel abroad. Wherever we traveled, whatever the season, we continued our search.

By 1990, the collection had grown too large to be exhibited in our home. We began to explore the possibility of exhibiting at churches and elsewhere to stimulate interest in the crèche tradition.

Disappointed by the limited amount of information available in English, we also began to entertain the notion of writing a book about the tradition and our collection. I continued to research ever more intently. Given the growth of the collection, the desire to find special crèches—especially fine works of art—became more important to us, and we decided to look for opportunities to commission works. We focused on locating gifted artists and crèches of certain cultures, and continued to travel, both abroad and in the United States. As a result,

by 2000, the collection exceeded 260 crèches; it had been exhibited publicly several times; nearly thirty crèches had been commissioned; and a book was under way.

The first opportunity to exhibit came in 1990. We were invited to show the collection at the Paul VI Institute for the Arts in Washington, D.C., an agency of the Archdiocese of Washington, through its director, Monsignor Michael di Teccia Farina. Monsignor Farina is widely recognized for his promotion of the arts, especially religious art, drama, and cultural presentations in Washington. We had initially contacted him in 1986 and acquired two wonderful crèches from him: one by a Belgian nun, Sister Angelica; the other—one of the finest and most admired in the collection—by a Parisian artist, Noëlle Fabri-Canti (see page 182). Through this encounter, Monsignor Farina learned of our collection and eventually extended an invitation to exhibit at the institute.

This acquaintance, developed in the search for crèches, led not only to other exhibitions, but also to a rewarding friendship. Monsignor Farina became, in a sense, a "patron" of our collection by providing opportunities for us to exhibit several more times. His support and that of the Pope John Paul II Cultural Center, which provided an exhibition venue for five years (2001–2005), have been instrumental in helping the collection gain public recognition.

WORLD OF FRIENDS

The process of building the collection has involved scores of people around the globe. That is why, although it bears the family name, I think of it as belonging to many people who were part of its development. When I look at the crèches, I see first of all the artists' interpretations of the wondrous event of Christ's birth. But many also represent touching personal experiences. The religious, artistic, and cultural dimensions of the crèche exist in a social context.

Part of this framework includes encounters with artists. For instance, the generosity of Lilia Shevchenko, a poor woman from Vladivostok, Russia, who made her first nativity and then gave it to me—even though we had never met—humbled me. The same is true of Geoff Pryor from New Zealand, who was so pleased to create a nativity in the Maori tradition that he presented it to me as a gift. There is Nicario Jiménez Quispe of Peru, from whom we commissioned one large nativity, but who made two. I was enriched by engaging with yet other artists: a third-generation firefighter from Texas, Alfredo Rodriguez, who devotes himself to preserving the Spanish Colonial tradition of carving santos—saints or religious figures; Hanneke Ippisch, who served in the Dutch underground, leading Jewish families to safety during the Nazi occupation; and the retired professor of Japanese culture Mitsuki Kumekawa, who accepted my request to make a nativity and expressed the honor he felt, not being a Christian, in doing so.

The stories of people who made special efforts to contribute give deeper meaning to many crèches. A museum curator in Croatia, Josip Barlek, had a nativity scene made for me by an artist who is one of only a few still making a particular regional style of nativity. In Young Cho, a Jesuit Brother in Cambodia, engaged several carvers—some of them land-mine victims—who strove meticulously for eight months to make a nativity with Khmer features. Our one-time tour guide in the Czech Republic, Václav Lojka, who has been an interpreter, shipping agent, and friend, helped acquire several crèches in his country. Many family friends presented us with nativities that they acquired in their travels throughout the United States and abroad.

The generosity of many of my former colleagues at the U.S. Agency for International Development (USAID) touched me deeply. Working all over the world, but primarily in Africa, they sought out artisans, commissioned crèches for me, and, more often than not, presented them to me as gifts. Others bought them for me on their personal travels to other corners of the globe. And my office staff had a Kenyan nativity commissioned for me as a retirement gift.

OYFUL EXPERIENCE

There is no way Emilia and I could have foreseen how the collection would affect our lives. My Christian faith has deepened as I have enjoyed encounters with Muslim, Taoist, Buddhist, Jew, and those of no specific affiliation, who created a number of the nativities. Even though I devoted my career to USAID, I have learned more about many cultures of the world, including the Wichi in northern Argentina, the Shipibo in Peru, the Makonde in Tanzania, and the Asmats in Indonesia, while forming the collection. I have connected with my ancestral roots in Lithuania. And, finally, I have engaged with other individuals from across the country as we formed Friends of the Creche, a national society devoted to the tradition of the nativity. This singular event opened up a new world for me: I have gained friends, increased my knowledge of the subject, and shared the enjoyment of the tradition with many others.

Above all, the journey of building the collection was a venture that brought great joy to Emilia and me. In her last months, she made me promise to carry on with the collection. So I do. It represents a special facet of a lifetime shared in so many ways, and to me is now imbued with the beauty of the care that Emilia bestowed upon it and the delight it gave her.

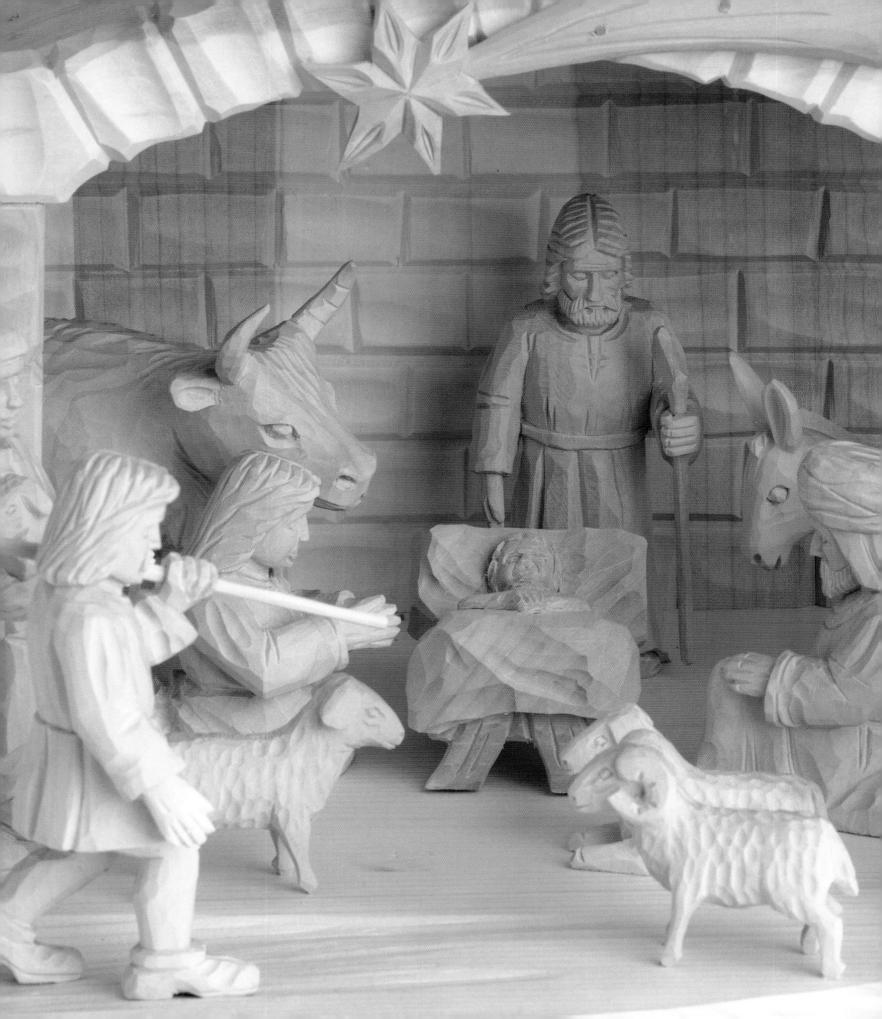

SİGII & SYMBOL

NATIVITY, INCARNATION, AND EUCHARIST

he accounts of Christ's birth in the Gospels of Luke and Matthew are familiar to every Christian, and provide the basic iconography of the event. Christ is born in Bethlehem and lies in a manger, possibly in a stable, but certainly where animals might be present or nearby. An angel announces the good news to shepherds guarding their flock. They rush to see the Infant. They are the first to witness the event, and they leave, glorifying God. In time, magi from the East follow a star that leads them to the newborn king. On finding him, they offer gifts and pay homage.

Each reader of the Nativity story forms an image of this event, an image probably influenced by representations in art—paintings, sculptures, icons, and myriad other art forms. This volume illustrates a few of the many variations of the scene that artists have used to depict the story. Whatever the image, however, Christians see the Nativity as the mystery of the Incarnation, the union of the divine and human in Jesus Christ. It is an expression of faith that has been reflected in art through the centuries.

Belief in the Incarnation has shaped articles of faith and religious rituals and devotions, so it is not surprising that some crèches explicitly allude to or include signs and symbols of Christianity. In the Venezuelan nativity (see pages 22–23), for example, the artist uses a chalice for the Infant's manger, evoking the moment of consecration in the Catholic Mass.

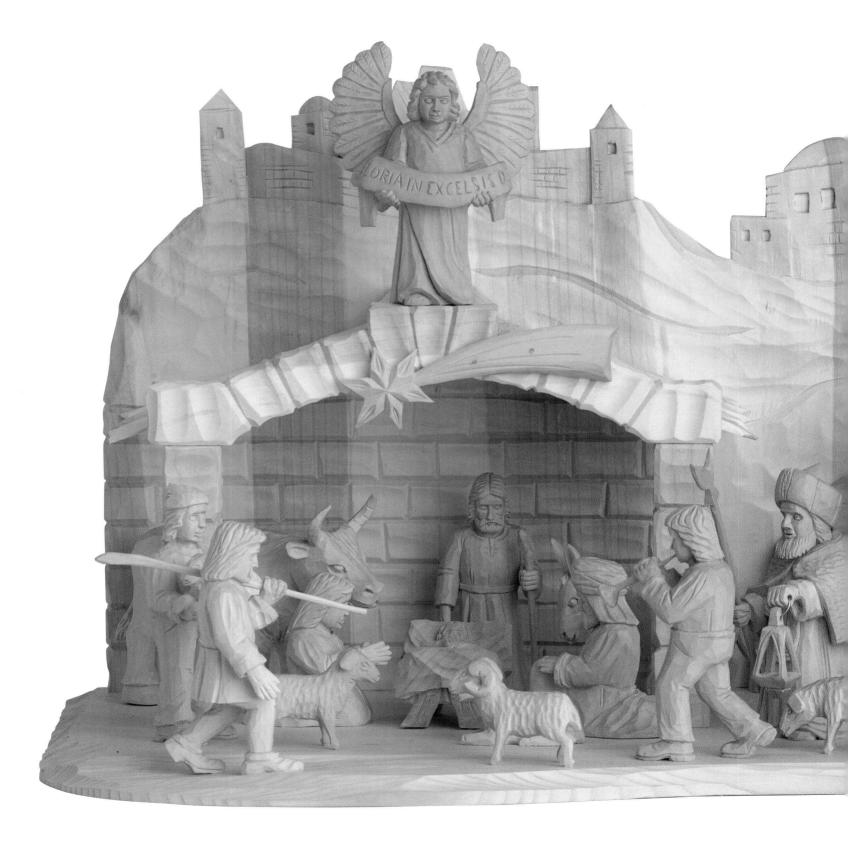

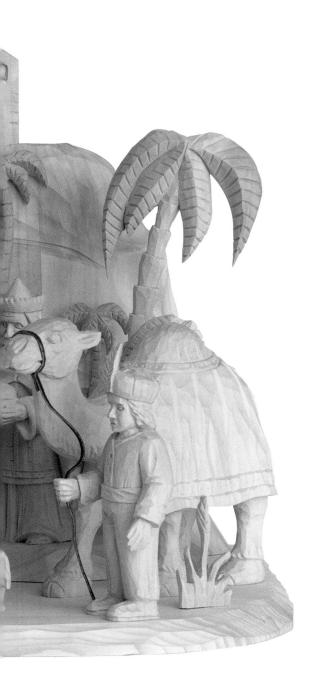

JAROSLAV FRENCL

CZECH REPUBLIC

On a delightful trip to the Czech Republic in 1999, Emilia and I were determined to find a crèche. After a fruitless search in Prague, we visited the countryside at České Budějovice, the regional capital of South Bohemia. The city is known for its large central square, and there we were lucky enough to find a lively market in progress. At one stall that day was Jaroslav Frencl, who displayed examples and photographs of his carvings—all crèches.

Our guide and driver, Václav Lojka, offered to be our intermediary for acquiring a crèche if shipping could be arranged. After returning home, we found a shipping agent in Prague. Through Václav, Frencl sent us more pictures of his work, from which we selected the style that most appealed to us. Václav collected the finished work from Frencl's studio in Volyně and arranged delivery. We formed a friendship with Václav, and I am still in touch.

> JAROSLAV FRENCL

Jaroslav Frencl was born in 1960 in the small town of Horni Dvorište in South Bohemia, near the Austrian border. He taught himself to carve at the age of ten, learning through books and inspired by the many Gothic and Baroque crèche scenes he had observed. He feels each creator of crèches

ART OF THE CRÈCHE

has his or her own style. "Everything depends on the wood," he says. When he looks at a piece of wood, he instinctively "knows" what kind of scene he will carve from it. His scenes are generally unpainted, though occasionally he does paint the background. He uses only hand tools in his work and stresses that each one of his crèches is an "original."

Frencl established his own studio and business shortly after the collapse of Communism in his country. He carves about twenty crèches a year, as well as undertaking church statues and other works for such public spaces as theaters. His crèches often feature elaborate architectural settings.

for example, a Bethlehem skyline. Frencl's scenes are sometimes set in box structures built with carved door panels that, when opened, form a triptych. Even his smaller, simpler scenes contain finely detailed stables.

This crèche presents the basic iconography of the Nativity, including an attractive representation of Bethlehem. The kings pass through a grove of palm trees. Holding a horn, a shepherd heralds the birth of Christ—musicians often appear in Czech scenes, perhaps reflecting the great love the Czech people have for music—while another leads a ram toward the Infant Jesus.

HOUSE OF BREAD MARY FULLER MASSACHUSETTS, UNITED STATES

Mary Fuller was inspired to make this scene by a nativity she was given by her daughter-in-law. It was a "bread nativity," found at a craft fair around 1990. Fuller adapted the design and has since made many pieces like this one, usually as gifts. She took the title for the nativity, "House of Bread," from "Bethlehem," which is composed of two Hebrew words, *Bet* and *Lechem*, meaning "house" and "bread."

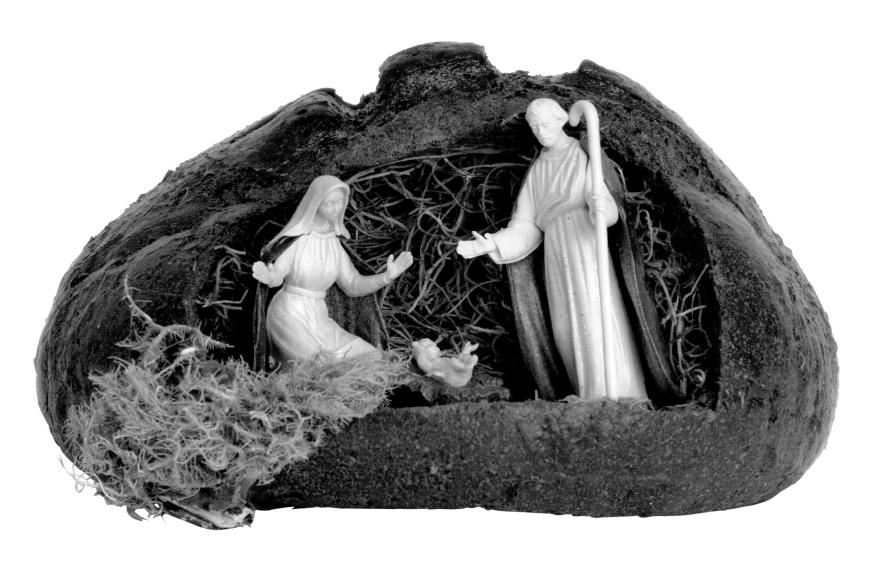

$\frac{MLuisaR}{\text{venezuela}}$

This triptych comes from the Venezuelan state of Mérida. The style resembles that of work from a wood-carving center in Tabay, but nothing is known about the carver who marked the piece "MLuisaR." When closed, the crèche reveals it has been carved from a single tree trunk or branch. The composition is one of the most unusual depictions of the Christ Child in the collection. His manger, a chalice, suggests the sacred moment of consecration in the Mass: the changing of bread and wine into the body and blood of Christ. One angel, the largest, portrayed in half-body form, seems to float on a cloud. Among several smaller ones, appearing with only childlike heads and wings, are a black and a white angel joined together above the Infant, possibly symbolizing harmony among people.

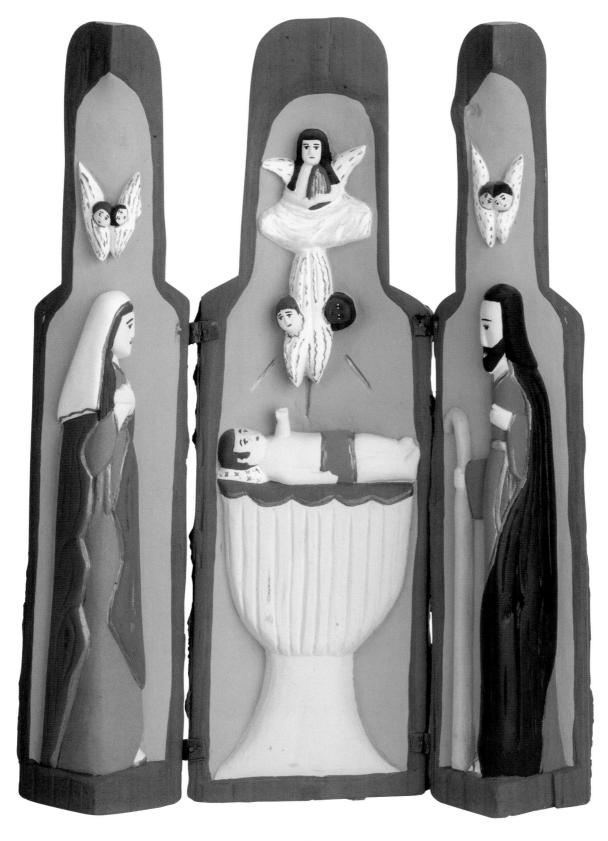

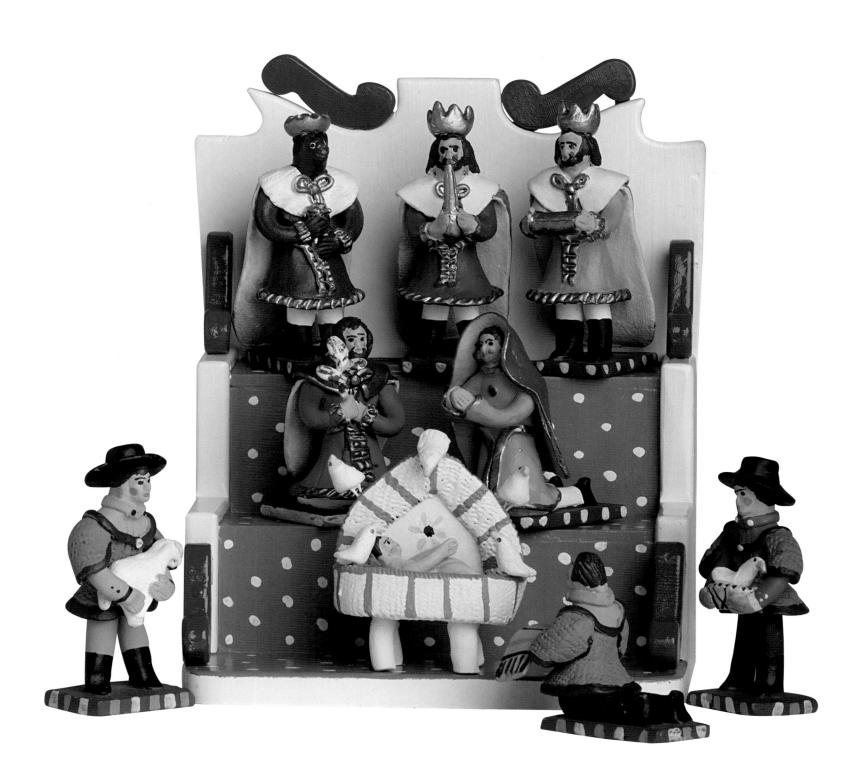

THE ALTAR

QUIRINA (figures) ROBERT DAVIS (altar)

PORTUGAL/CALIFORNIA, UNITED STATES

This rendition shows the special reverence due to the Nativity, while reminding us of the symbolism inherent in the Eucharist by presenting the crèche figures on an altar-like base. This form originated in the late 1920s in Estremoz, a small town east of Lisbon, and is now a traditional representation in the region. The style is attributed to José Maria de Sá Lemos and an associate, Mariano da Conceição. They sought not only to revive the making of nativity figures, which had been popular in earlier centuries, but also to create a new setting. The inspiration came from the presentation of popular saints, such as St. Anthony of Padua, at festivals: they were placed on large staircase thrones, and sometimes accompanied by other elements, such as falling water. The "altar nativity" became a miniature version of these festival shrines.

The clay figures are placed on the altar in a traditional

scheme, with the kings at the top, the Holy Family in the middle, and the shepherds on the lowest level. The shepherds wear clothing in the rural style of the Estremoz region in the nineteenth century. The birds perched on the manger are chickens, which underline the humble setting of the birth.

The figures in this scene were acquired separately from the altar. In the early 1990s, a colleague of Emilia's brought back from Portugal figures signed "Quirina," an artisan of note in Estremoz. I subsequently discovered that the figures often sit on an altar, so, more than a decade later, I asked some friends who were planning a trip to Portugal if they would bring back an altar piece. Robert and Judith Davis visited Estremoz, but the altars they saw there were too heavy and perhaps too fragile for overseas shipment. So, once back in the States, Robert decided to make this altar for me as a gift.

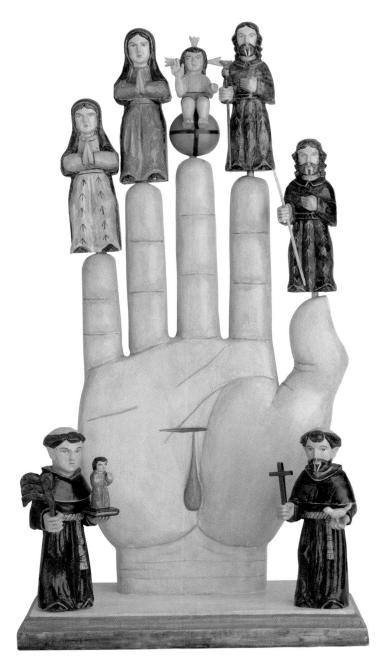

THE POWERFUL HAND ALFREDO RODRIGUEZ TEXAS, UNITED STATES

I commissioned a crèche—his first—from Alfredo Rodriguez in 1995 (see also pages 44–45). Alfredo and I stayed in touch and, on several occasions, discussed various Catholic devotional practices and crèches. He introduced me to the devotion to, and image of, *La Mano Poderosa*, "The Powerful Hand," having recently carved such a piece. The image is familiar in Hispanic culture, especially in Mexico. Early in 2005, I asked Rodriguez to carve an image of the Powerful Hand, with an emphasis on the Nativity, in memory of my late wife, Emilia.

The general depiction consists of a hand, the hand of God, which has a wound recalling the stigmata, or wounds, Christ suffered. There is a traditional grouping of figures on the fingers: St. Joseph, the Virgin Mary, her parents—St. Joachim and St. Ann—and the Child or Infant Jesus. Jesus is sometimes placed on the thumb as the most important figure, and sometimes on the middle finger as the central figure. In paintings, the scene is often embellished with angels, various saints at the base of the hand, and sometimes blood flowing from the wound into a chalice surrounded by lambs. The image was popular in Mexican religious painting—often on tin—during the nineteenth century, and it still exists in the form of holy cards, medals, candles, and, occasionally, carvings.

The origin of the image is uncertain, and has varying interpretations. In modern Catholic practice, it is associated with prayers seeking divine protection or the presentation of petitions to God. The hand as a sign or source of protection has expressions in other cultures, and dates to ancient times.

In the crèche scene in memory of Emilia, I wished to include, in the saints at the base of the hand, St. Francis, to link the work to the crèche tradition, and St. Anthony of Padua, because Emilia held a special devotion to him, and because the saint is usually portrayed holding the Child Jesus. This derives from a story about the saint in which the Child appeared to him one night, filling with light the room in which he was praying. The two saints are also linked because St. Francis appointed St. Anthony as the first teacher of theology in his Order of Friars.

The Powerful Hand depictions I found in my research tended to present Jesus as a young child, but I found one that presented him as an infant, and asked Rodriguez to present him that way. Rodriguez placed him on the middle finger of the hand, sitting on an orb as he extends his blessing to the world. To his right is the Blessed Virgin, and St. Ann is on the little finger. To the Infant's left is St. Joseph with a flowering staff, and St. Joachim is on the thumb. St. Anthony holds Jesus, who stands on the Bible in the saint's left hand. The Bible alludes to the saint's role as a learned man and teacher. He clasps a palm in his right hand. St. Francis holds a cross with one hand, and a bird perches on his other. While Franciscans are usually identified by their brown habits, Rodriguez presents the two saints in blue, the color Spanish Franciscans favored in earlier times.

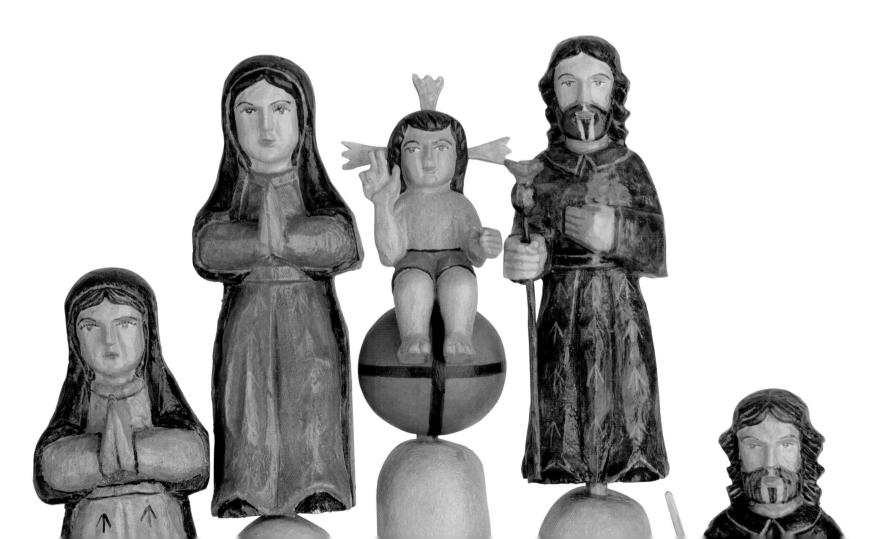

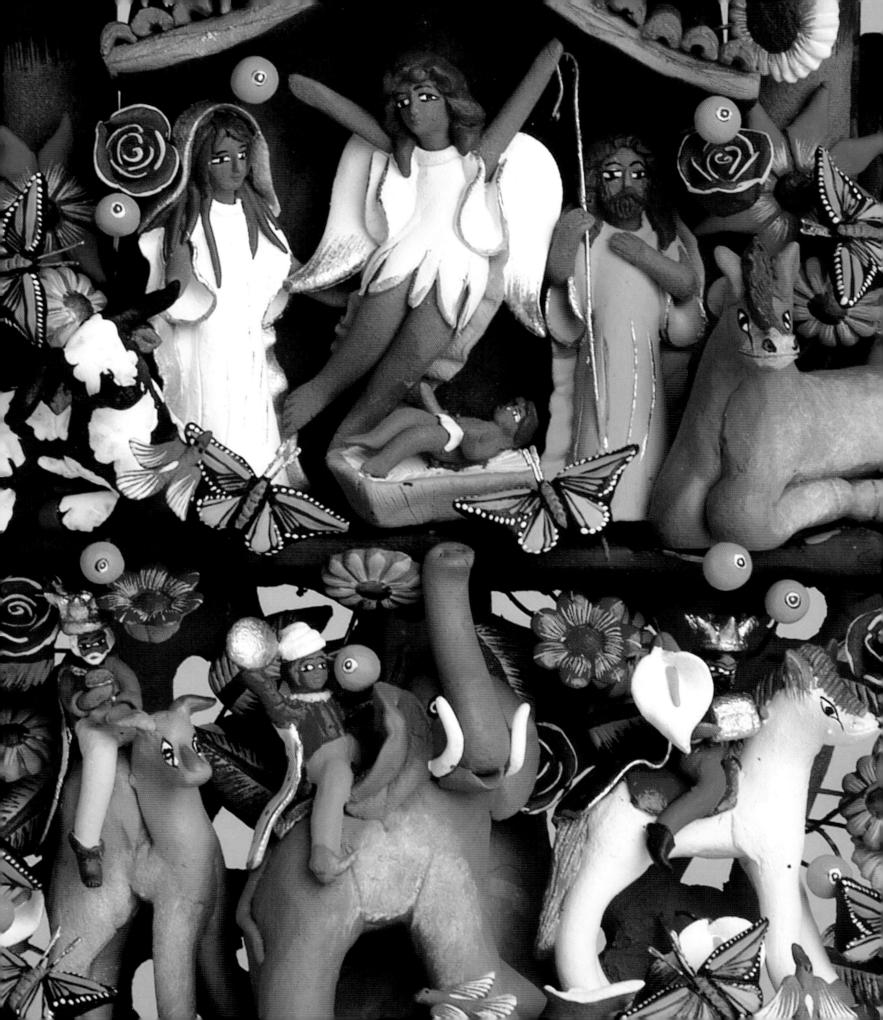

WHAT CHILD IS THIS?

THE EVOLUTION OF ARTISTIC EXPRESSION

St. Francis of Assisi is often credited with creating the first crèche scene—on Christmas Eve, 1223. Other notable depictions show that representations of the Nativity have long been part of Christian tradition. Scenes of the Adoration of the Magi, perhaps dating from the late second century, were found in Roman catacombs. From around 1290, nativity sculptures by Arnolfo di Cambio graced the first church dedicated to Mary, Mother of God—Santa Maria Maggiore in Rome—and parts of this sculptural grouping can still be found there today. Di Cambio's work has traditionally been considered the earliest known three-dimensional crèche, although recent scholarship suggests that a crèche in a church in Bologna and another in Venice may date to around 1250 or earlier.

Though it began in Italy, the tradition of three-dimensional depictions of the Nativity eventually spread throughout Europe. When this tradition was, in turn, brought to other parts of the world, it was further embellished and enhanced by local imagination and artistic tastes.

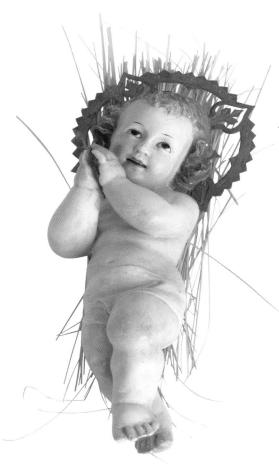

PRESEPIO: THE ITALIAN CRÈCHE

By the latter part of the seventeenth century, crèches had become familiar objects of Christmas devotion in public and private settings in Naples, and artists were gaining fame for their skills in creating them. The fervor with which the Neapolitan religious community, royalty, and artists celebrated the crèche contributed significantly to the popularity and spread of the custom beyond their city. Neapolitan crèches, or *presepi*, of the Baroque period, perhaps the most classic representations of the Nativity, often set Christ's birth in a scene of an entire village. This renowned artistic tradition continues to flourish, and greatly influences the popular image of the Nativity.

The zeal for creating Baroque-style crèches waned toward the end of the nineteenth century, but a vibrant center for making them still exists on the via San Gregorio Armeno, a little street lined with artisans' shops in the heart of old Naples.

A lesser-known but still venerable tradition of making crèches thrives in the Baroque town center of Lecce, in the Puglia region. Papier-mâché is used in a tradition known as *cartapesta*, which dates back to the seventeenth century. In some figures, the head, hands, and feet may be terra-cotta.

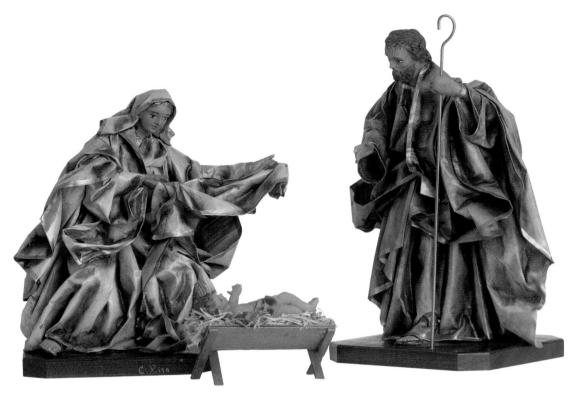

PRESEPIO

CLAUDIO RISO

ITALY

Emilia and I found this papier-mâché crèche in Claudio Riso's small family studio in Lecce in 1995. After we met him in his shop, Riso invited us into his adjoining studio, where he demonstrated how the figures are made. The bodies are made of straw, to which the paper is applied in layers for the clothing. The paper is much like gray blotting paper. It is dipped in heavy glue and worked into shape on the figures before it hardens. The paper is then smoothed with a hot iron. Finally, a thin layer of plaster is applied, and the figure is finished with oil paints.

This beautiful Holy Family depiction illustrates the versatility of the papier-mâché process. Flowing lines define the forms of both Mary and Joseph; Mary expresses a sweeping motion as she places a blanket on the Christ Child; Joseph turns toward him. The Infant's extended

arms create a classic pose, often used in Italian *presepi*, symbolic of his reaching out to humanity. Color has been applied to Mary and Joseph's clothing, but Lecce artisans generally favor the less colorful, brownish speckled garb worn by the Infant.

Born in Bari in 1966, Riso developed an interest in the art of *cartapesta* at an early age. He moved to Lecce, where he was able to work and study in the studio of Antonio Malecore, one of the leading *cartapesta* artists of the twentieth century. Riso has been creating crèche figures for more than two decades.

> CLAUDIO RISO

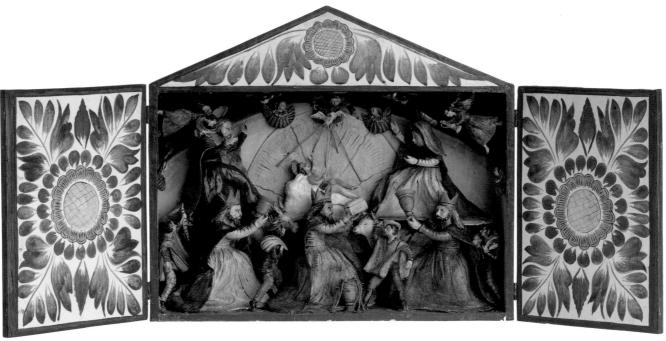

RETABLO NICARIO JIMÉNEZ QUISPE

PERU

In the Andean region, another type of crèche that evolved from a centuries-old custom was revived as an art form in the twentieth century. This is the tradition of the *retablo*. literally "behind the altar." A retablo may comprise painted images of holy figures on flat panels, but may also consist of devotional figures in a box that can be used as a portable altar. Retablos originated in Europe during the Crusades, and the Spaniards carried them, often with the image of St. James, during their campaign against the Moors. Spanish missionaries brought them to the New World and used their religious imagery for instruction. In Peru, the portable altars often held an image of St. Mark and so became known as St. Mark's boxes (cajas sanmarcos). Herders considered St. Mark an adaptation of a local deity who was a protector of herds, and the *retablos* were often carried to the fields to help protect the cattle. They were also used in an annual ritual known as the branding

ceremony, which was held on St. Mark's feast day in April, to seek the protection and increase of the herd.

The retablo custom began to wane in the early twentieth century, but was revived mid-century by retablo-maker Joaquín López Antay. His work transformed the retablo from its icon-like purpose into a medium for expressing both secular and religious subjects. In reviving an art form steeped in history and tradition, López Antay and others, including Nicario Jiménez Quispe, who made this crèche, gained respect as leading Andean folk artists (see also pages 118–21).

Jiménez's nativity depicts a traditional composition of the Adoration of the Magi, joined by Peruvian figures. The scene seems to be in motion, as if the kings are in the act of offering their gifts. Shepherds in Andean dress join them, and angels fill the sky. God, the Father, and a dove representing the Holy Spirit look down on the Christ Child.

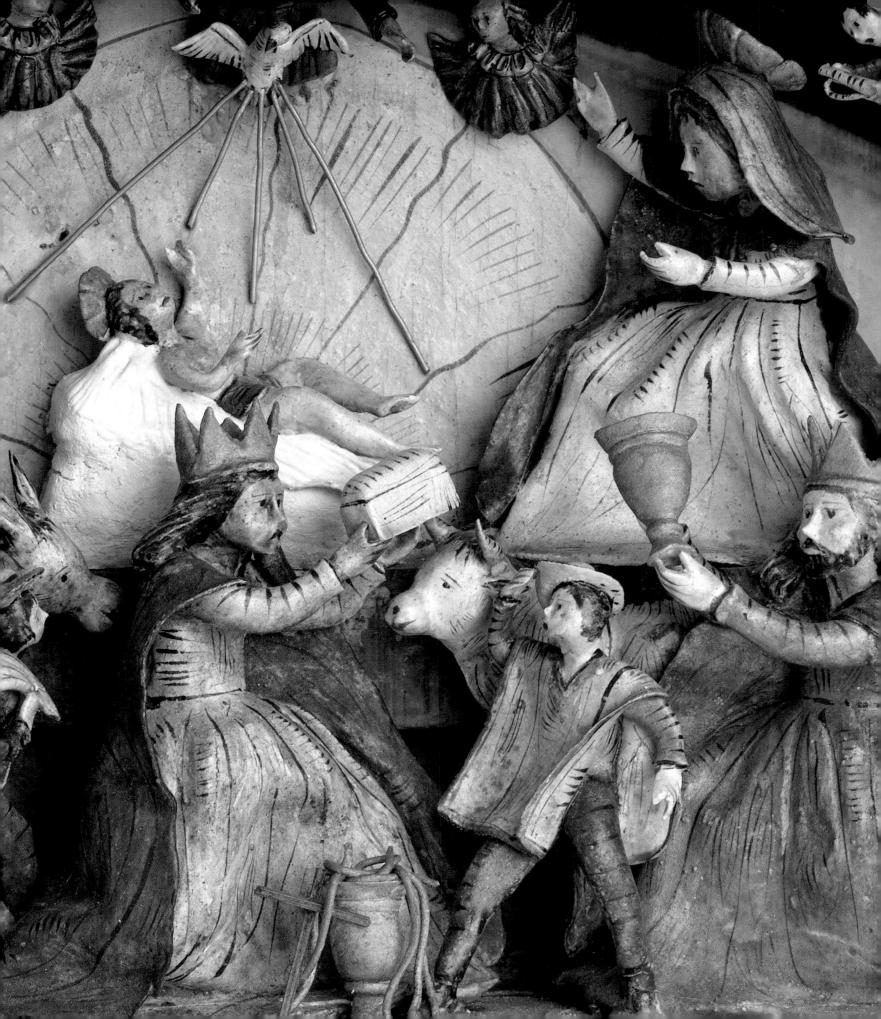

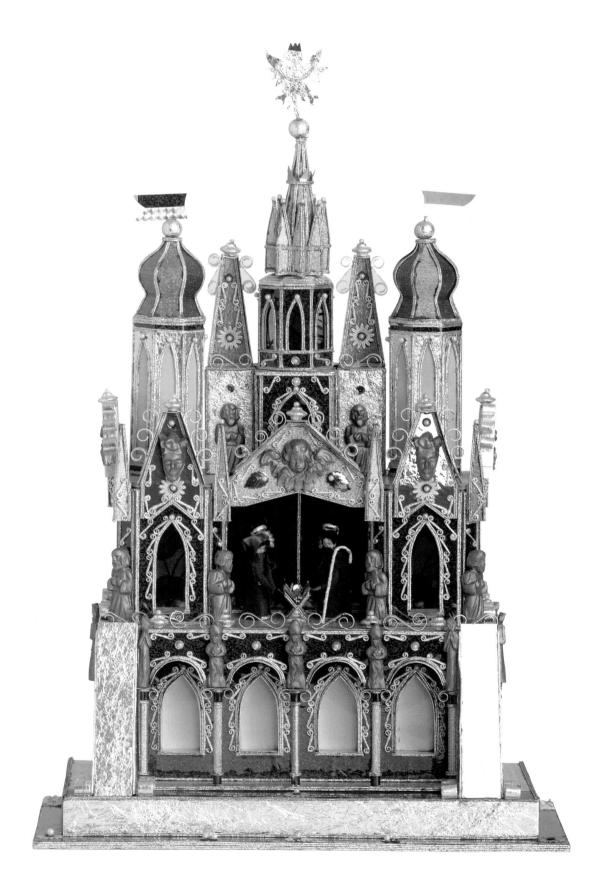

KRAKOVIAN SZOPKA Jacek Głuch Poland

In Poland there are fourteenth-century nativity figures in the convent of St. Clare in Krakow that may have been brought there by Franciscan friars. Early crèches consisted of the traditional nativity figures, but later, stables and secular elements were included. In the Baroque period, puppet figures were introduced. In time, these figures were set in three-dimensional structures that took on architectural styles and provided settings for nativity plays. In Krakow, in the nineteenth century, these presentations developed into a unique style that became known as the Krakovian crib, or szopka. In the twentieth century, stationary figures replaced the puppets.

Today the Krakovian *szopki* are set within splendid architectural structures that reflect the buildings of the city, especially the towers, spires, and onion domes. The crèches are celebrated in an annual competition each December in Krakow's huge market square. Over one hundred may be entered, and prizes are awarded in various categories. The late Witold Gluch entered the competitions in the 1960s and became a well-known prize-winning szopka artist. His son, Jacek, is also a competition winner.

This szopka by Jacek Gluch uses the traditional szopki materials, cardboard and colored paper, as well as tinfoil and light wood. The façade of the architectural setting is embellished with religious figures made of wood. The Holy Family is placed at the higher level, as is typical, and the lower level is left empty. Artists often fill the lower level (or levels) with figures both religious and secular.

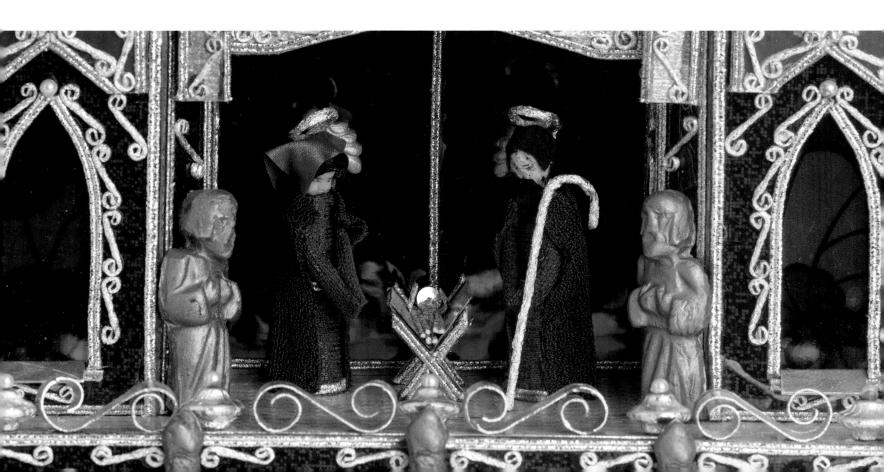

$\frac{ \begin{array}{c} \text{PYRAMID} \\ \\ \underline{\text{UNKNOWN ARTIST}} \\ \\ \overline{\text{Germany}} \end{array}$

In the Erzgebirge mountain region of eastern Germany another unique style of crèche appeared, often called "pyramid" because of its shape. These crèches have one or more tiers of nativity figures. They are topped with a fanlike piece that, when powered by the heat from lighted candles on the lowest level, turns the other tiers to produce a parade of figures. The pyramidal form reflects the mountains of the region, which were mined for silver, tin, and other ores. Some miners took up carving in their off

season; eventually, as mines closed, carving became the principal source of income. This pyramid tradition reaches back to the eighteenth century, and artisans are still making crèches in such towns as Seiffen and Schneeberg.

In this scene, kings surround the Holy Family on the first tier, shepherds occupy the second, and angels blow their horns in celebration on the top tier. Another family owned this nativity for about thirty years before it was given to me for the collection.

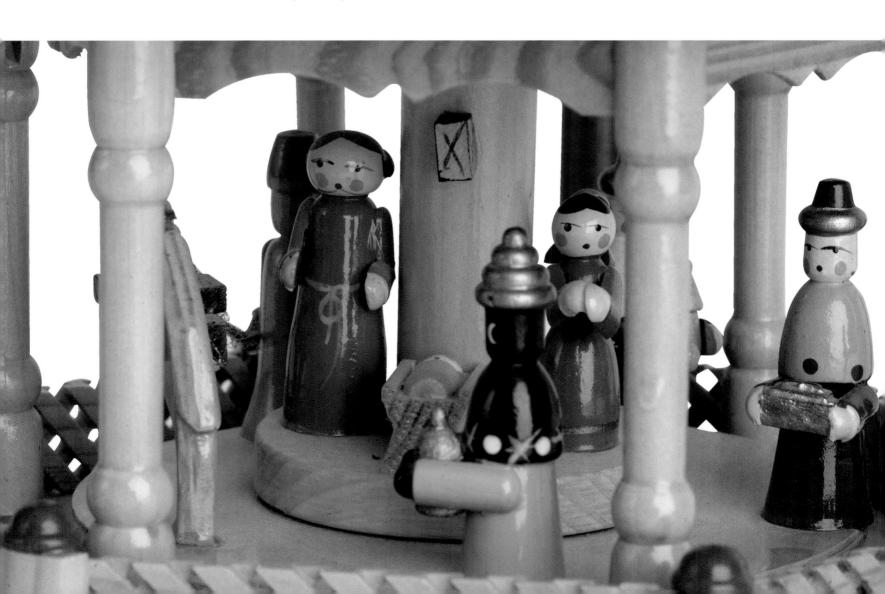

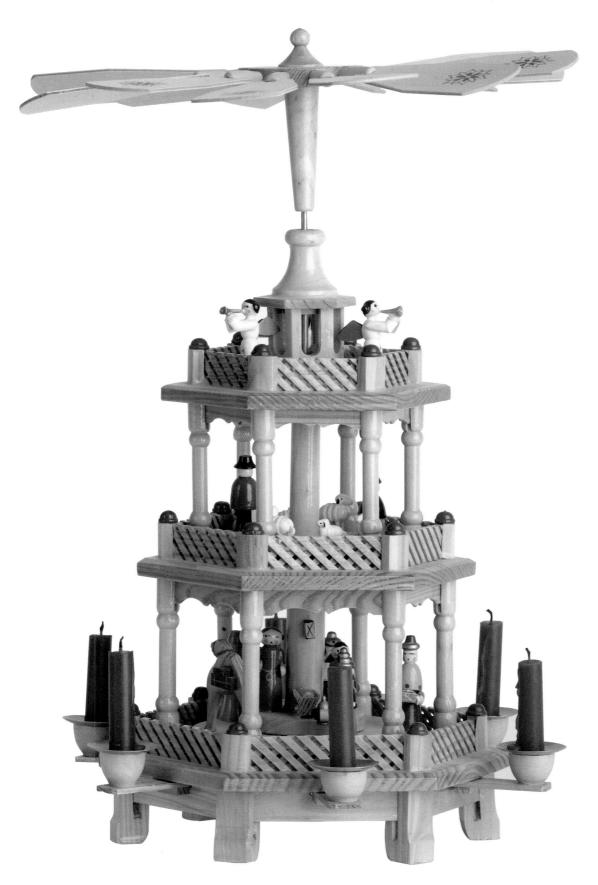

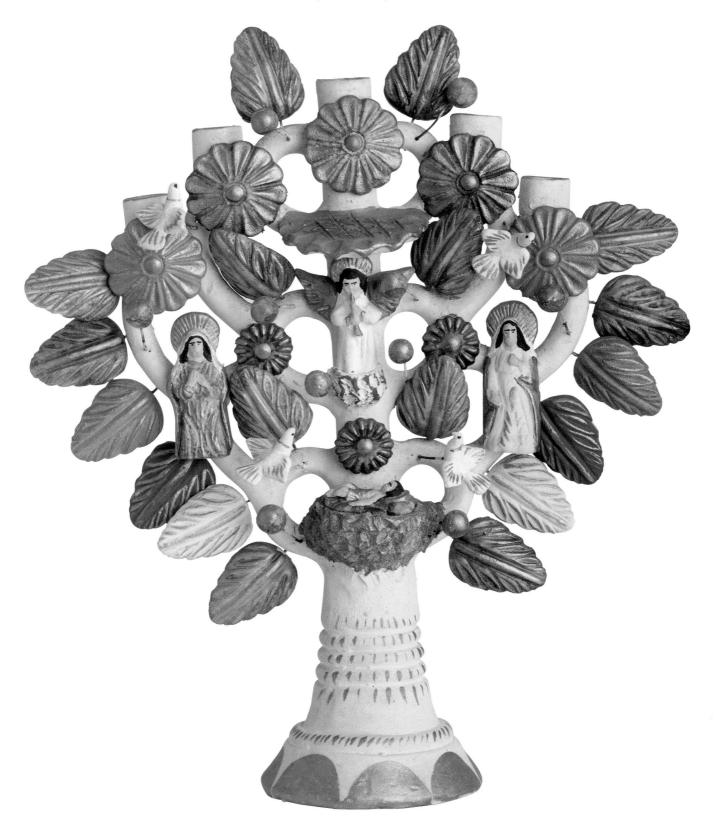

⇒ ARBOL DE LA VIDA, UNKNOWN ARTIST, MEXICO

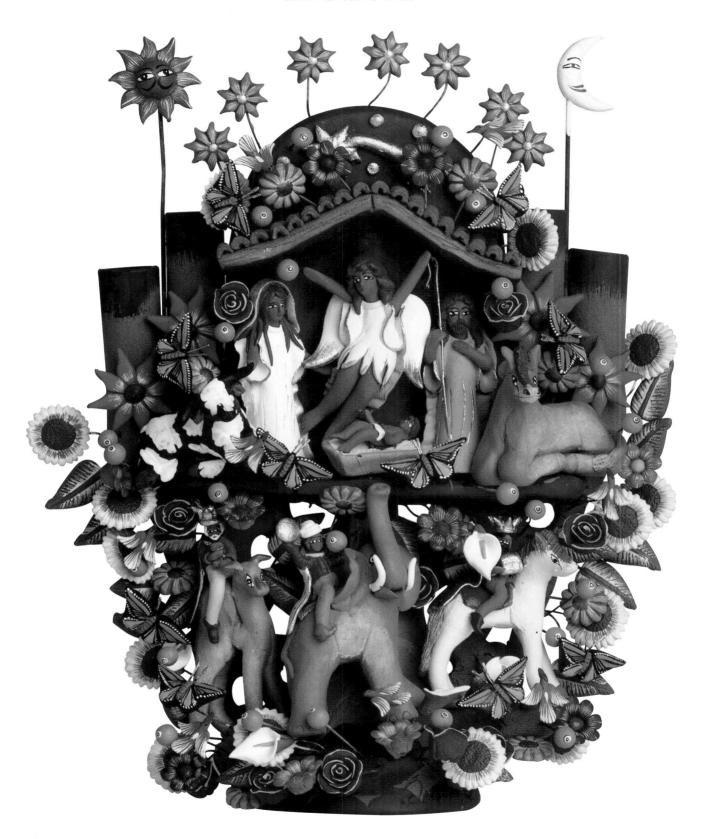

ARBOL DE LA VIDA, JUAN HERNÁNDEZ ARZALUZ, MEXICO

ARBOL DE LA VIDA UNKNOWN ARTIST

MEXICO

In Metepec, not far from Mexico City, artists follow a tradition of creating clay models of a fanciful scene known as *Arbol de la Vida*, the "Tree of Life." The inspiration for this art form, which has been associated with fertility and life, is unclear. Some suggest that the origin of the Tree of Life dates back to pre-Hispanic influences; some suggest it was inspired by Franciscan teachings; yet others assert that this

particular imagery was a twentieth-century development. These treelike forms, with branches, vines, and sometimes flowers, contain religious and secular scenes. Initially the religious images often depicted Adam and Eve, but other biblical scenes, including the Nativity, became common. The models were often made in the form of candelabra and incense burners to be used in weddings and other ceremonies.

ARBOL DE LA VIDA Juan Hernández arzaluz

MEXICO

Juan Hernández Arzaluz of Metepec is rapidly gaining recognition for his intriguing Trees of Life. In 1997, the president of Mexico awarded him one of the country's most prestigious awards for artists, the Galardón Nacional de Tlaquepaque, Jalisco. Hernández is known for miniature trees that portray such scenes as the Nativity and Noah's Ark, as well as everyday Mexican life. He began modeling with clay at the age of seven with his father, and started making Trees of Life at the age of fifteen. Now in his thirties, he says, "Nativity Trees are one of my favorite pieces to make."

The incredibly detailed trees are filled with figures, flowers, and symbols. Hernández's trees are typically just 8 or 9 inches (20 or 23 cm) tall, but this one, which was made for me by commission, is 12 inches (30 cm) high. It is fashioned in the traditional form of a candelabrum. The Holy Family and angel greet the kings, who are arriving on an elephant, a horse, and a camel—a depiction common to Mexican portrayals of the magi. The sun, the moon, butterflies, birds, and sunflowers adorn the Tree of Life. Hernández's detailed work reflects the progression of this art form today.

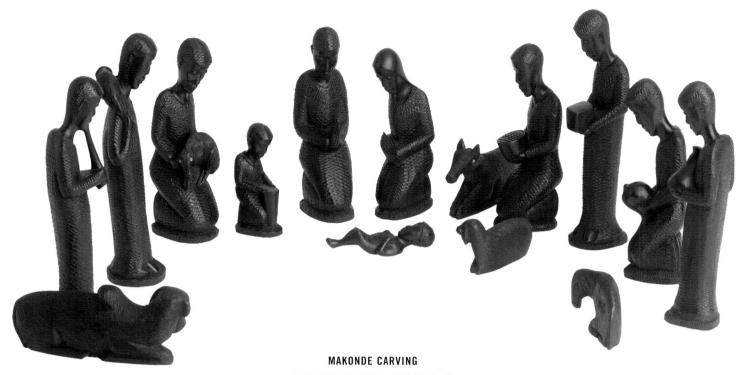

UNKNOWN ARTIST

TANZANIA

The Makonde people, who live along the coastal border of Tanzania and Mozambique, have developed one of the most unusual art forms in Africa. Wood carving has always been important to them, since their tribal belief is that the first Makonde female came to life from a carving. Contemporary pieces are abstract in design but continue to reflect customary beliefs and traditions. Artists are gaining attention for their beautiful and traditional carvings of Christian themes, especially crèches, and their art has won considerable acclaim.

Christian missionaries arrived among the Makonde in the 1920s. Since then, carvers have been creating religious pieces for churches. This crèche was made by an artisan associated with a Benedictine mission in Mtwara, Tanzania, and I acquired it in a Catholic shop in Nairobi, Kenya, in 1985. It is one of the most delicately and beautifully carved crèches in the collection, and it is sad not to know who made it.

This crèche, like most
Makonde carvings, is made
from the brownish-black
heartwood of the African
blackwood, or *mpingo*, tree, a heavy,
dense, finely grained wood. The
artist blends African touches, such as
indigenous animals and musical instruments,
with traditional crèche elements, such as
the shepherd carrying a sheep across his
shoulder. The exquisitely carved, silky
smooth-looking figures convey a sense
of deep adoration.

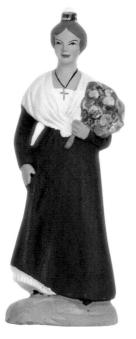

SANTONS SANTONS MARCEL CARBONEL FRANCE

Artisans in the French region of Provence created an indigenous expression of the Nativity through figures that became known as *santons*, or "little saints." The custom of making small clay figures began at the end of the eighteenth century, largely as a reaction to the French Revolution. The revolution suppressed religion: many churches were closed, and nativity scenes were forbidden. In response, the home became the central setting for crèche displays. In 1798, artisan Jean-Louis Lagnel started to use molds to make clay *santons*. This permitted a sort of mass production of the little figures, and thus made them more easily available. *Santons* were included in the Nativity Fair in Marseille first held in 1803, and soon became popular.

Santons represent the rural people of Provence, and those who make them are called santonniers. Some figures are drawn from popular Nativity plays or early pastorals. Others have been introduced over time. Many have become traditional characters and appear in every scene. Santons were originally made to be included in small nativity tableaux, but eventually populated entire village scenes. There are two styles: one made of clay; the other, cloth. The small clay figures are produced using molds and made in several sizes. Some may be 6 inches (15 cm) tall. The

clothed figures may stand up to 12 inches (30 cm) or more.

The santon tradition still thrives, especially in the environs of Marseille. The custom was reinvigorated in the twentieth century, particularly due to the work of the late Marcel Carbonel. Carbonel and his descendants have created hundreds of different santon figures in their Marseille workshop. Carbonel began making santons in 1935 and, in 1961, won national acclaim. He was the first santonnier to fire the clay figures, making them more durable than previous dried-clay examples. Despite the fragility of the dried-clay santons, they can still be found. A major collection is normally on display in the Museum of Old Marseille.

The clay figures in this crèche were made with molds, but each is exquisitely painted by hand. The Holy Family and magi are presented in traditional style, but the other figures represent the villagers of Provence. They appear in period costume and offer the fruits of their labors as bakers, fishermen, and other artisans. This scene, made by the workshop Santons Marcel Carbonel, consists of only thirty figures and no buildings, so does not fully convey the range or setting of Carbonel's village of worshippers. However, it does illustrate the diversity of the communal gathering and the skilled work applied to each piece.

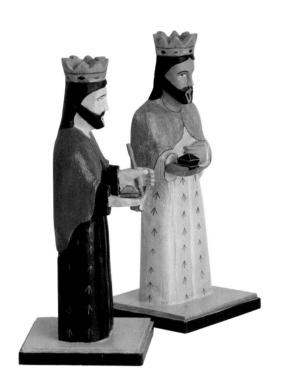

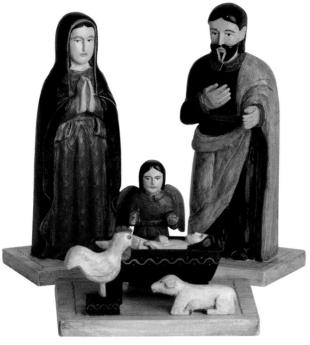

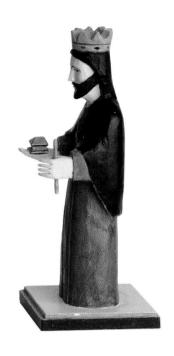

SANTOS

ALFREDO RODRIGUEZ

TEXAS, UNITED STATES

In the southwestern United States, Latin America, and the Philippines, a Spanish tradition exists of carving *santos*, or saint figures. Those who make such figures are known as *santeros*. Unlike the French *santons*, which began as saint figures but developed into regional rural figures, the Spanish-originated *santos* have remained exclusively depictions of saints.

One fine crèche in this tradition is the one commissioned for the collection from Alfredo Rodriguez, a carver living in San Antonio, Texas. After seeing an article about him and pictures of his work, I made contact with him in 1995. He told me he had recently begun his first crèche, and willingly agreed to finish it for me.

Rodriguez says his carving is "a way of life," and he

devotes himself to the preservation and promotion of the Spanish Colonial tradition of carving *santos*. Self-taught, he has gained increasing recognition as a *santero*, although by profession he is a firefighter—the third generation in his family in this line of duty. Rodriguez takes great pride in his ancestry and considers his family part of the original Tejanos, people of Mexican and Spanish descent who settled in this region of Texas; he can trace his ancestors in the area back to the 1770s. His interest in carving began when he was a child, but he became dedicated to making *santos* around 1987. Carving helped him find solace from the grief he experienced at his father's death. "Through this medium I was able to find the peace of mind I was searching for," he says.

The revival of carving traditions from the Spanish Colonial period in southern Texas is important to Rodriguez. While early methods owe a debt to Mexico and Spain, local forms nonetheless developed at the time and have endured to the present. Rodriguez believes these carvings evolved as part of the custom of making *santos* for private worship at home altars, a religious practice common in the Southwest and Mexico. As a way of promoting local traditions, he participates in programs in schools and other public places to inform people about the rich heritage of Spanish Colonial art and to demonstrate his carving.

Rodriguez uses Colonial methods and such traditional wood as Mexican cedar, pine, or cottonwood. His implements include chisels and homemade knives, similar to the tools employed in the Colonial period. To finish his figures, he uses a natural gesso, a water-based pigment made with natural ingredients, and pine shellac.

The carvings of Rodriguez have become increasingly well known. Other projects have included restoring antique figures of the Holy Family for a church in Brooklyn, New York, for which he also carved other figures to add to the scene. A gallery in Santa Fe sells his carvings, and his santos, crèches, and other religious carvings have been

exhibited in the San Antonio Museum of Art and the Texas Governor's Mansion. They have also been exhibited in Dallas, Santa Fe, and Puerto Rico. Rodriguez won an award for his carving at the first International Art Fair in San Juan, Puerto Rico, in 2000, and he has also received a grant to train apprentices.

The crèche, or *nacimiento* ("nativity" in Spanish), Rodriguez carved for the collection was his first, but he has continued to carve more, including the Powerful Hand nativity I subsequently commissioned (see pages 26–27). He carved this Holy Family in 1995, and the three kings in 1997. "In carving a nativity, I attempt to honor my family, past and present, because I find the faces I create at times resemble those of my family," he explains. The nativity figures are much in the style of his other *santos*. The strong colors give character to the simply formed pieces.

This group includes a rooster, a figure that frequently appears in Spanish crèches. The tradition dates from the sixteenth century in Spain, when the first Mass of Christmas was called *Misa de Gallo*, "Mass of the Rooster," because, it is said, the only time that a rooster crowed at midnight was when it heralded the day that Christ was born. This Christmas—rooster connection was vividly presented to Emilia and me in another context. On a visit to a church in Puerto Rico, during the Christmas season, we saw a *nacimiento*

that was augmented by a live rooster in a wire-mesh enclosure behind the altar.

> ALFREDO RODRIGUEZ

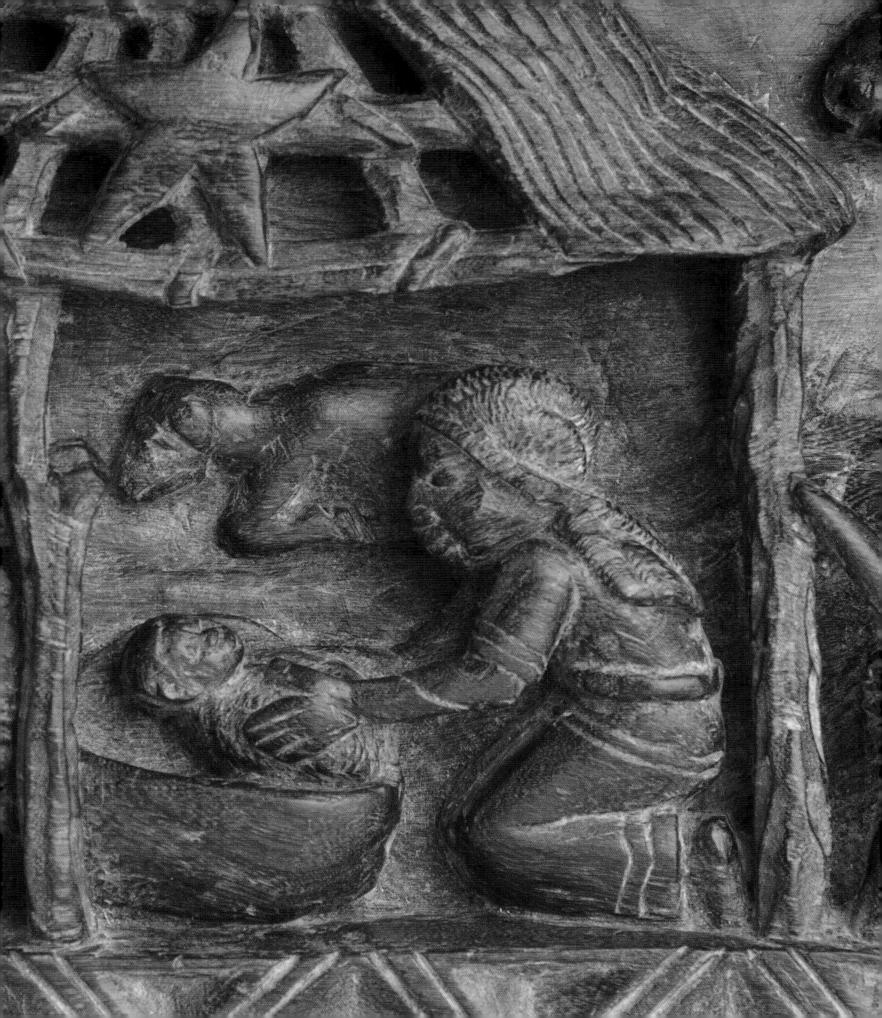

O COME, ALL YE FAİTHFUL

CRÈCHES IN TIME AND PLACE

n the person of Christ, Christians believe that God became human. The crèches in the Govan family collection present wonderful examples of "God like us"—a human being in time and place for the purpose of our salvation. Just as God created us in his image, the artists of these crèches have each created God in their own image, interpreting the Christmas story in terms of their own cultural milieu.

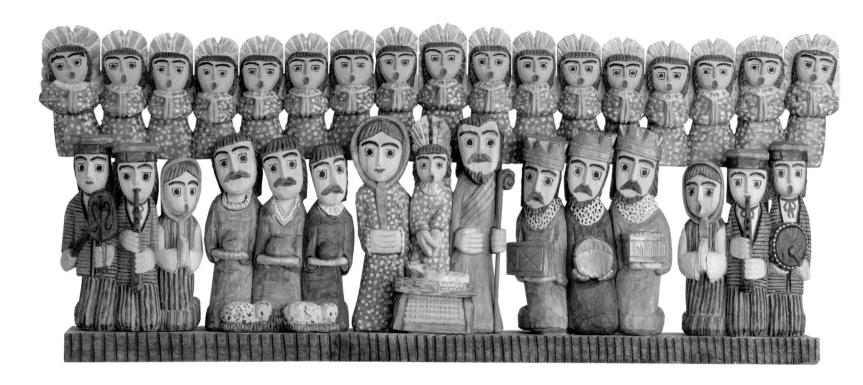

ANTONI KAMIŃSKI

POLAND

This work, replete with Polish character and one of the most endearing crèches in the collection, was a gift from one of our sons in 1999. The piece came from Folk Arts of Poland, a shop in Santa Fe, New Mexico, owned by Gregory Quevillon, who provided some information about the carver, Antoni Kamiński.

A self-taught carver, Kamiński was born in Kowalewo, Poland, in 1947. He writes: "There were no sculptors in my family. When I was a child, I saw some wooden carvings at the Ethnographic Museum in Torun, and I decided to try to make sculptures." Kamiński graduated from technical school and went to work as a drainage engineer on irrigation systems. He started carving as a hobby and

developed an interest in fanciful pieces, often using the shapes of branches and roots to create birds and other forms. Kamiński followed "the pattern of nineteenth-

century folk sculpture from the Leczyca district" early in his career, and he was also influenced by his wife, who is a painter and an art teacher, as well as by some other young carvers in his region.

As Kamiński's carving progressed, he began to make complex scenes that could be

> ANTONI KAMIŃSKI

described as multilayered compositions. In some carvings, there might be as many as five layers of figures carved either in a stair-step fashion or a mostly flat-panel presentation. Initially, Kamiński's carvings were unpainted or simply stained and varnished, but now he paints his works with watercolors. Carving in three dimensions and bas-relief, Kamiński creates a variety of subjects. His works reflect folk tales, religious stories, historical events, and rural scenes. Some of his outdoor works are 12 feet (3.6 m) high or more, but he enjoys carving crèches, and makes around twenty a year.

Kamiński won his first national competition for carving in 1975. The next year, Cepelia, a major outlet for folk art in Poland, began to sell his work. This encouraged Kamiński to give up his job in 1978 so that he could commit himself fully to his carving. Many successes followed. His works are included in a number of municipal and regional museums throughout Poland. In the last two decades, he has won twenty-four awards in the thirty-five competitions he has entered, and he has presented exhibitions in Poland, France, and Germany. Among his commissioned art is a piece for the Vatican Museum.

This crèche attracts the viewer with its striking composition and large scale. Mounted on a 3-foot (90-cm) base are six groups of figures. The most striking is the single-piece carving of a heavenly choir of seventeen angels heralding the birth of Christ. Another angel joins Mary and Joseph with the Infant, and they are flanked by groupings of kings and shepherds, all of whom bear gifts. Two groups of villagers, some with musical instruments, accompany the angel chorus.

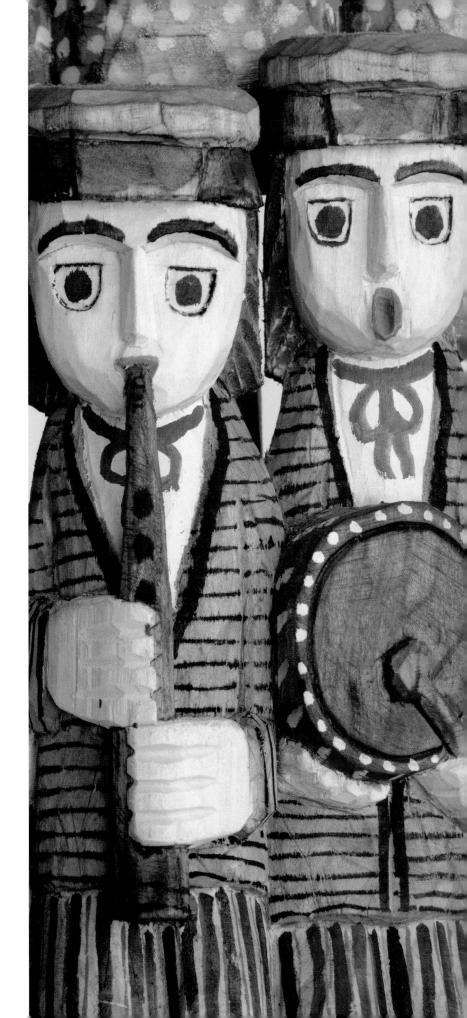

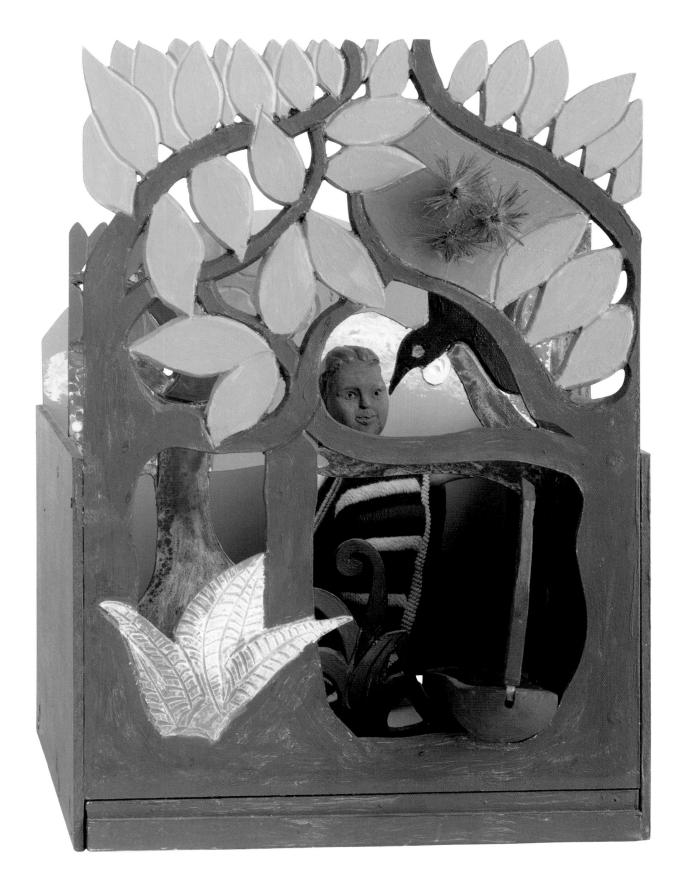

GEOFF PRYOR

NEW ZEALAND

While New Zealand does not have a long tradition of crèche-making, pioneers do exist in the field there. During my efforts to obtain a crèche featuring the culture of New Zealand, I was put in touch with Geoff Pryor (see also pages 128–29). Although he had never made a crèche, he was enthusiastic and wrote to me that he had "already started to envisage it in terms of our culture." By this he meant the culture of the Maori. New Zealand's indigenous people.

Pryor described his initial concept for this crèche before undertaking it, and, on its completion, he also sent a statement interpreting his depiction. His portrayal is set in a box with three panels, or scenes. Pryor wanted to focus on the Christ Child, who is the only three-dimensional figure in the crèche. This figure, carved from a plum-tree branch that was dried for seven years, is clothed in a cloak of Maori design. Pryor depicts the Christ Child arriving by canoe from a faraway land. He wanted to incorporate "some element of the mysterious to reflect this lone figure on an uninhabited New Zealand beach in a bush setting." He also sought to convey "the sense of remoteness of New Zealand from the event in time and space": New Zealand is about 10,000 miles (16,100 km) from Bethlehem. The Christ Child stands in front of the third panel of sky and clouds, and is viewed through openings in the first two panels. The second panel contains a painting of a woman's face representing Mary or the mother's spirit, watching over her son's journey to this far-off land. Mary's chin is painted with traditional Maori markings. The front panel contains a forest scene, with the blossoms of the pohutakawa tree, known as the New Zealand Christmas tree, protruding from

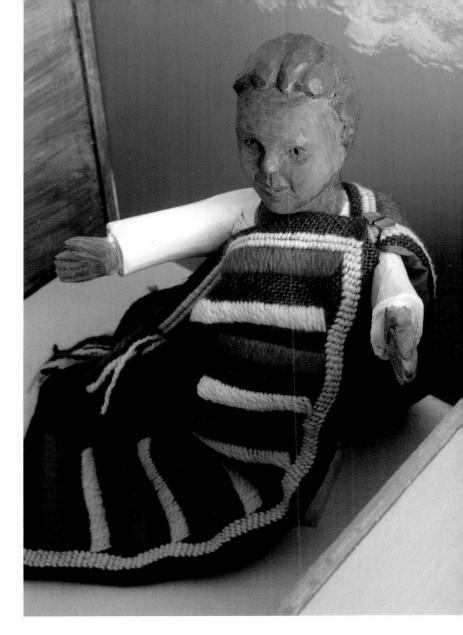

the panel. Resting on the base of the first two panels is the canoe, or Maori *waka*, by which the Christ Child arrived.

Pryor explained that, in thinking about a theme for the crèche as he was completing it, at four o'clock one morning, "a little voice whispered to me: 'The new-born Christ dreamt of a distant land. *Aotearoa*, The Land of the Long White Cloud, held its breath in wonder and burst into bloom'." Pryor wrote a formal statement describing the meaning of the presentation and the Maori character of the crèche: "Just as the wise men and the shepherds in the desert had to seek out Christ, so do we through the native bush and in the bushlands of our hearts."

> VLADAS RAKUCKAS, LITHUANIA

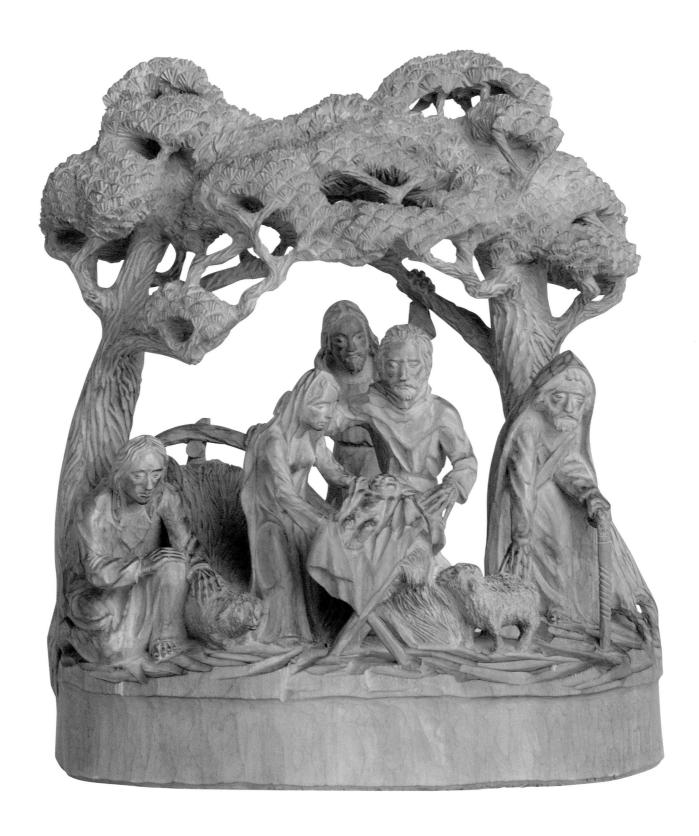

> VLADAS RAKUCKAS, LITHUANIA

VLADAS RAKUCKAS

LITHUANIA

Emilia and I especially wanted crèches that reflected our ancestral heritages. It was easy to acquire Italian examples, but many years of effort failed to find a Lithuanian crèche to reflect my heritage. Lithuania, the last European country to be converted to Christianity, has strong folk traditions in which wood carving plays an integral part, but it endured years of Communist prohibition of religious expression.

During our search, I met an American-Lithuanian owner of a Baltic goods shop in Boston at a Lithuanian festival in Baltimore. Some time later, he told me that he had arranged for a Lithuanian wood sculptor to come to the U.S. for three weeks to work on a project for a Lithuanian-American community in Florida. I was told the sculptor, Vladas Rakuckas, would be willing to make a crèche on commission during his stay. Rakuckas had never created a crèche before, but he was willing to carve his interpretation of the scene, and I requested that he include a Lithuanian motif.

Working on the Florida project by day, Rakuckas carved the crèche during his evenings, sometimes working through the night to complete it. He created a stunning work from a single piece of tree trunk, though at first glance it appears that the figures were carved separately and attached to the base. Emilia and I were thrilled to meet Vladas when he unexpectedly stopped at our home in Virginia, en route back to Lithuania, and presented us with the carving.

On arriving home, Rakuckas decided to make a crèche for himself. He exhibited it in Vilnius, where a German merchant noticed it and persuaded him to produce similar crèches to be sold in Germany. Early in 1993, Rakuckas sold me the second crèche, the only one still in his possession. He found carving crèches an all-consuming

effort, and wrote, "I think that the best place for it is among your collection." On seeing the second crèche, I understood his comment about the production of his crèches being labor-intensive: the meticulous carving was obviously demanding. This crèche, created from a single block of linden wood, was an intricate scene set in an exceptionally detailed grove of trees, a context symbolizing the Lithuanian love of trees and forests that predates the Christian era.

Born in 1956 in Vilnius, Vladas Rakuckas studied computer programming at Vilnius University but began carving at the age of twenty-four. He soon became an active member of folk-art associations and participated in exhibitions in Lithuania, Hungary, Sweden, and Japan. In 1993, he established a woodworking business to make furniture, toys, and other items, but subsequently made at least one more crèche for a church in Hanover, Germany.

Both crèches remind me of the peasant origins of my maternal ancestors. The figures are humble. There is no regal air in the depictions. The stable in Rakuckas's first crèche displays Lithuanian folk-art motifs, as I requested, on the eaves of the roof and above the door. The cow

poking its head through the stable door offers a slightly humorous touch. The other scene, amid the trees, evokes the simplicity and humility that St. Francis created for his Nativity celebration near Greccio so many centuries ago, outdoors and with a grove of trees nearby.

> VLADAS RAKUCKAS

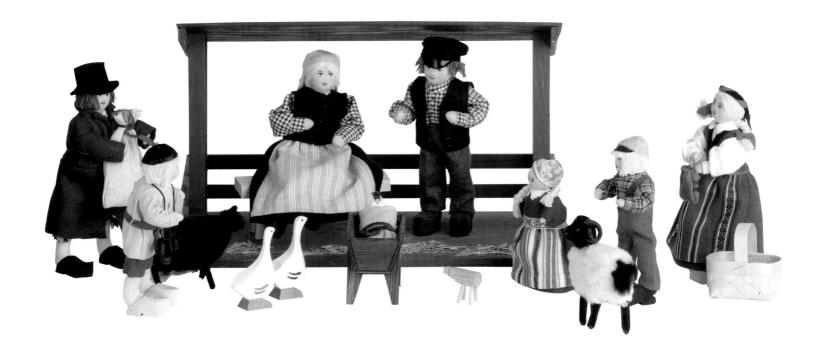

CHARLOTTE WEIBULL

SWEDEN

Preserving Swedish traditions by making dolls wearing folk costumes has been a passion for Charlotte Weibull for more than fifty years, and an interest her family has shared for two centuries. Born in 1917 on a farm in the province of Scania, she founded a folk center, Möllegården, in Åkarp. The center houses a museum, exhibition hall, and doll workshop, among other facilities. Weibull documents and preserves the country's folk costumes by creating dolls in traditional dress. She is the creator of the nation's current Swedish folk costume, which Queen Silvia wears on Sweden's National Day.

Möllegården's museum houses Weibull's crèche collection of more than two hundred scenes from around the world. Her interest was stimulated by a visit to Poland in 1958, where she was impressed by crèches reflecting Polish heritage. Weibull has designed two crèches, both of which are made in her workshop. One is a traditional nativity. The other one, represented here, is a colorful Scanian scene, in which the people are dressed in the folk costumes of her region. Bearing local gifts, they are joined by sheep and geese.

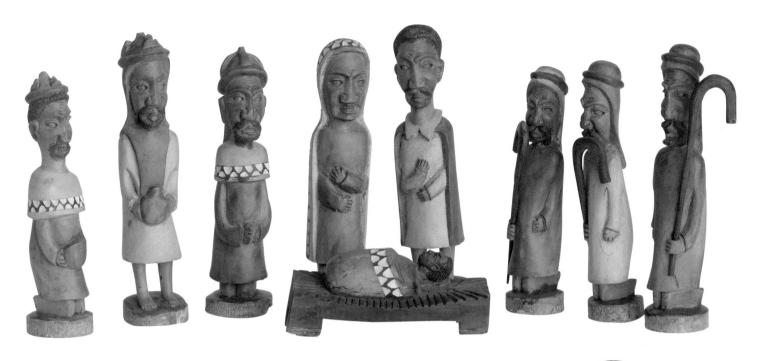

$\frac{ZAGARIAFUMO}{\text{SWAZILAND}}$

The carver of this crèche lives in Swaziland, a small country bordering South Africa and Mozambique. The piece, signed simply "Zagariafumo," shows a traditional grouping in which the people are depicted as Africans. While this is common among the African crèches in the collection, the expressively carved figures make this indigenous portrayal particularly notable. Unusually for an African nativity, the wooden figures are painted rather than stained or polished.

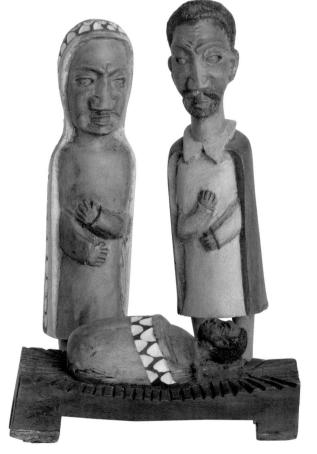

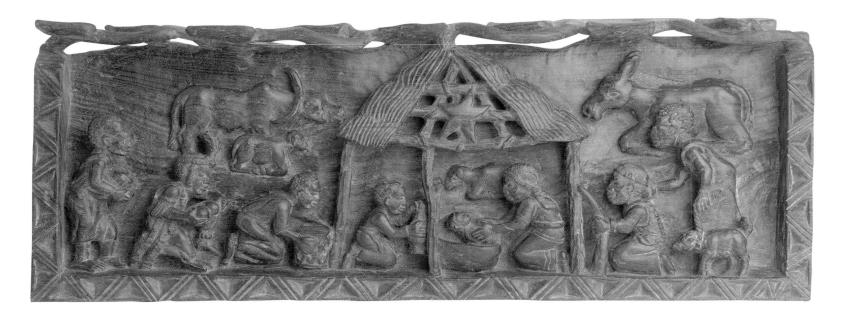

DENIS MOYO

MALAWI

The crèche tradition is becoming a part of the African Christian culture, as evidenced by this carving from Malawi. When we visited Malawi in 1989, Emilia and I could not find any crèches. However, a year later, we received as gifts two beautiful works of Malawian art from USAID friends. One was bought there as a finished crèche (see pages 99 and 137); the other, the relief carving featured here, was commissioned for us.

Malawian crèches illustrate how the tradition has been encouraged and adapted in Africa. This crèche, the one commissioned for us, was made by an artisan who was training at the Catholic KuNgoni Center of Culture and Art in Mua, located with (but separate from) the Mua Catholic Mission. The White Fathers founded the mission in 1902. In 1976, Father Claude Boucher founded the center, the purpose of which is "to promote Malawian awareness of its

own culture and its expression in a variety of art forms in view of positively contributing to the gradual expression of the Christian message." The center has become renowned for the excellence of its craftsmanship, and works by its artisans have been made for individuals and churches throughout Europe—including the Vatican.

This crèche was skillfully carved in relief form by Denis Moyo, who was born in 1976 at Balaka. He is no longer based at the center but continues with his carving. His scene is modeled after the work of another carver from the center, the late Michael Chawanda. The depiction is charming: the stable is a hut with a star in the roof and, unusually, Mary is tending the Baby Jesus in his crib. This is one of the very few crèches in the collection in which Mary is not in the traditional pose of either holding or watching the Infant.

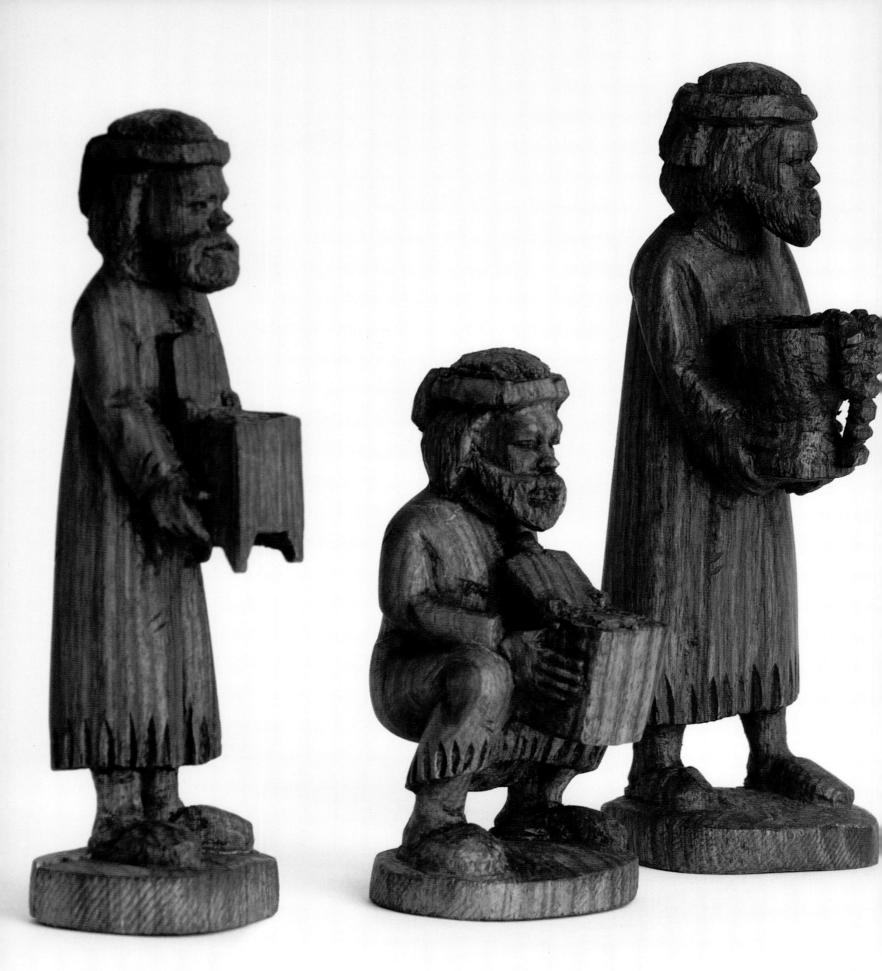

ROBED İП GLORY

COSTUMES

ertain costumes evoke certain cultures, and the costumes worn by a crèche's figures often reveal the provenance of the scene and sometimes its historical period. Much can be inferred from the artist's use of costume: social status, occupation, and, on occasion, religion.

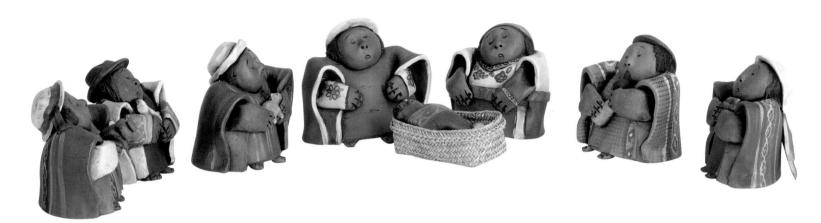

MICHAEL AYALA

ECUADOR

Ecuadorian artist Michael Ayala explains, "Many nativities I have seen in my country don't represent the native people very much; some even have blond and blue-eyed characters in the Holy Family. So I decided to design something very Ecuadorian and to represent the different ethnic groups in

my country." Primarily a painter, Ayala started working with clay around 1991 and now creates ceramics as well as paintings. With his ceramics, he likes to depict Ecuadorian themes—especially popular festivities,

including the Nativity.

During our correspondence, Avala explained that he started his workshop on his kitchen table, and then moved to a small space under the stairs. Later, he was able to rent a studio space. Ayala is self-taught and developed his

ceramic skills by studying from books and traveling to visit and observe other ceramists. He was inspired to create crèches by some childhood experiences: he remembers visiting many houses where the families each "tried to have the biggest and most beautiful nativity."

> The figures' clothing in this crèche, made by hand in terra-cotta, represents different regions of

> > Ecuador. The Holy Family wears the dress of the Otavalo region. An angel, with a panpipe, represents Cañar. A shepherd with a hen represents the Salasaca region, the one with a pig, the Tungurahua region; and the shepherd with a guinea pig (cuy), Cotapaxi. Another shepherd represents Otavalo and plays a bocina, an Andean horn.

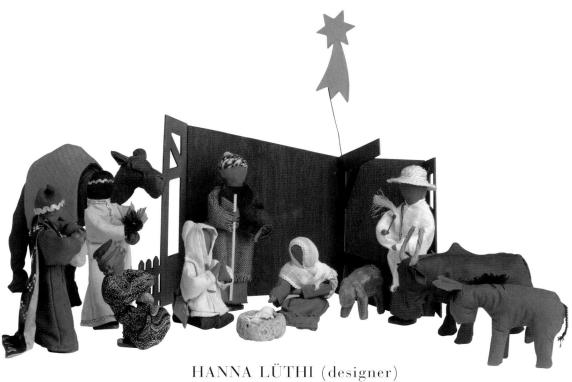

LISTEWORK ATNAFU (textile worker)

ETHIOPIA

This attractive Ethiopian nativity was made by individuals supported by the Signum Vitae Project, an organization that helps people with disabilities through job and handicrafts training—especially in the manufacturing of eyeglasses (the agency also operates a clinic for people with eye problems).

Hanni Lüthi, along with her husband and a team of Swiss and German volunteers, founded Signum Vitae in 1989. The aim was to "show disabled young persons God's care

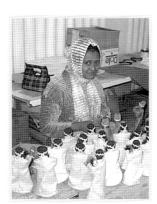

> LISTEWORK ATNAFU

and love" by providing an opportunity for vocational training and, after two or three years, a job with a good salary. A former Swiss arts and crafts teacher, Lüthi designed this nativity, and Listework Atnafu, who is disabled, produced the crèche. Atnafu works at home

and makes about thirty crèches a year, assisted by fellow craftspeople who create the wooden portions.

Most Christians in Ethiopia belong to the Ethiopian Orthodox Church, and the primary expression of their religion in art is through painted icons. The indigenous presentation of this three-dimensional nativity is very appealing. The figures are clothed in fabric: Mary wears a netela, or shawl, which is used as an everyday garment, especially in northern Ethiopia, but also worn on festive occasions. Joseph holds a djira (flyswatter), and the Infant Jesus lies in a stone manger of a kind often used in Ethiopia for feeding cattle. Indeed, some scholars say that the Infant was likely to have been laid in a stone manger, not the wooden one of common imagery. The standing shepherd represents people of the Ethiopian highlands, many of whom breed sheep, while the kneeling hooded figure represents the younger generation of Ethiopians, who increasingly wear Western clothes.

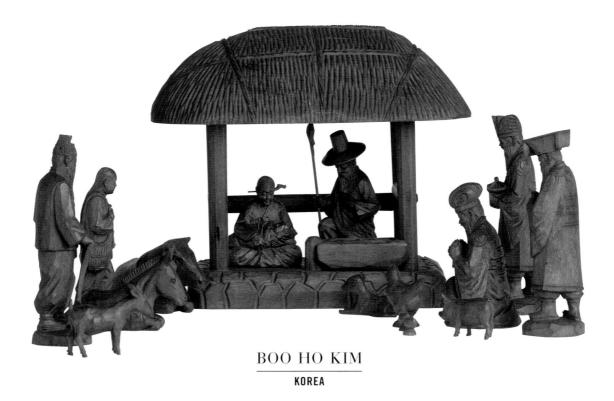

The beautifully rendered costumes in this nativity evoke exotic Asian silks but were, in fact, crafted from wood by a master carver. In 1961, this crèche's creator, as a young man in his twenties, started a wood-carving business in Seoul. Boo Ho Kim considers himself self-taught, yet he became a teacher of teachers, demonstrating his carving skills so that fine-arts instructors could learn technical and practical aspects of the subject they teach. He began by carving wooden dishes and cups of the type used by Koreans in the home on special occasions. His interest spread to

carving figures, both human and mythical. He has also carved Christmas ornaments, chess pieces, and some decorative items.

Kim, a Catholic, began making nativities in 1965, when a foreigner asked him to carve one in a Western style. He saw a new market for his carvings and was among the first Korean carvers to produce this type of work. He liked to experiment with forms, and made Korean-style scenes as well. Kim has made nativities and crosses for churches.

Kim does not consider himself a famous carver. He carved to earn "his bread," as he says. He retired in the early 1990s and moved to a small farm outside the city. There he practices organic farming, works as a private acupuncturist, and carves as a hobby. He especially likes to make toys for his grandchildren.

This finely carved nativity, made from linden wood, reflects the style of sixteenth-century Korea. Mary cradles the Infant as she sits beneath a small farm structure with a straw-thatched roof. The kings wear stately garb typical of the Chosun Dynasty.

> BOO HO KIM

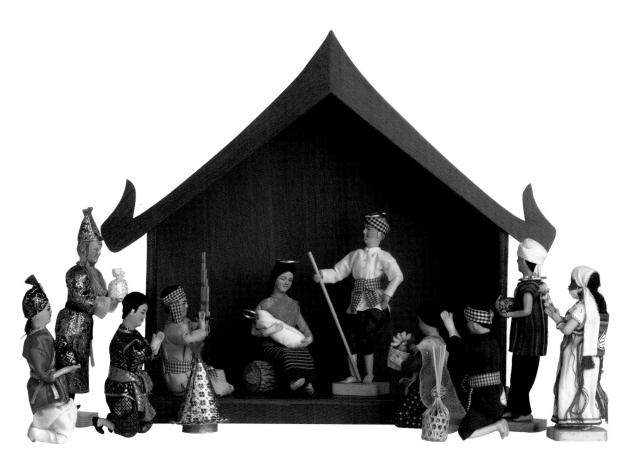

KHUNYING TONGKORN CHANDAVIMOL

THAILAND

What is a doll without costumes? It is not surprising that this crèche from Thailand's master doll-maker includes remarkable costuming.

Khunying is a title similar to that of "Lady" in Britain. The Thai government gave doll-maker Tongkorn Chandavimol the title in the 1960s for her contribution to Thai culture. Impressed by the tradition of doll-making in Japan on a visit in 1955, she attended a short doll-making course in Tokyo. She returned home and began to make dolls dressed in the traditional costumes of the Thai people. She set up a workshop, Bangkok Dolls, which employs about twenty people, and soon gained an international reputation. Thai

royalty has presented her dolls as gifts to several world leaders, and Khunying Tongkorn Chandavimol's workshop also made a doll of Pope John Paul II for a Christian group, who presented it to the pontiff when he visited Thailand.

Khunying Tongkorn Chandavimol, a Buddhist who attended Presbyterian school, began making nativities in the 1990s. In this crèche, the Holy Family is presented in contemporary Thai dress. The common people are represented by figures dressed as farmers of the Karen people. All the kings are dressed in silk, one as a Thai nobleman, another as a Chinese mandarin, and the third as a prince of India.

HASSA PASCAL MOUNKORO

MALI

Hassa Pascal Mounkoro is a

Catholic who enjoys making
crèches as "a sort of
evangelization, a way to talk
about my love for Jesus."

Born in 1968 into an animist

family, he lives in Mali's capital, Bamako. He was considered a master carver at the age of twenty-four, and he began training several other carvers, who went on to establish their own workshops.

Mounkoro's specialty, nativities, are rare in Mali, which is a predominately Muslim country. He began to make them after accepting a request from a Norwegian missionary, who gave him a book with nativity scenes from which he derived ideas.

Mounkoro's considerable talent is evident in the finely detailed figures, which display indigenous characteristics. The shepherds wear the round and pointed hats that are customary for the Fulani herders in the region.

> HASSA PASCAL MOUNKORO

JENI BABIN NEW MEXICO, UNITED STATES

Not all costume inspiration comes from clothing: the intricate design in this crèche was inspired by a cathedral in France. The artist has used the decorative motif from the rose window of Chartres Cathedral for the pattern on the figures' dress.

Jeni Babin, born in New Orleans and now living in Arizona, is known for her sculptural stoneware. Initially she drew and painted, but she began working with clay in the early 1980s. Since then, she says, "I just couldn't do anything else. Clay simply sings to my spirit with a powerful voice." Babin

studied under Japanese masters for three years and spent ten years developing her style. She is not sure, however, how to describe it: "robust contemporary with traditional overtones? I like to merge past and present into a contemporary artifact." In this crèche she achieves this mixture of enduring and contemporary by incorporating the stained-glass design into her work. All of Babin's crèches have been one piece, all very similar to this one. She says, "I put a lot of love into my pieces and feel that they are a way of reaching out, giving, connecting with people in a fulfilling manner."

HEAVER & MATURE ABOUND

FLORA AND FAUNA

It surprises some to learn that the only animals mentioned in the Gospel accounts of Christ's birth are the shepherds' flock. Animals abound in artists' renderings and retellings of the Nativity on account of a key element of the story: the manger into which the newborn Christ was laid. Conjecture, Old Testament prophesies, and legends have all contributed to the menagerie that sometimes surrounds the Baby Jesus in crèche scenes. As the tradition has been interpreted around the world, animals—like costumes, plants, and flowers—have become another medium for indigenous adaptation. This earthly abundance joins Heaven's angels and star in celebrating the event.

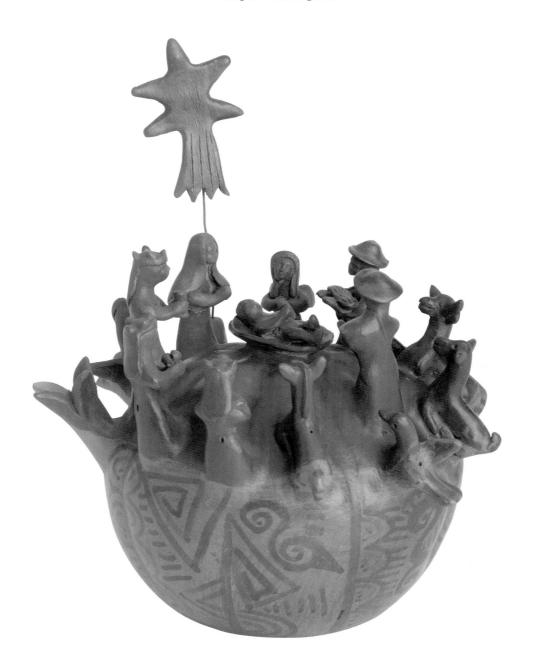

UNKNOWN ARTIST

MEXICO

This intriguing nativity presentation is set atop a rounded ceramic base. The heavenly star rises above the assembly of angel, shepherd, kings, and animals, and the Holy Family. There is a plant to one side. A bird, perhaps a dove representing the Holy Spirit, alights

on one side, while a rooster appears on the other. In addition to the expected cow, donkey, and sheep, a goat appears. Emilia and I acquired this piece in Guadalajara, but there was no information about its origin.

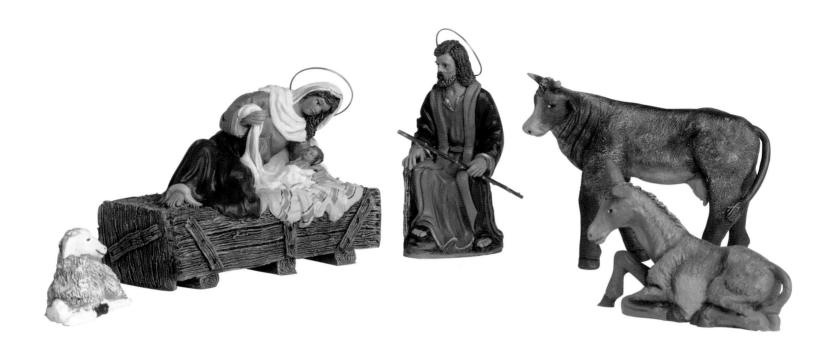

JOSEPH CAMILLERI

MALTA

An avid promoter of the tradition of the Nativity in his native country, Joseph Camilleri (or Joe, as he prefers) is known for his fine work with clay. He was born in 1943 and lives in Gozo, the sister island of Malta. He enjoyed playing with clay as a youth and made figures from molds, but only started working as a ceramist seriously when he was thirty years old. He learned some techniques from other potters

but considers himself mostly self-taught.

Camilleri was inspired to create his first crèche, sculpting it using toothpicks, after attending the international congress of crèche societies held in Madrid in 1992. These gatherings are sponsored by the international federation Universalis Foederatio Praesepistica. This nativity drew praise in a local exhibition, and Camilleri has devoted himself to crèche art

is an affiliate of the federation. He does make secular figures, but prefers to spend most of his time making nativities.

In this scene, the customary grouping of cow, donkey, and sheep attends the Infant's birth. Mary reclines, as she so often does in the Eastern iconographic tradition. Unusually, Joseph is depicted sitting. This nativity was commissioned for the collection.

⇒ JOSEPH CAMILLERI

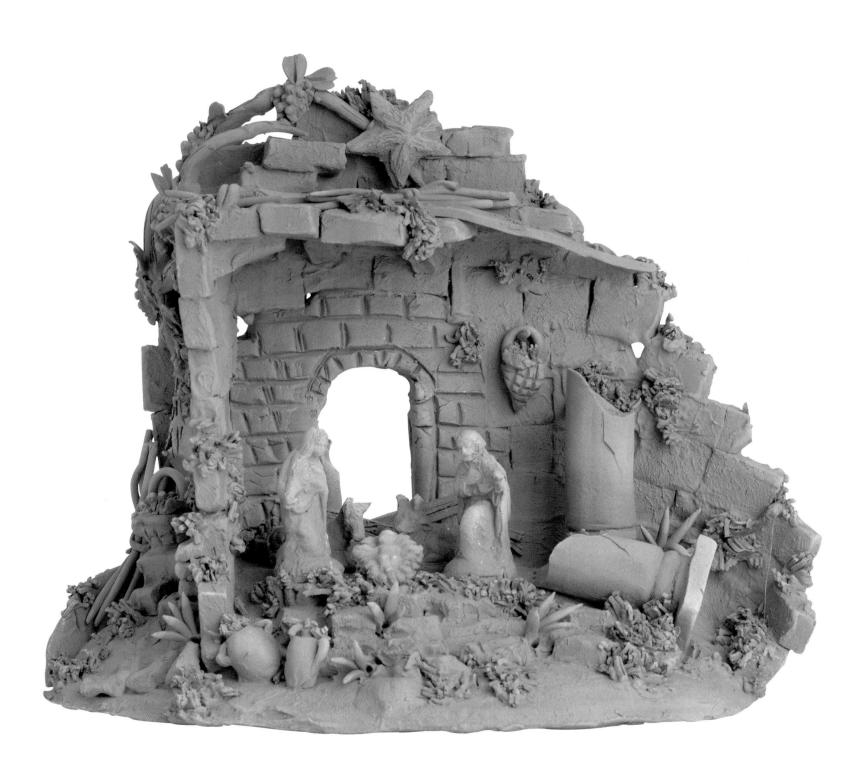

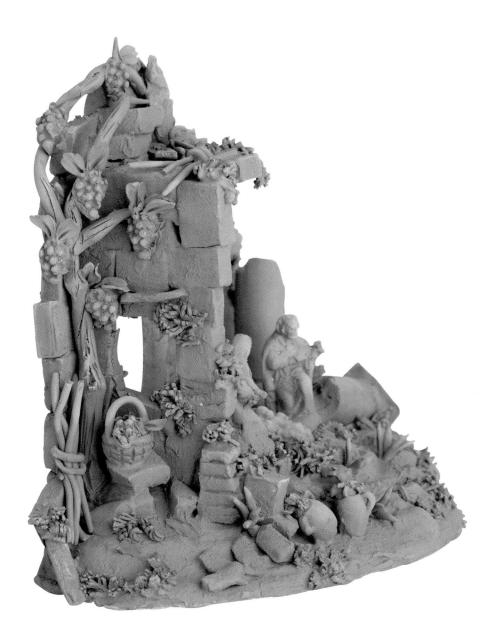

UNKNOWN ARTIST

ITALY

This *presepio* holds a special place in the collection and is unusual for its elaborate use of plants. The marvelous clay composition is from Procida, the island in the Bay of Naples where Emilia's parents lived before coming to the United States. We acquired it on one of several visits to family relatives. Though the ceramist lived in Procida, we were

unable to locate her to learn about her and her work. This fragile clay scene is filled with tiny details of plants, flowers, and jars. A basket of grapes sits at one side. The broken column, a common element in Neapolitan *presepi*, is often interpreted as symbolizing the fall of the Roman Empire and the rise of Christianity.

CARMÉLIA RODRIGUES DA SILVA

BRAZIL

This crèche, a gift from one of our sons, includes a rooster and cacti, and comes from the village of Alto do Mauro in northeastern Brazil. This small community, and the

> CARMÉLIA RODRIGUES DA SILVA

adjoining city of Caruaru, are considered by UNESCO to be the most important centers for figurative art in the Americas. The small clay figurines traditional in the area were first created by Master Vitalino Pereira dos Santos, who died in 1963. His style inspired artisans of the region to make

similar figurines often depicting, as he did, the everyday life of the people, and the tradition still thrives. There are about two hundred artisans in the village, most of whom work in Vitalino's style.

Carmélia Rodrigues da Silva has worked with clay since she was seven. She learned from her father, who she says was "one of the first disciples of Master Vitalino." Also influenced by this family tradition, Rodrigues's mother, her children, and other relatives work with clay, creating both religious and secular figures. This crèche, with its brightly hand-painted figures, is very much in Vitalino's style. The rooster, as in many Hispanic crèches, is prominent among the creatures present.

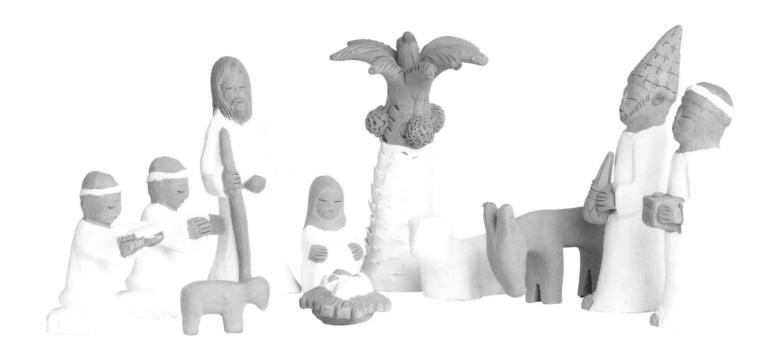

$\frac{\text{ABDOU ZEINHOUM}}{\text{EGYPT}}$

Abdou Zeinhoum is known for his delicate nativity figures. He has practiced his pottery handicraft for thirty years, living in old Cairo for most of that time. He sells his crèches primarily to shops visited by tourists. The figures and the finely detailed palm tree in this scene reflect its Middle Eastern origin. The nativity was a gift from a USAID colleague.

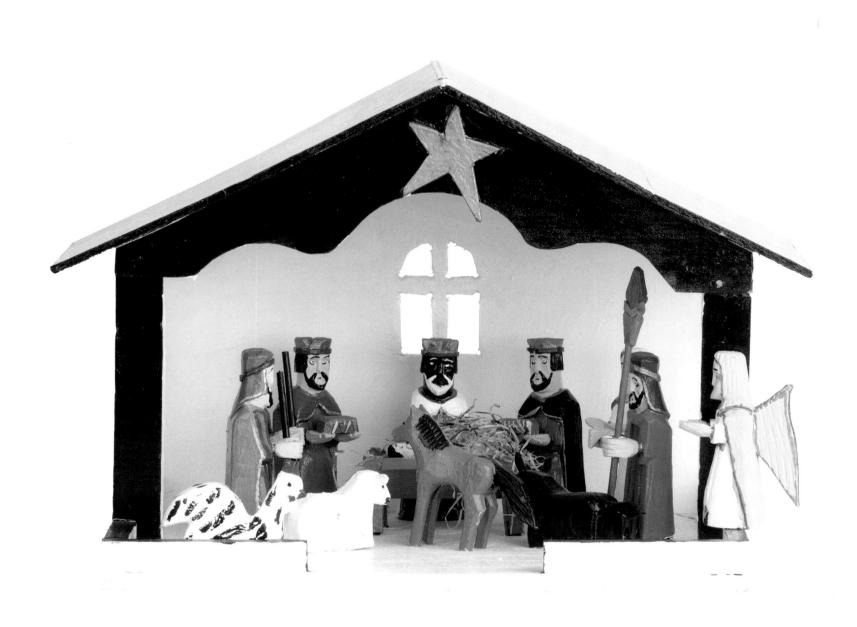

JUAN CRUZ AVILÉS

PUERTO RICO

Emilia and I visited Puerto Rico in 1991, and hoped to find a crèche made by a Puerto Rican santero. We did not meet any santeros, but at our hotel we took the names of several whose carvings were in the hotel shop. On returning home, I wrote to one of them, Juan Cruz Avilés (or Nito Cruz, as he prefers). Within a couple of weeks, he surprised us by sending, unannounced, an unpainted crèche with a short note asking us to be "patient," since he would soon be making the painted one we had requested.

Nito Cruz lives in Lares, a small village in the mountains in the west of Puerto Rico, where he was born in 1919. He was raised by his grandparents on a small farm. His schooling was interrupted by the need to work to help support the family, but he eventually obtained a high school diploma. Cruz worked for many years for the town administration, where part of his responsibility included providing potable water in the town, but when he retired

he decided to dedicate himself to his carving.

Many *santeros* have lived in Lares during the last two centuries, and Cruz was undoubtedly influenced by their legacy.

Cruz began carving when he was fourteen years old, having "received a message in a dream to begin carving" to help with school expenses. The message also indicated that he should restore *santos*. Cruz was skeptical about the dream, but he told his grandmother. At first she forbade him to touch her *santos*, but finally she relented, and Cruz began to restore and to carve them as a young teenager, without ever receiving outside training. He likes to carve both *santos* and crèches, having carved his first crèche around 1945. Cruz believes that the ability to carve was a gift given to him at a particular time in his life to solve a problem. Because of this, he charges minimal prices for his work, but notes sadly that some people have resold his carvings for many times the original price.

This crèche is the second one Cruz sent us and, but for being painted, is much like the first. The carving reflects Cruz's simple and somewhat primitive style. The bold colors

> of the figures set against the white interior of the stable give the scene vibrancy. Animals are positioned around the Infant almost as if they are shielding him from the elements.

> JUAN CRUZ AVILÉS AND HIS WIFE, MARÍA

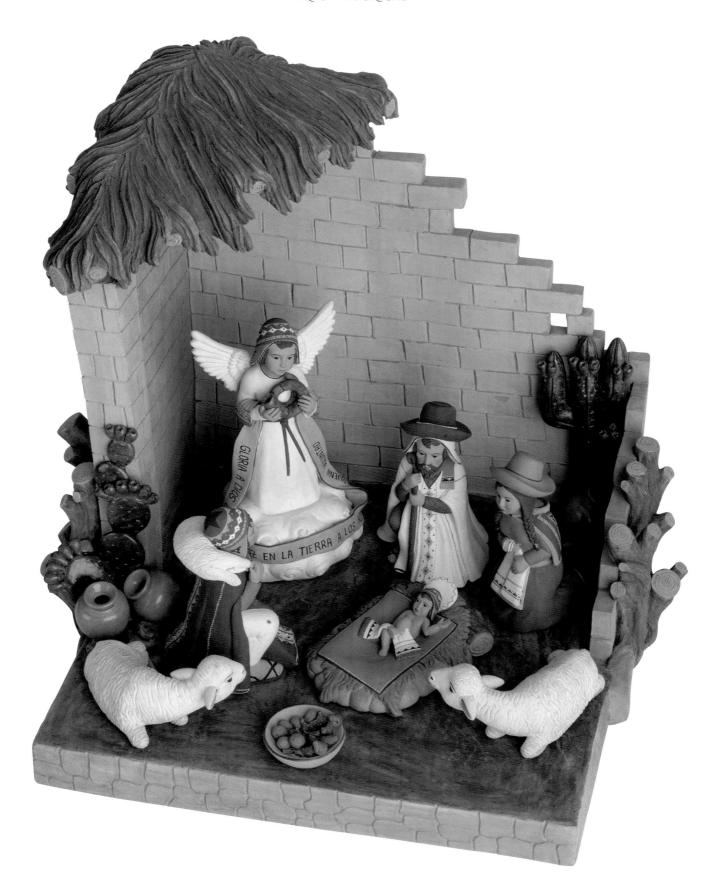

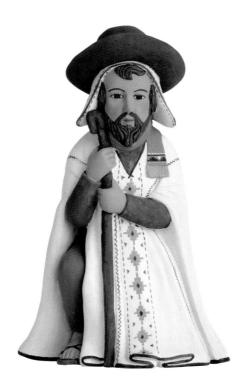

VICTOR FAUSTINO CHÁVEZ QUISPE

PERU

Born in Lima in 1966, Victor Chávez faced a number of hardships as he grew up and sought to become a ceramist. He worked from an early age to help his mother support a family of four children. The menial jobs of his youth included shining shoes and washing cars. As a teenager, Chávez went to live with his grandmother in Quinua, where he began to make ceramics. Unable to pay for classes, he learned the craft without formal training, but was befriended by several artisans who taught him various techniques. Once he gained some recognition for his work,

he returned to Lima, where he eventually became a ceramic instructor with an organization directed by a Spanish priest.

This nativity was commissioned for the collection and portrays a scene set in the Andean highlands, complete with cacti. Nature's bounty is also represented by the gift of food presented in a bowl, which includes cactus fruit and cuy (guinea pig). The Christ Child, angel, and shepherd wear the traditional hat called a *chullo*. Chávez's artistic skills are evident in the figures' delicately defined facial features and the finely detailed decoration of their clothing.

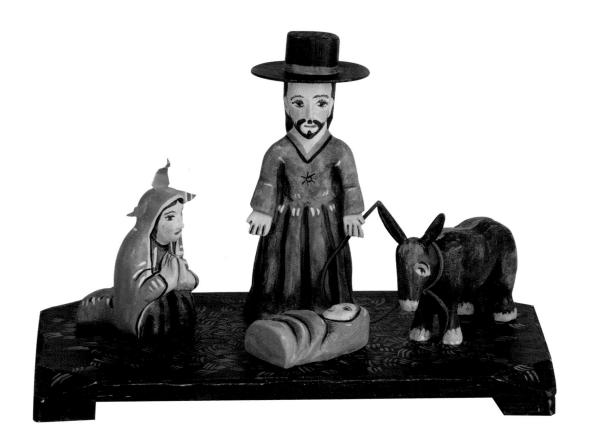

CHRISTOPHER MAYA

CALIFORNIA, UNITED STATES

Christopher Maya was exposed to devotional art as a youth, in his family home. Born in El Paso, Texas, in 1961, he now resides in California. He began to carve in the mid-1990s and is dedicated to making *santos* and holy images; he also paints and makes woodblock prints. He says he creates "as a devotion." In this nativity, carved in the Spanish Colonial style, Joseph is a commanding figure, but the artist's focus is on the donkey, or *burro*. Maya feels that the *burro* is "undercredited in the Nativity story," and as animals give "love unconditionally"—in this instance to the Christ Child—they are the real stars of the Nativity story.

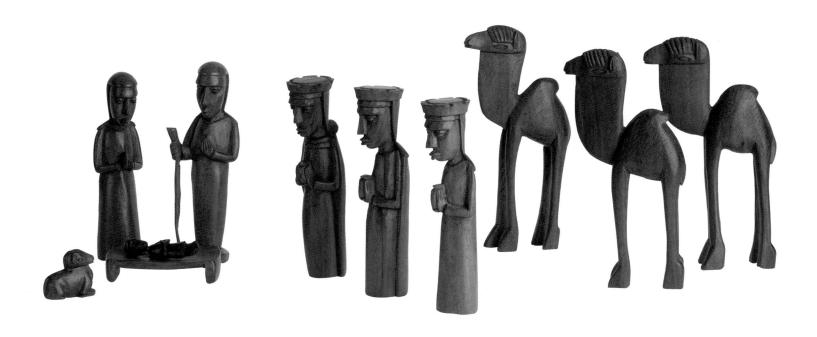

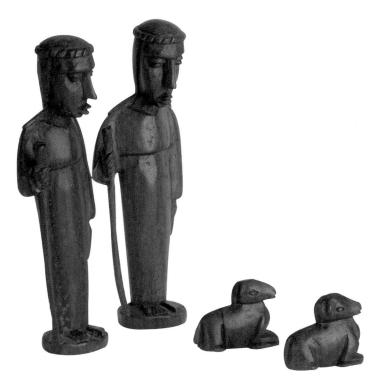

UNKNOWN ARTIST

LIBERIA

Some elements of the Nativity story, such as the camels on which the magi traveled, are embellishments, but they have become, for many, essential to the tale. Crafted from redwood, this crèche projects a warmth, especially in the appealing camel figures. It was commissioned as a gift for the collection by a USAID friend who was working in Monrovia at the time, and was carved by skilled Liberian artisans who occupied a roadside stall opposite my friend's office.

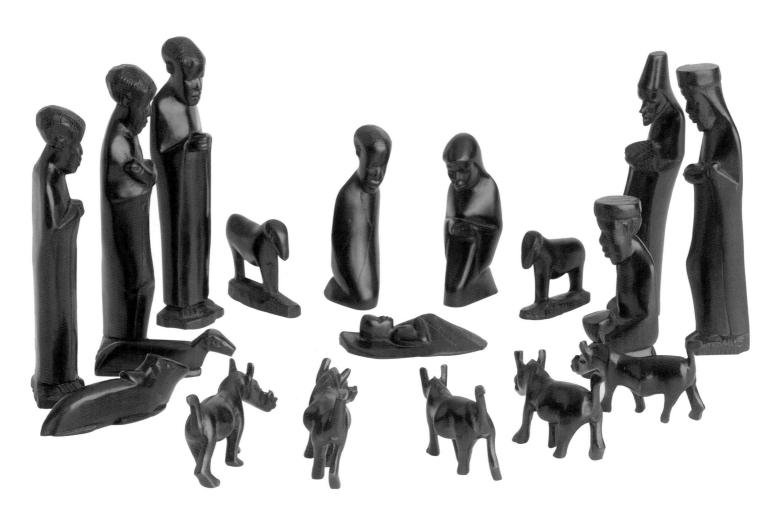

UNKNOWN ARTIST KENYA

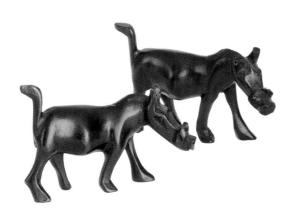

This crèche is probably the only nativity in the world in which most of the animal characters are warthogs. It was commissioned for me by my staff at USAID. They entrusted an agency employee in Nairobi to find a carver, and presented the nativity to me on my retirement after thirty-four years with the agency. My staff had asked for warthogs to be included because of my fondness for them, and in remembrance of a stuffed toy warthog we named Wally that was the gift of a former staffer and had been the office's mascot for a decade. Unfortunately, the name of the carver who created this warthog nativity is not known.

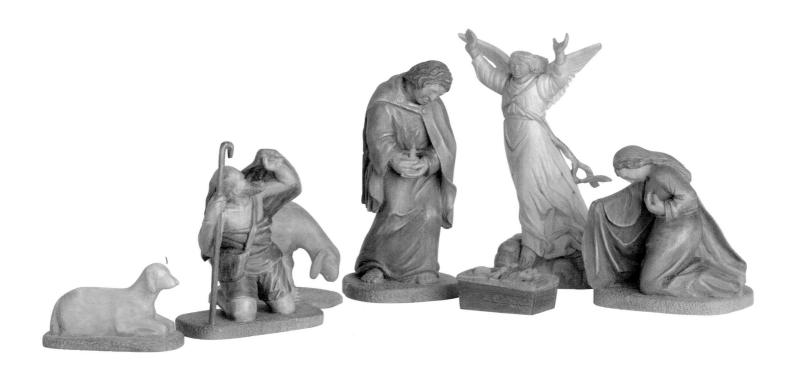

TRAYAN GABROVSKI

BULGARIA

Sheep are often considered essential in crèche scenes because of Luke's mention of the shepherds' flock. In this scene, two sheep are beside the shepherd who, startled, shields his face at the appearance of the angel, who has come to proclaim the good news of Christ's birth. This portrayal of the shepherd is unique in the collection.

Trayan Gabrovski, born in 1950 in a northern village, now lives in Teteven in central Bulgaria. Since the age of thirty he has made his living as a wood-carver. He says that he did not learn his craft in a school, "but it might be God's blessing for me." Gabrovski carves reliefs as well as three-dimensional pieces, and his works include both religious and secular themes. This softly colored crèche was commissioned for the collection.

> TRAYAN GABROVSKI

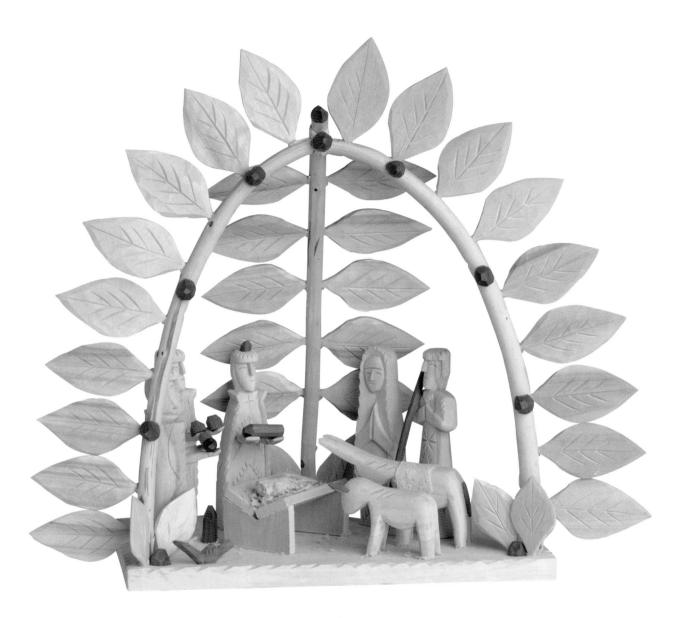

SABINITA LÓPEZ ORTIZ

NEW MEXICO, UNITED STATES

José Dolores López of Cordóva, New Mexico, was one of the *santeros* who helped revive interest in Spanish Colonial carving in the early twentieth century, and his descendants continue to carve in the "Cordóva style." Among them are two of José Dolores López's grandchildren, Sabinita López Ortiz and Eluid Levi Martínez, both of whose work is represented in the collection (see also pages 186–87).

The curved branch above Sabinita's scene is one of the signatures of the family's traditional carving style. Sabinita López Ortiz was born in 1938, the daughter of Ricardo López, also a carver, but she was adopted by her uncle, George López, and his wife, Silvanita, who were childless. George had asked Ricardo if they could adopt one of his children, and Sabinita chose to be the one.

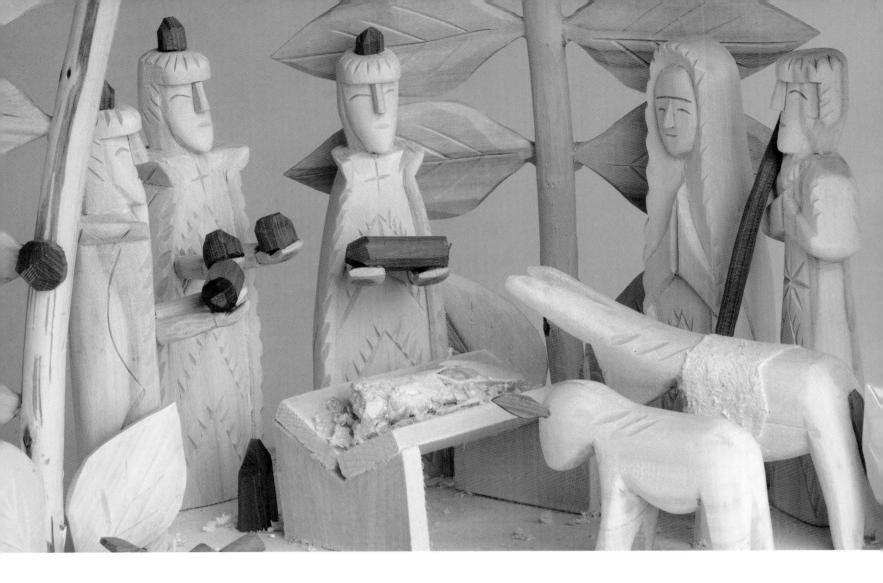

She began to carve when still a child, under the guidance of her new father. After she married, she taught her husband, Cristóbal Ortiz, to carve, and he also worked with the family. Cristóbal and Sabinita shared a workshop

> SABINITA LÓPEZ ORTIZ

with George and his wife for some years. The family tradition continues with Sabinita's five children, who have also learned to carve.

Although Sabinita and her relatives followed José Dolores López's style, each of them has developed his or her own distinctive work. For example, it was Ricardo and Benita, Sabinita's birth parents, who introduced a curved willow branch above the figures in some of their carvings. This curved branch, called a *coronita*, or little crown, was then decorated with carved leaves extending from it.

Despite some innovation, Sabinita describes her carving as "the same as my father and grandfather." She uses a pocket knife and works with cottonwood and aspen, or sometimes cedar. Her crèche in the collection is carved from aspen and small pieces of cedar, and incorporates such elements of the family style as the *coronita*, the leaves, and a bird. Sabinita's carving has gained some recognition. She has, for example, appeared at events sponsored by the Smithsonian Institution in Washington, D.C., including at the National Museum of American Art.

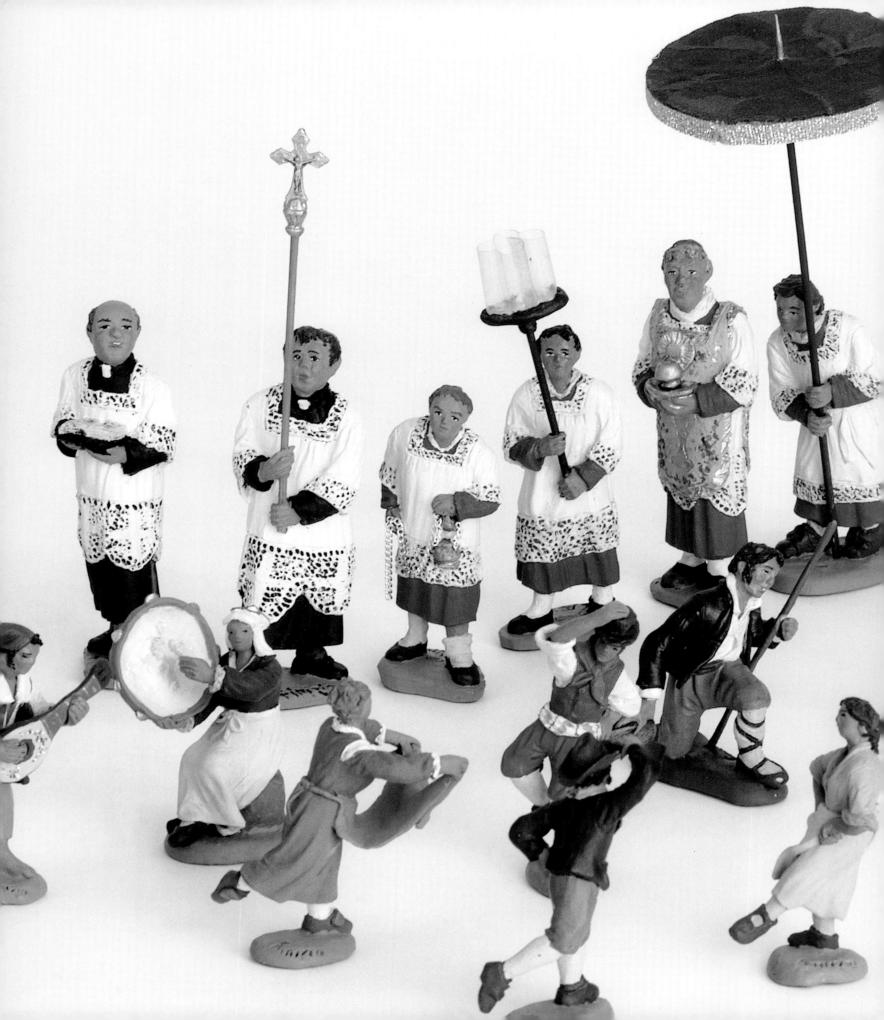

A JOYFUL HOISE

MUSICAL EXPRESSIONS

III usic has become an integral part of Christmas traditions around the world. Each world culture has its unique form of musical expression—particular musical instruments, dances, and songs—so it is not surprising that a diverse range of musical genres can be found represented in crèche scenes.

MOHAMMED AMIN

GHANA

Musical expression abounds in this crèche from Ghana. Mohammed Amin is a self-taught potter who devotes his skills to honoring the culture and customs of the people of Ghana, especially those of northern Ghana, where he lives. Born in 1968 in Salamba, he began pottery work in the late 1980s, after being encouraged to do so by a Canadian priest. He obtained a certificate at secondary school level but had no training in the arts. Amin is a Muslim, and is married to a Catholic. He has taught cultural traditions and art at the Tamale Institute of Cross Cultural Studies, a school run by the Christian Brothers, and now he has his own ceramics workshop.

Amin's crèches are steeped in the culture of the region. A member of the Dagomba tribe, he presents the Holy Family as Dagomba. The musical instruments are familiar in the area. Drums are especially important to the community, being a source of entertainment as well as communication. In this scene, the drummer is announcing Christ's birth and summoning all. The xylophonist is a Dagaties tribesman; the flutist, a Kasina. Both instruments are important in ceremonies and festivals, and here they celebrate the Christ Child. The kings—only two—are portrayed on horses and represent the chiefs of the Dagomba and Gonja people. The size of the umbrellas and quantity of adornment on the horses signify the importance of the chiefs. When Amin includes a third king in his crèches, he is portrayed as a nomadic Tuareg, riding a camel. The background for the nativity scene shows huts of the style used to house animals in northern Ghana.

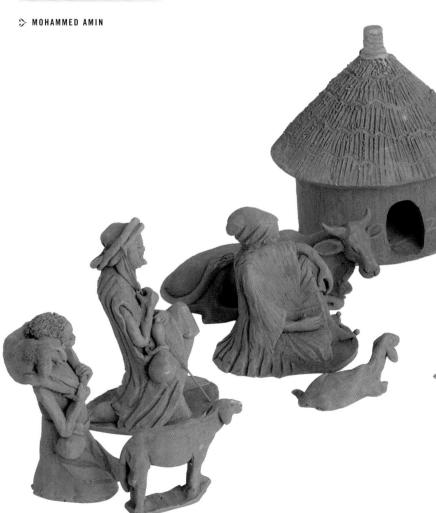

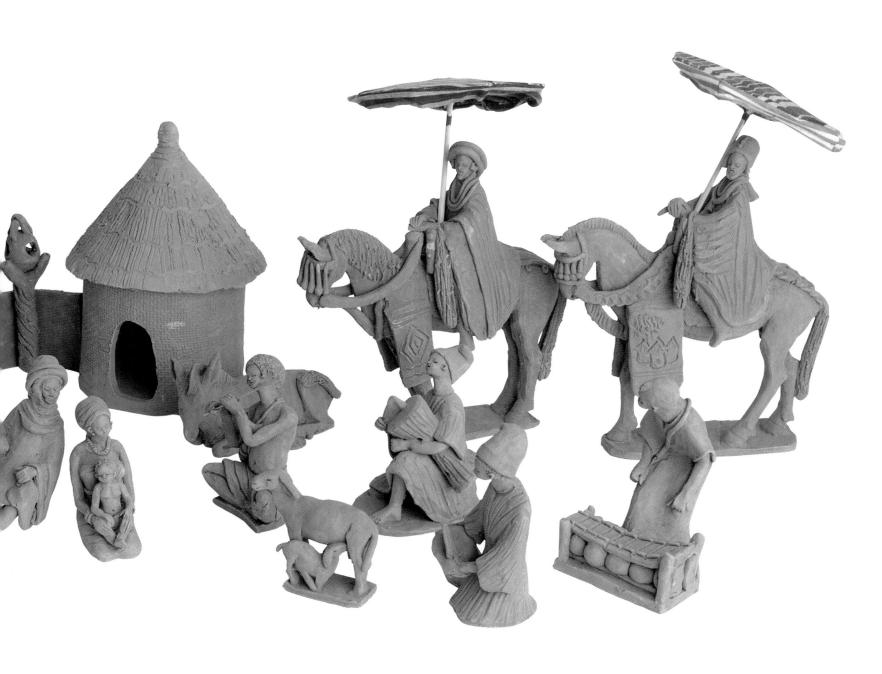

$\frac{\text{JAN VOKOUN}}{\text{czech republic}}$

Many Czech nativities include musicians in their portrayals, not surprisingly given the Czechs' great love of music. This piece is by artist Jan Vokoun, who was born in 1956 and began carving when he was about forty years old. Vokoun considers himself self-taught, but feels that working with wood is partly a family tradition since his grandfather was a carpenter. His first carvings included crèches, which he continues to make, and he also enjoys making marionettes, especially figures of local villagers as musicians.

This crèche was commissioned when I met Vokoun demonstrating his craft at a crèche museum in his town, Třebechovice pod Orebem. He invited me to his home studio, where we discussed the kind of nativity he would make. The resulting scene reflects his style, which he says is in the folk-art tradition of his region. Mary holds the Infant while a merry trio of musicians serenades him. The shepherds and kings gather in adoration while the angel rings a bell, perhaps in accompaniment to the musical trio.

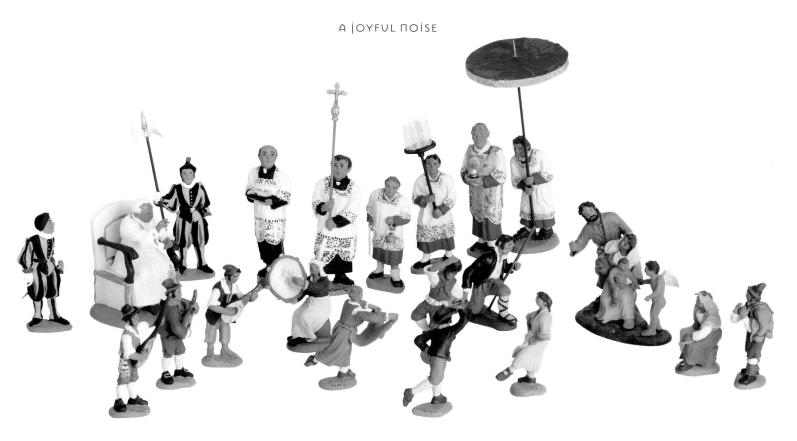

ALBERTO FINIZIO

ITALY

This art piece evokes music both festive and sacred. The people dance to celebrate the birth of Christ; a figure of Pope John Paul II blesses the assemblage; and a Eucharistic procession takes place. To many Christians, the Eucharist symbolizes Christ's presence in the world today. Alberto Finizio created this engaging presentation, which was commissioned for the collection with the specific request

> ALBERTO FINIZIO

to include a figure of the then pontiff, John Paul II.

Finizio was born in Abruzzo in 1956, and now lives near Rome. He began to make nativities as a child and is self-taught. He is active in the Associazione Italiana Amici del Presepio, an organization for supporters of the crèche in

Italy, and has learned much by working with other master artists in this association. While he generally likes to make miniatures, some of his figures reach 14 inches (36 cm). Finizio uses clay and a synthetic material similar to clay. In the Italian tradition, he also makes detailed background settings for his nativities. He considers his style traditional, but strives to create original presentations. In this scene, the people are dressed in the styles of Rome and the

surrounding countryside during the nineteenth century.

Finizio says that for him "the nativity scene is a reminder of childhood and of family, a message of love and brotherhood, a passion that occupies a great deal of my time."

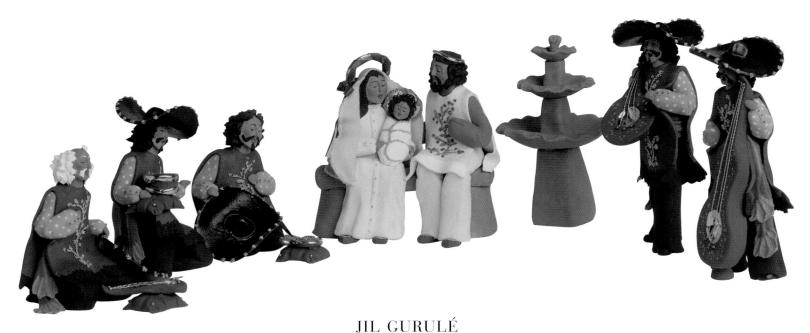

NEW MEXICO, UNITED STATES

This nativity was commissioned for the collection with the specific request that the artist include mariachi figures. Mariachi music, along with a style of dress, originated in the Mexican state of Jalisco. Jil Gurulé, a New Orleans native now living in New Mexico, creates expressive nativity scenes with bold and attractive coloration developed from her work as an oil and acrylics painter (see also pages 200–201). She has worked with clay since 1977, and is self-taught. She feels drawn to the "quiet dignity and beauty" of the native peoples of New Mexico, especially northern New Mexico. She enjoys creating pieces for the Native American market. Gurulé also makes many colorful saint figures to sell in Santa Fe's annual Spanish Market, and collectors seek her Santa Claus figures.

Gurulé began making nativities in 1984 and estimates she has made more than one thousand of them since then. She creates a new presentation every year and then retires it, or she may work from one of these earlier presentations and modify it so that it becomes a different presentation. Each one is individually made; she does not use molds. Asked why she is attracted to the theme, Gurulé replies that she likes nativities because "to me, they are peaceful." She feels "the Nativity story is a beautiful, hopeful story," and she strives to make each crèche "reflect the love in the story."

In this scene, some of the musicians perform for the Christ Child while others offer their instruments as gifts. The Holy Family is placed on a bench as if they were sitting in a Spanish square or park.

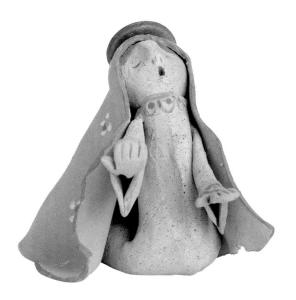

CAROLINE TAIT VIRGINIA, UNITED STATES

This joyful clay scene was created by Caroline Tait, an artist who was living in Virginia at the time we acquired it. The figures all seem to be honoring the Christ Child with song, led by Mary and Joseph. The Christ Child lies comfortably in swaddling clothes. The innkeeper, keys at his side, and his wife join the kings and shepherds. A dog and a cat complete the scene. Tait has created similarly delightful

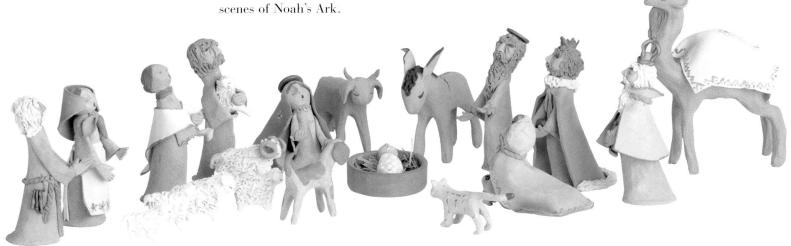

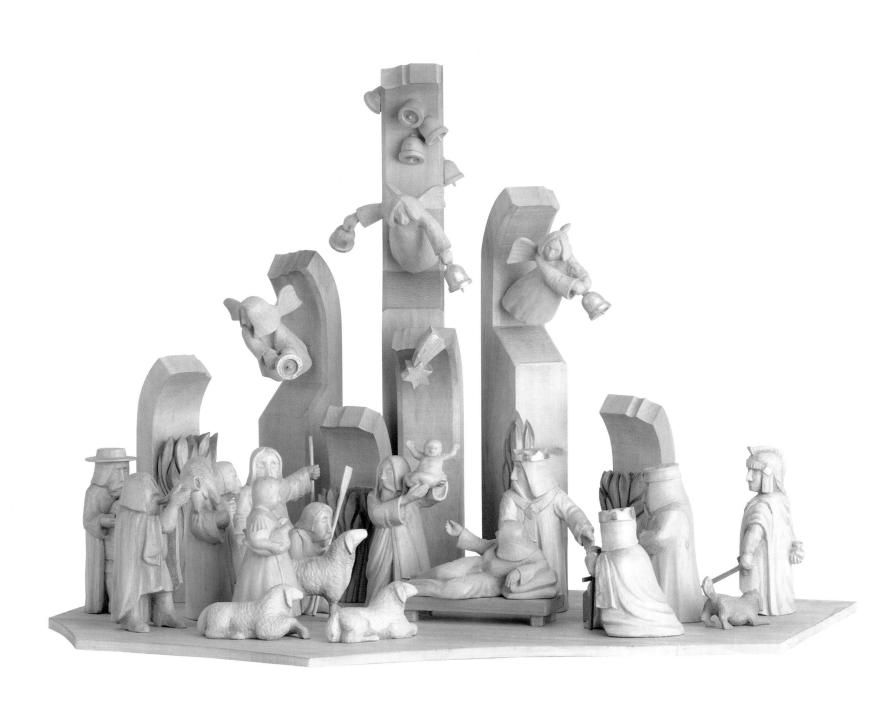

$\frac{\text{PAVEL MATUŠKA}}{\text{czech republic}}$

This Czech piece includes a *shofar*, a horn (often a ram's horn) traditionally used to announce an important Jewish event, especially Rosh Hashanah, the Jewish New Year. This unusual incorporation might be expected from Pavel Matuška, who likes to create unconventional portrayals and to use humor in most of his work. He still lives and works in the house in Třebechovice pod Orebem where he was born in 1944. He had some university education for his work as a graphic designer, but he considers himself a self-taught cartoonist, painter, and carver. He began his

Matuška created a large outdoor nativity scene for the public square in Třebechovice pod Orebem, which also boasts a nativity museum. The museum houses the Probošt Nativity, a declared national treasure, created by Josef Probošt, who studied with Matuška's grandfather. The Probošt Nativity, which is 21 feet (6.4 m) wide, contains over two thousand parts, many of them mechanically moving pieces. Matuška said he did not begin carving until

artistic career in 1967 but started carving only in 1998.

> PAVEL MATUŠKA

late in his career because he was hesitant to follow such illustrious artists.

Matuška has made only a few nativities. The crèche pictured here is the third one of this scale. In this scene, which he entitled "Listen III," Matuška eschews the traditional stable with an ox and donkey, and instead chooses a "neutral" background of columns and angels spreading the news. Although he considers humor a hallmark of his work, he has given this nativity a foreboding feel. While Joseph holds the Infant aloft and Mary beckons all to greet him, the Roman soldier, holding a sword and a bag of silver tucked behind him, symbolizes the betrayal and violent fate awaiting the Christ Child. Matuška says: "No one is paying attention to the soldier; only a little dog senses something ominous." The Christ Child's extended arms suggest he is reaching

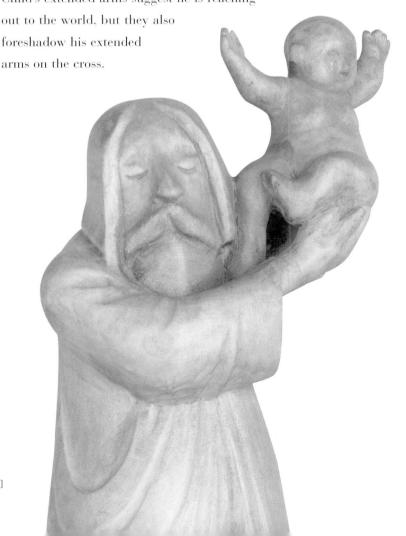

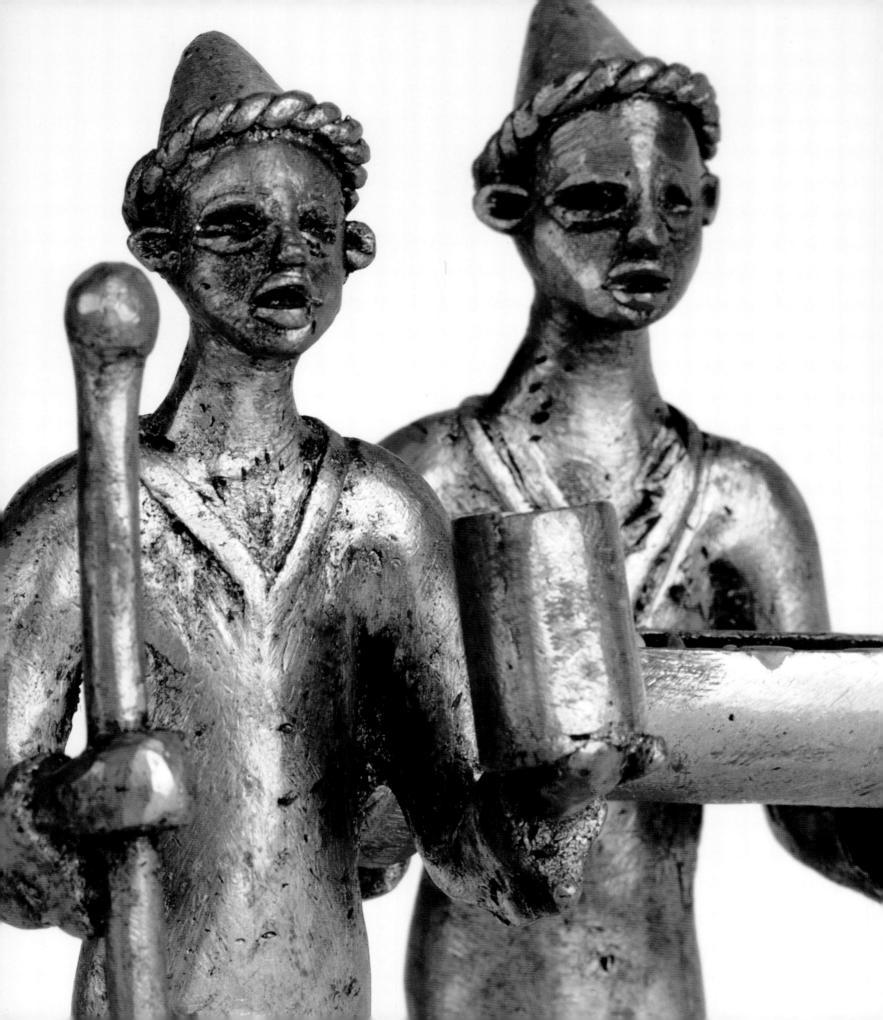

GİFTS OF THE MAGİ

EXPRESSIONS OF HOMAGE

nyone familiar with the Christmas story can name the gifts that the magi presented to the Baby Jesus, but few can interpret their significance. Although the gifts' profundity is often forgotten, their value and the determination of the magi to make their presentation are remembered through the celebrations of gift-giving at Christmas and Epiphany. Gold, frankincense, and myrrh have powerful associations in Western culture, but the solemnity of the gifts can also be expressed in valuables and materials that are sacred to other cultures around the world.

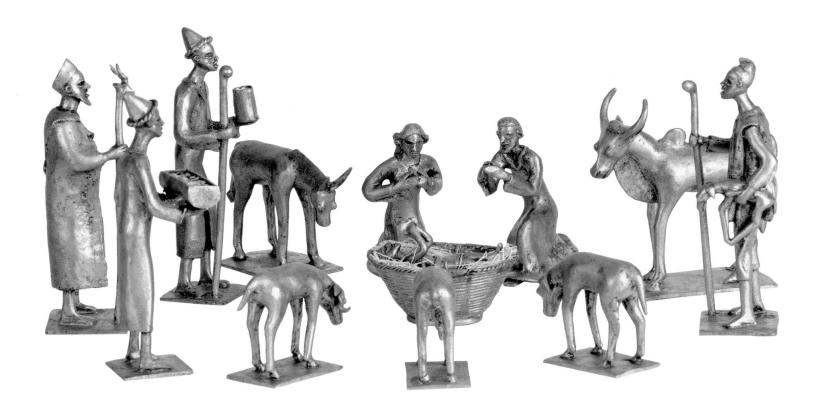

UNKNOWN ARTIST

BURKINA FASO

One of the reasons this crèche from Burkina Faso is such a favorite is the wonderful portrayal of the kings and their unique gifts. Burkina Faso, a former French colony in West Africa, is a largely Muslim country with a Christian presence. This striking bronze crèche was commissioned for the collection through a USAID colleague, and was made by a group of artisans in Ouagadougou, the capital city of this poor Sahelian country. The pieces are each

signed and were probably made by artisans at the Centre National d'Artisanat d'Art. The crèche figures are in Burkinabe dress. The kings merit special attention: two of them bear gifts of real grain, most likely sorghum and millet, while the third, regal with beard, holds a staff topped by an animal's head, which has been very finely sculpted. The indigenous animals bow in adoration to the Christ Child.

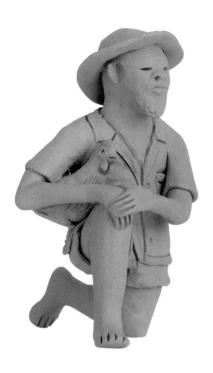

$\frac{\text{UNKNOWN ARTIST}}{\text{HAITI}}$

In this red clay scene depicting the rural people of Haiti, the poor but dignified figures bring gifts of their produce: a rooster, bananas, and a bag, perhaps of sugar. They gaze at the Christ Child with expressions of profound reverence.

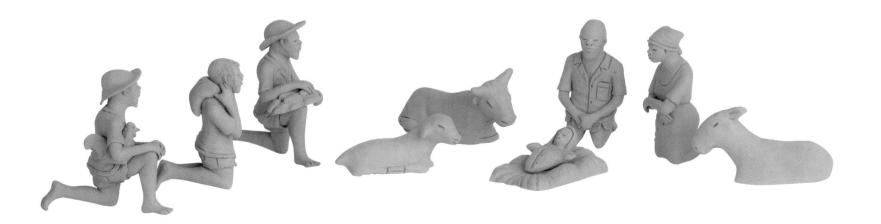

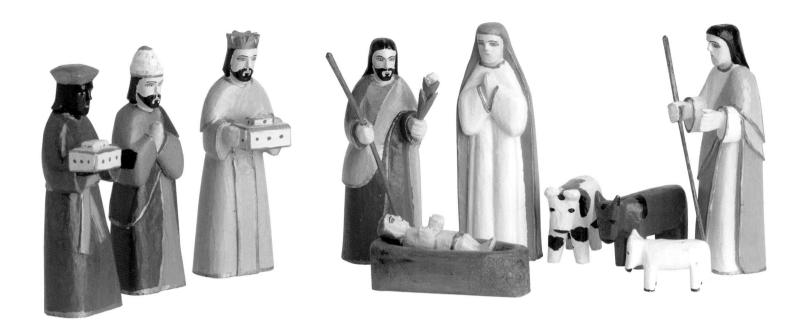

$\frac{\text{RODRÍGUEZ}}{\text{Paraguay}}$

This crèche is signed "Rodríguez," perhaps by the woman carver Juana de Rodríguez. The style of the figures, all carved from a lightweight wood, suggests that the carver may have been from around Tobati, which has long been a center for crafts. The tradition of carving in Paraguay—especially of religious themes—dates to the Jesuits, who arrived in the seventeenth century. Figures of saints (santos) have always been among the most popular carvings of the Tobati artisans. Joseph holds a lily, an allusion to the story of his staff bursting into bloom as he became Mary's husband, sometimes interpreted as a symbol of purity. Two kings hold gifts of treasure boxes; the third holds his hands together, suggesting that his gift may be prayer.

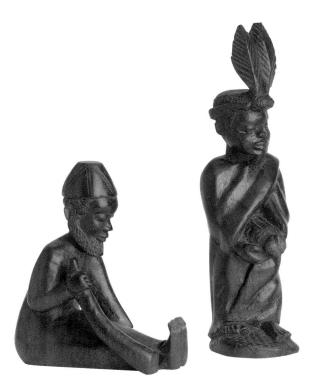

SUWEDI BIGULA

MALAWI

Suwedi Bigula, the carver of these three kings, which form part of an expressive crèche (see page 137), is from the Yao tribe, and was born in 1951 in the village of Mwachumu in the Zomba district of southern Malawi. In the 1970s, Bigula received support from Catholic

missionaries, who inspired him to carve
Christian themes. He began working at the
KuNgoni Center of Culture and Art in Mua in
1983, and became one of the master carvers.

Bigula's crèche, carved from mlamba wood,

conveys feelings of warmth and piety. The magi convey nobility and wisdom. They represent three proud tribal peoples of Malawi: the Yao king sits with legs outstretched and offers a gift of ivory; the Ngoni king is a chieftain with a feather headdress who offers a chicken; and the other

> king, representing the Chewa, sits offering a gourd containing medicine for the Child. Mary sits and Joseph kneels, both extending their arms as they invite homage to the Infant Jesus, who sleeps with a serene countenance.

> SUWEDI BIGULA AND HIS WIFE, ESTHER APHIA

JERRY SAINT GERMAIN

PUERTO RICO

In this scene, the three kings, who are especially honored in Puerto Rico, pay homage to the Christ Child.

According to the ceramist's widow, Leticia Saint Germain, the scene signifies the new beginning for humankind brought about by Christ's birth—a gift for all humanity. The boatlike setting, which evokes Noah's Ark, reinforces this theme.

The artist, Jerry Saint Germain, was an architect and sculptor who also taught. Born in 1933 in Detroit, he moved to Puerto Rico in 1972. A few years later, he established a ceramics studio in San Juan. He devoted himself to sculpting and other art, such as murals, until his death in 1990. His work is somewhat abstract—as reflected in this nativity, which was a gift from a friend.

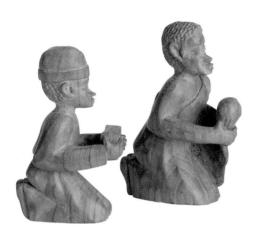

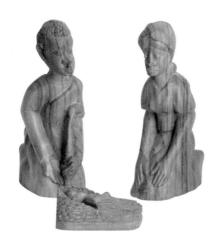

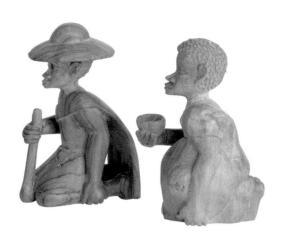

ROGER BAWI

TOGO

Rather than three kings, two local leaders adore the Infant Jesus in this crèche made of acacia wood. One, wearing a wide-brimmed hat and cloak of goatskin, is a tchodjo, a traditional priest from Togo's northern region. He is present to bless the event. The other, a chief in a royal hat, offers a box of gold. Two shepherds humbly hold their hats. One carries a sheep, the other a calabash, a gourd containing milk.

This charming scene was acquired through contacts at a Benedictine monastery in the Midwest, who, in turn, contacted a Benedictine monastery in Togo. A brother at the African monastery was aware of a young carver, Roger Bawi, whom he

> ROGER BAWI

contacted, and who agreed to make a crèche for me.

northern town of Lassa-Algalade. He learned to carve while working with a Catholic missionary center in southern Togo, and began his own career as a wood sculptor in 1986, occasionally working with a Catholic mission in the town of Saoude, where he lives. In addition to crèches, he also makes such major church elements as

altars, and other carvings.

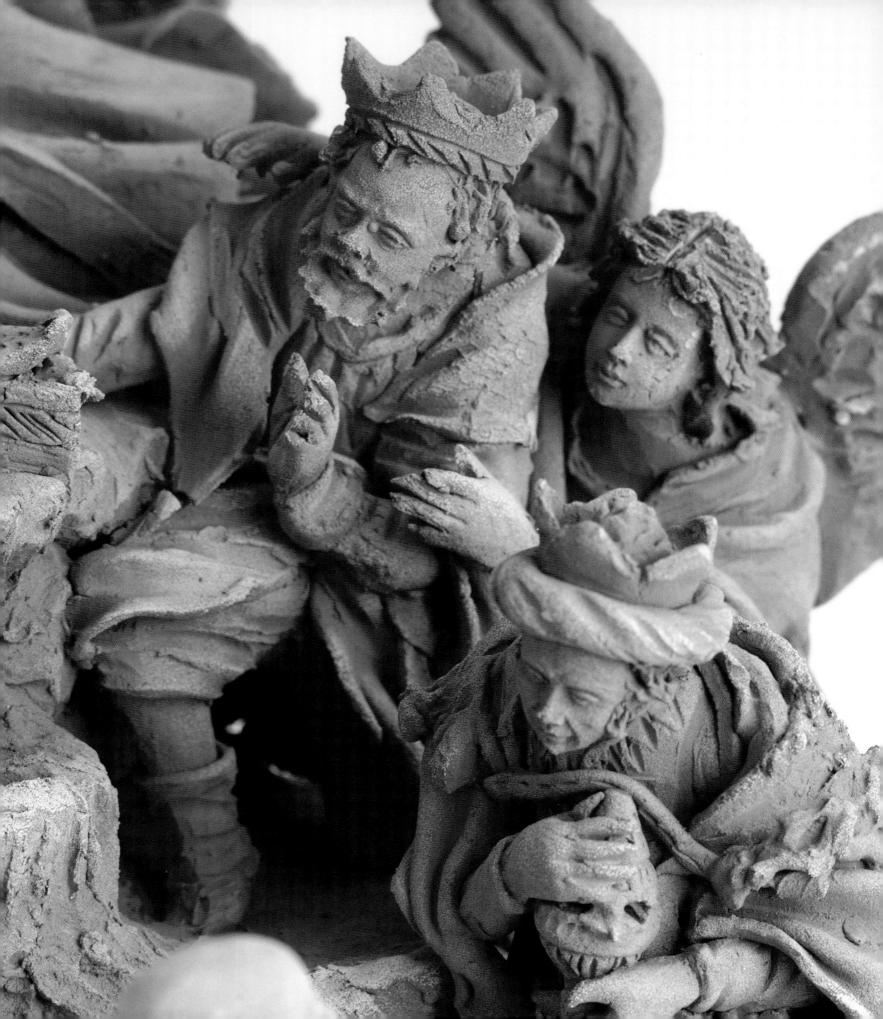

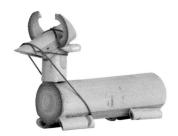

TRADITION & INNOVATION

CREATING CRÈCHES

he materials and methods used in creating crèches are as varied as the people who produce them. Presented here are a variety of crèches made of varying materials—from the usual, such as clay and wood, to the unusual, such as potato clay and cinnamon paste. The techniques used in creating these wonderful scenes are equally diverse, and each one is a tribute to its creator's ingenuity, imagination, and skill.

TERRA-COTTA FRANCESCO SCARLATELLA

ITALY

Francesco Scarlatella is one of the many clay artists living and working in Caltagirone, Italy. This Sicilian city, sometimes called the "city of crèches," has been a ceramics center for centuries. Born in 1951, Scarlatella has worked with clay for nearly four decades and considers himself a self-taught artist, although he has received some help from his brother, Ignazio, who had some formal art education.

Scarlatella's works are primarily unpainted terra-cotta, but he also occasionally incorporates wood or volcanic stone from the region of Mount Etna, and applies color to some pieces. He considers his style to be in the tradition of Giacomo Bongiovanni-Vaccaro (1772–1859), who lived in Caltagirone in the eighteenth century and is arguably Sicily's most famous sculptor.

Scarlatella has sculpted religious works from the beginning, but has devoted himself especially to making crèches, or *presepi*, since the mid-1980s. He finds "spiritual grace" in his scenes and often identifies

> FRANCESCO SCARLATELLA

himself with the shepherd figures. Two of his *presepi* are among the collections owned by the Vatican Museum.

In the large crèche commissioned for the collection, the kings arrive with their gifts. An angel guides one of them toward the Infant.

and a shepherd welcomes another to the holy event. One angel holds a book, perhaps the Old Testament. Joseph looks on, and Mary lies at the side of the Baby Jesus. The smaller crèche, also commissioned, is an unusual portrayal, since Joseph is holding the Infant. Mary tenderly embraces Joseph as she looks on. The figures are placed on a lava stone from Mount Etna.

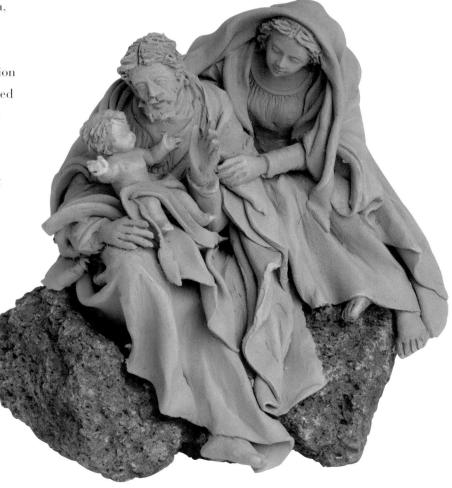

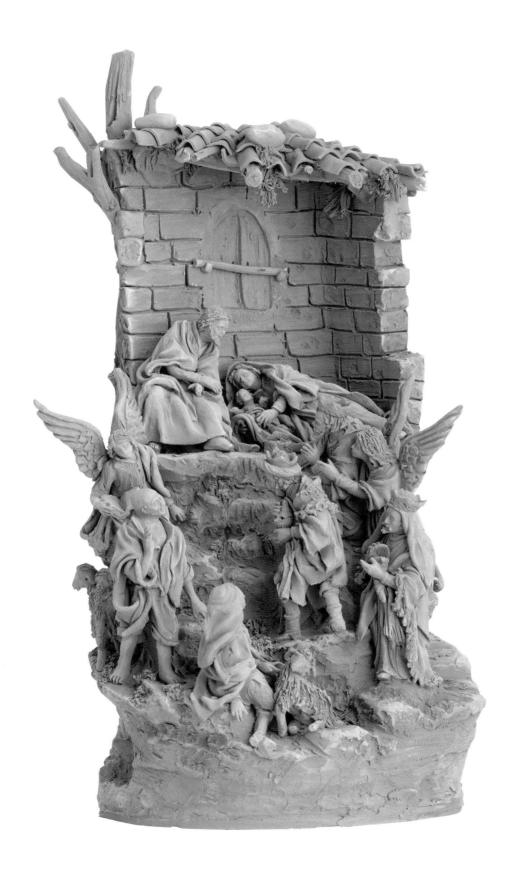

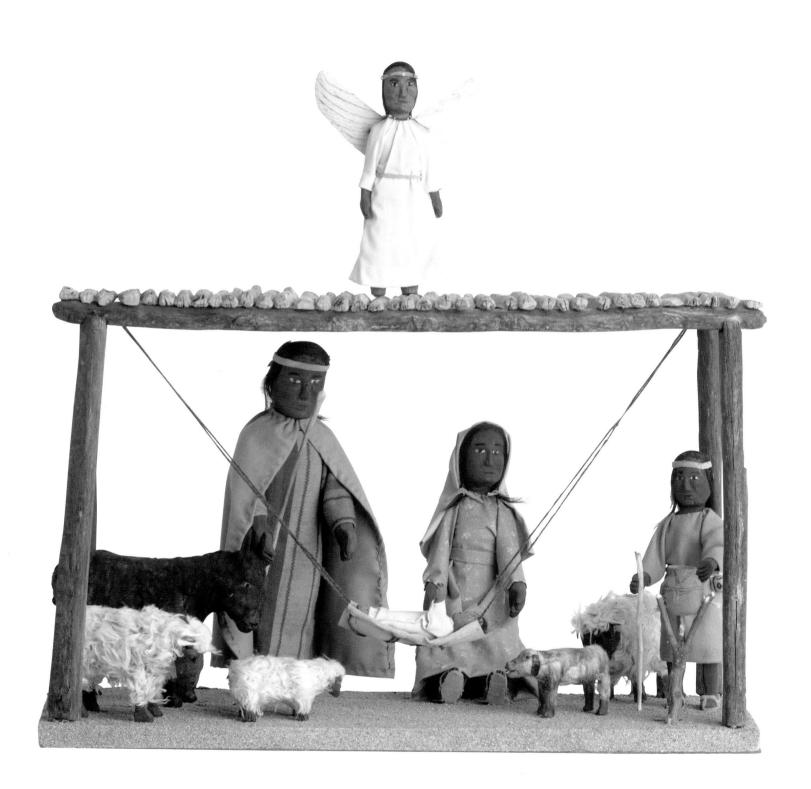

SAGUARO CACTUS THOMAS AND ELSIE FRANCO

ARIZONA, UNITED STATES

This crèche, primarily made of cactus, was commissioned for the collection. It was made by Thomas Franco, with the help of his wife, Elsie. Thomas, born in 1929 on the San Xavier Reservation—near Tucson and part of the Tohono O'odham Nation—considers himself a Wa:k Tohono O'odham, while Elsie is Tohono O'odham. Thomas's parents,

> ELSIE AND THOMAS FRANCO

Domingo and Chepa Franco, were wellknown carvers who also created crèches. They, along with Manuel Vigil, were among the first Native Americans to begin making nativities in the mid-twentieth century. Thomas works in a style similar to that of his parents, but began carving only after they had died. He creates rustic-looking scenes, and among the crèches he has made is one for the picturesque church of San Xavier del Bac near his home.

In the crèche pictured here, all of the figures are carved from the woody ribs that support the main stem of the saguaro cactus. The stable, called a *ramada*, or shelter, is also made from saguaro. The loglike pieces of the roof, shaped as they are, come from the ends of the ribs. Elsie dressed the figures, giving them real hair and making their sandals. She also applied the hides to the sheep and dog. Among the many unique features of this striking crèche is the placement of the Infant Jesus in a hammock.

CHAGUAR FIBER WICHI PEOPLE

ARGENTINA

This scene was made by Wichi women living in Los Blancos, Argentina. The Wichi people, numbering perhaps only thirty thousand today, live in the northwestern part of the country, near the borders of Bolivia and Paraguay. Formerly seminomadic, they now live on marginal land and make their living from it, retaining their own language and much of their culture. They are one of the few Indian communities remaining in Argentina, and they are mostly Christian.

In this depiction, the Holy Family is covered by a toldo,

a canopy like those that Wichi women use today to shield themselves from the sun as they work. The spartan setting reflects the simple life led by this community, and the earthen colors reflect the native landscape. The distinctive cultural feel is heightened by the medium used. This "chaguar" crèche features fiber thread that derives from the *caraguatá*, or chaguar, an indigenous plant belonging to the bromeliad family. Making the thread is a long, painstaking process.

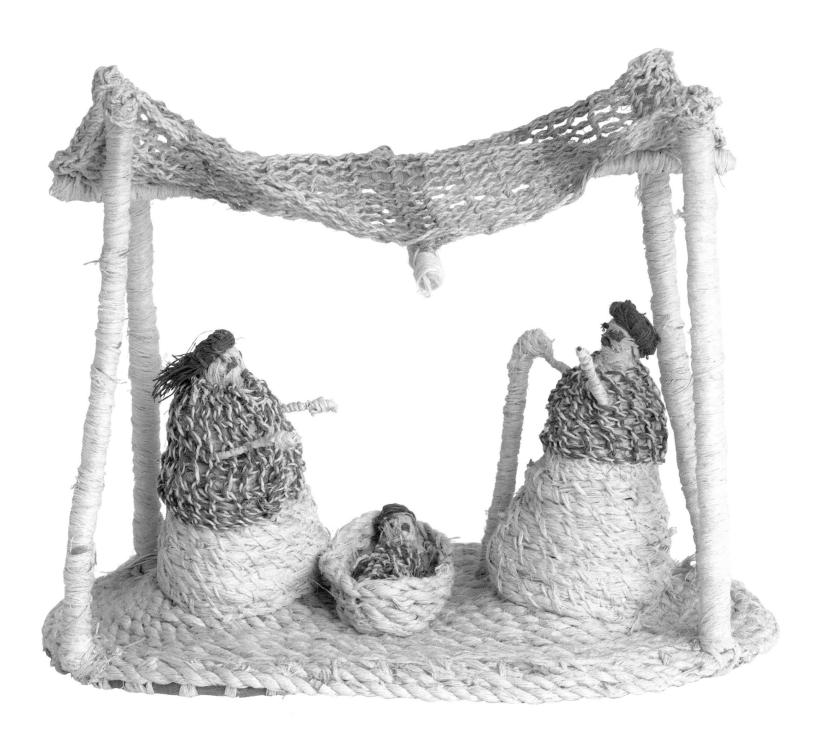

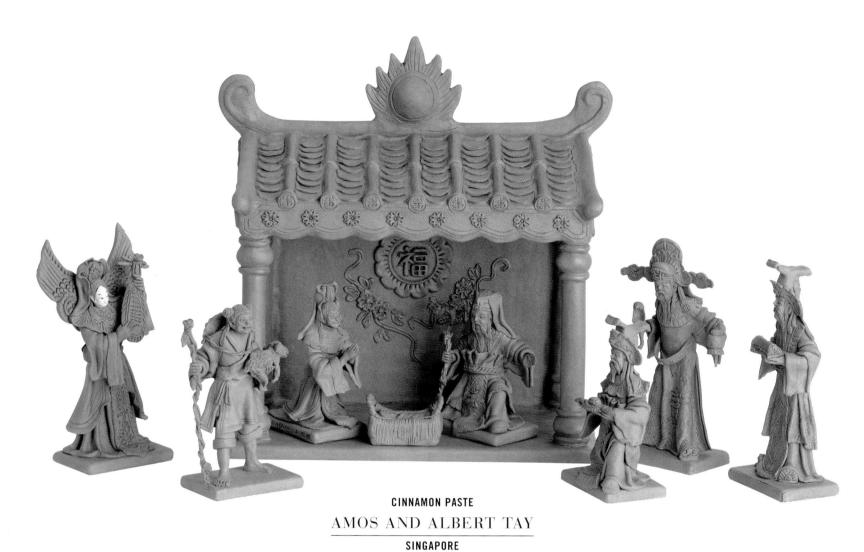

The Tay family creates crèche figures from cinnamon-wood paste, which they also use to make large joss, or incense, sticks for burning in temples and homes during Chinese festivals. These ceremonial sticks are carved with symbolic figures and animals, and the family eventually began to make these figures as separate objects. From this practice, the idea of making nativity scenes evolved. As Taoists, the Tays' interest in the Nativity is merely artistic, but they have created both Chinese and traditional Western styles for about twenty years.

This crèche was made by Amos and Albert, two of the sons of Tay Yang Poh, who began the enterprise. Amos,

born in 1962, began learning how to make figurines when he was eleven, and has gained considerable acclaim for them. Albert, born in 1959, usually makes the stables. Both men use the wood of the wild cinnamon tree, which is ground into a powder and made into a paste. The figures' limbs are formed of wire, and then straw is attached to help shape the body. Then the joss dough, or cinnamon paste, is rolled into sheets and applied, at which point the figures are sculpted with knives, scissors, and some homemade tools.

In this Chinese representation, the three kings, drawn from characters in Chinese literature, are lavishly adorned. Mary resembles the Taoist Goddess of Mercy, Kuan Yin,

TRADITION & INNOVATION

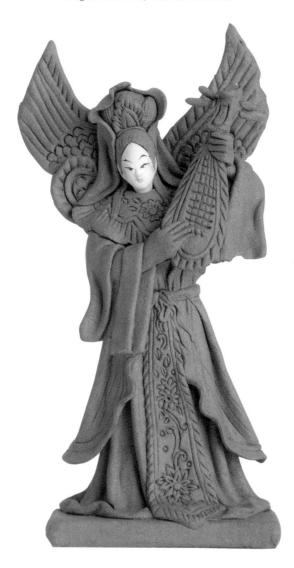

> AMOS TAY

while the Christ Child is presented as a commoner. The striking angel figure plays a *pipa*, a traditional musical instrument, and the white mask is inspired by the painted white faces of Chinese opera.

The angel figure represents another personal act of kindness encountered during the making of this collection. In my search for a crèche from Singapore, I met Catherine Chua, who was the assistant to the late sculptor and founder of an arts school in Singapore, Brother Joseph McNally. I met both while they were visiting the United States. I was aware of the Tays' work through information received from a friend, and asked for Catherine's assistance in obtaining a crèche. When she returned to Singapore, she became my "agent" with the Tays: she ordered the nativity, checked on its progress, and helped with shipment. As if all this were not generous enough, she also paid for the angel figure as a gift to me.

BRONZE UNKNOWN ARTIST

IVORY COAST

One of the most elegant crèches in the collection, this bronze Holy Family comes from Abidjan, the capital of Ivory Coast. This piece may have been made by artisans from Burkina Faso, who live in the city's Adjame district. Each of the figures is finely constructed, and the composition conveys tenderness and warmth. Mary gazes intently at the sleeping Child as if pondering the miraculous birth, and Joseph's tall, protective figure bows to Mary and the Infant, giving the entire piece a gentle, loving atmosphere.

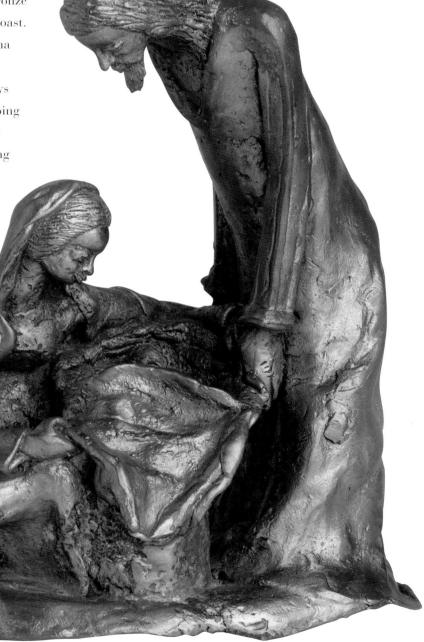

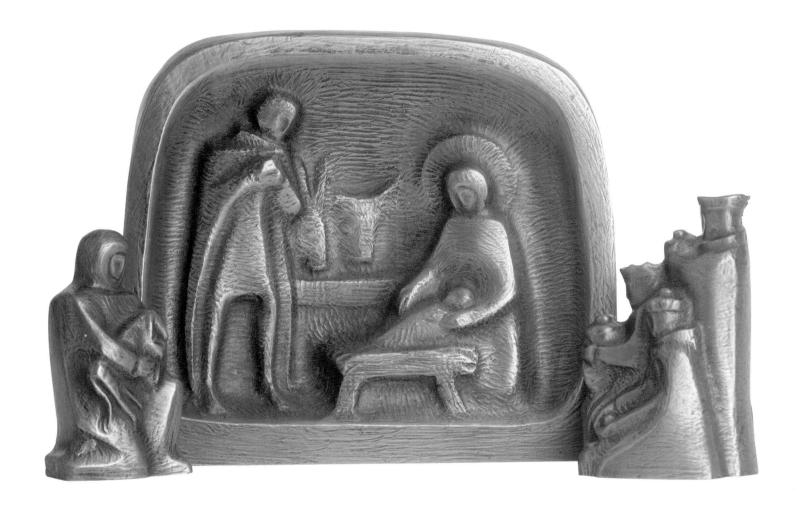

$\frac{\text{POWDERED METAL}}{\text{THE WILD GOOSE STUDIO}}$ ireland

This Irish crèche in bas-relief was made using powdered iron bonded with resin through a process called cold cast. It was created by the Wild Goose Studio of Kinsale, County Cork, a studio known for creating religious, Celtic, and secular objects. The Wild Goose Studio commissioned and purchased the design for the crèche from Nell Murphy, a distinguished Irish sculptor. The cold-cast process results in pieces with a thick outer shell of durable metal (in this case iron), backed by a resin compound.

$\frac{ \begin{array}{c} \text{BAMB00} \\ \hline \text{UNKNOWN ARTIST} \\ \hline \text{Taiwan} \end{array}$

The origin of this delightful bamboo crèche is uncertain. It was given to me by a friend from my parish, St. Ann Catholic Church in Arlington, Virginia. She in turn had received it from a missionary priest who brought it from China around 1960, making it one of the older crèches in the collection. Bamboo crèches are made in the southern part of Taiwan, and it is likely that this one comes from that region. In this skillfully worked piece, Chinese red cords or ropes adorn the animals, and the camels are particularly fanciful. Angels play instruments as they greet the magi.

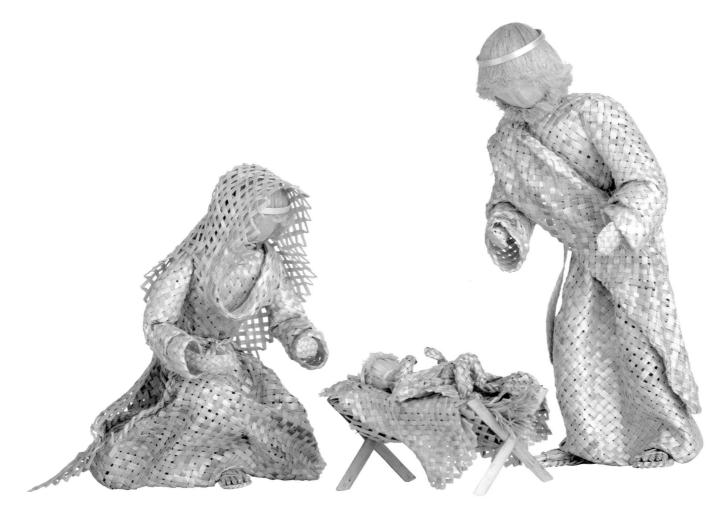

STRAW LUBOV SELIVONCHIK BELARUS

Straw is a medium used widely in Belarus to create utilitarian, decorative, and artistic objects. Through one of Belarus's leading authorities on straw art, Tatiana Repina, I contacted Lubov Selivonchik, whom Repina considers to be a "magnificent artist." Born in 1958, Selivonchik lives in Minsk. Educated as an architect, she found limited opportunities in her professional field. In 1996, she began work with the Belarusian national crafts center and was encouraged to create with straw.

Her drawing skills as an architect helped her especially to design and make straw objects that suggest moving forms.

Selivonchik likes to make animals and dolls. Although she had made Madonna figures, she had never before created a nativity scene, and she was touched by making this, her first one. Repina informed me that Selivonchik, who considers herself a spiritual person, was inspired as she made it, and now considers it to be one of her favorite pieces. Indeed, she looks forward to making more.

THORN WOOD UNKNOWN ARTIST

NIGERIA

Thorn-wood carving is an art form that developed in the twentieth century in the southwestern region of Nigeria, and is unique to Africa. The thorns come from varieties of silk-cotton trees and have dark, light, or reddish shades. Since the size of the thorns is limited, ranging from 2 to 4 inches (5–10 cm), carvers glue many pieces together to form sometimes simple, sometimes expansive,

scenes of the Nativity, as well as of everyday life.

This crèche was a gift for the collection from USAID friends. The finely carved figures reflect their African character, and the little angels climbing about the stable roof add a humorous, happy note.

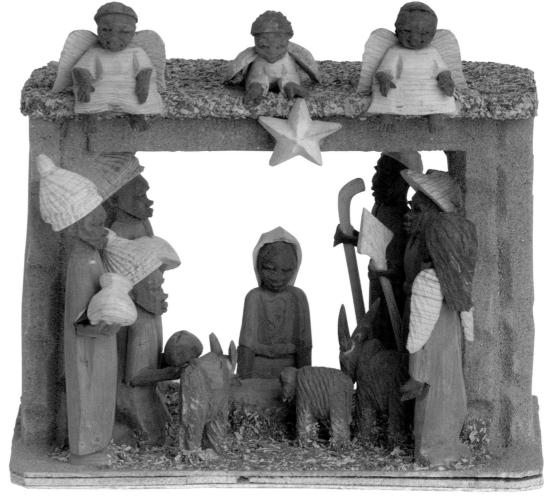

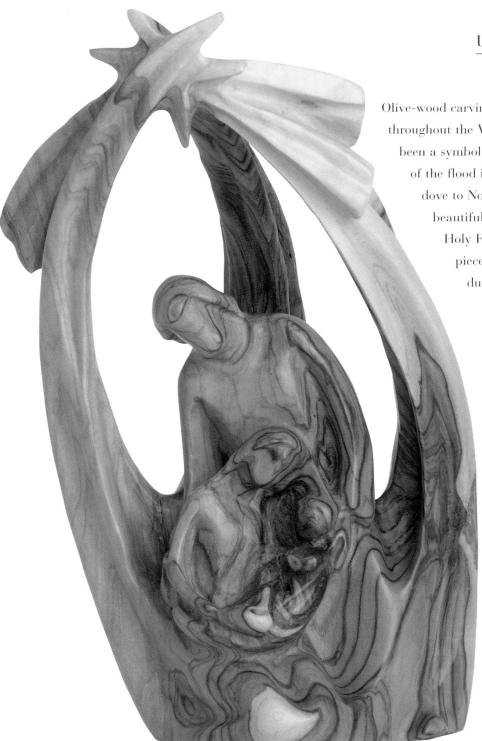

$\frac{\text{UNKNOWN ARTIST}}{\text{West bank}}$

Olive-wood carvings from the Holy Land are familiar throughout the Western world. The olive branch has long been a symbol of peace: in the book of Genesis, the end of the flood is signaled by an olive twig brought by a dove to Noah. Olive is a hard wood cherished for its beautiful tones and grain. Carvings such as this Holy Family scene, which comprises just one piece of wood, are made using branches taken during pruning.

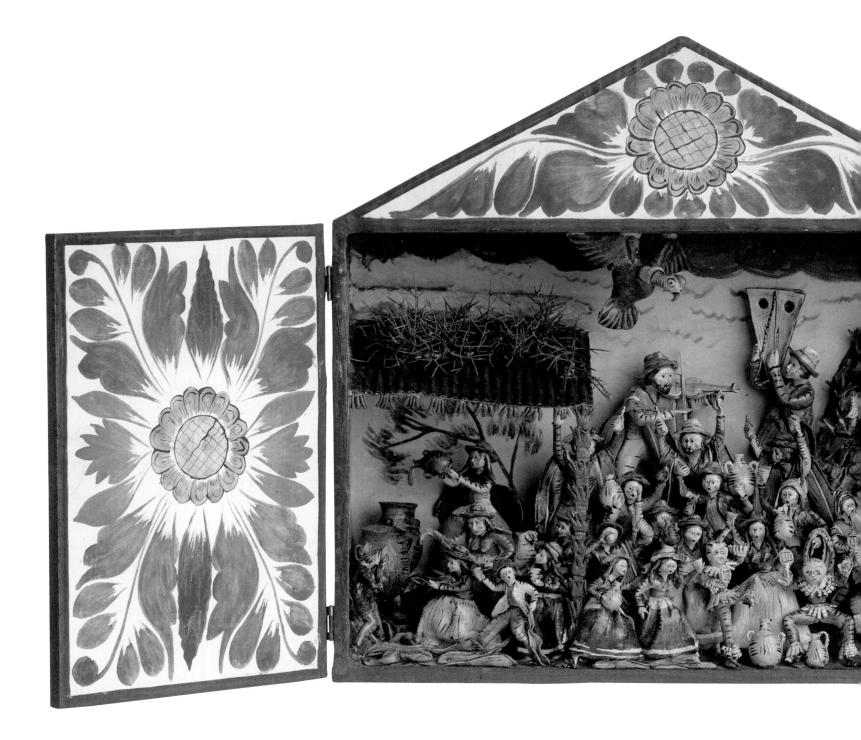

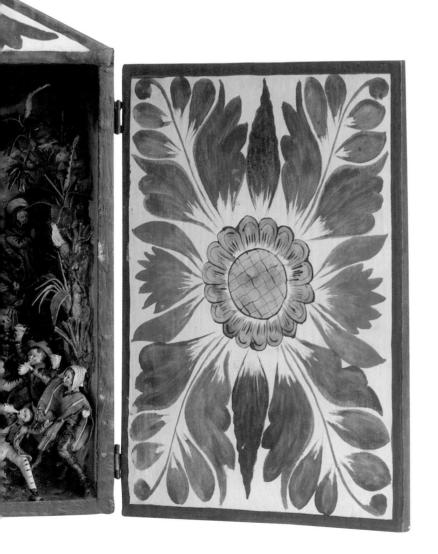

POTATO CLAY NICARIO JIMÉNEZ QUISPE

PERU

The *retablo* form of the crèche is a shrinelike box popular in Peru and other Andean regions. In this artwork by Nicario Jiménez Quispe (see also page 32), some scenes are made almost entirely from a potato-based "clay" consisting of potato and plaster of Paris. Jiménez uses only a small piece of sharpened wood, akin to a large toothpick, to shape the figures. He forms their various parts, air-dries them, assembles them, and then paints them before placing the figures in the scene. The *retablos* may also include tin, cloth, and paper, and the frames are made of wood. The use of the potato seems appropriate for a Peruvian art form, since the plant is native to the Andean region, where scores of varieties are grown.

Nicario Jiménez Quispe is among Peru's most celebrated folk artists. He has expanded the art form of the retablo by creating scenes of historical—as well as social and political—significance. He views himself as an indigenista, one who promotes the local traditions and culture of his native region. Some of his retablos, for example, depict injustices suffered by the Andean people. Speaking in his native tongue, Quechua—with an interpreter's aid—Jiménez has lectured on the retablo as a tradition and art form at leading universities throughout the United States. He has also created a work held by the Smithsonian Institution in Washington, D.C., that is dedicated to the historical significance of the potato in the Andes. Now living in Florida, Jiménez also makes retablos depicting American scenes, some of which reflect political views on such contemporary issues as immigration.

Born in 1957, Nicario Jiménez Quispe is a thirdgeneration *retablo* artist. In addition to repairing rural shrines and chapels, both his grandfather and father made *retablos*, which were bartered to herders for goods. When Nicario's father, Florentino, moved the family to Ayacucho

> NICARIO JIMÉNEZ QUISPE (RIGHT). WITH THE AUTHOR

in Peru, they began to work for Joaquín López Antay, who has been credited with reviving the art form of the *retablo* in the 1940s. Jiménez began carving when he was seven or eight years old, and then learned to make *retablos* working alongside his father. He worked with his family in

López Antay's workshop, and later attended university in Ayacucho. There he met his wife, who is a noted weaver from a family recognized for the craft. The couple moved to Lima, where Jiménez's artistic reputation grew. He began to exhibit his work in 1979, in Lima, and since then has been awarded honors in international exhibitions in Korea, South America, and the United States.

Jiménez's retablos can be single or layered scenes in a box, or even triptych style, with three panels of scenes. They often include scores of figures. Emilia and I acquired a small scene, which Nicario signed for us, at a folk-art gallery in McLean, Virginia, in 1990. Two years later, we met him at the same gallery when he was exhibiting his work and demonstrating his technique, and we acquired two more single-scene crèches, one of which is shown here. We also commissioned a nativity retablo in triptych form. Nicario generously made two for us.

This retablo reflects the artist's blending of Andean culture with Catholicism. The scene is a joyful village fiesta celebrating the Nativity, which appears almost lost in the upper right-hand corner. At the top of the scene is a condor, a symbol of power among the native people of Peru. For Jiménez, the bird is a messenger between God and the people. On the left, the villagers are making a local drink called *checha*, derived from fermented corn. Many of the decorative elements of the boxes reflect both pre-Christian and Christian symbolism. For example, the red of the border is not only used as the color symbolizing St. Mark, but it can also symbolize the animals' blood offered in homage to deities in pre-Christian times.

SEASON OF GIVING

ACTS OF GENEROSITY

hristians believe that the Christ Child came to give his life for us, so that we might live. In turn, the wise men brought gifts for him. In many ways, the crèche tradition embodies this spirit of giving. Our family began collecting crèches more than thirty years ago, and over the decades the help of friends and the kindness of strangers have enhanced our journey of collecting. The generous contributions of friends—both old and newly met along the way—have made the journey a gift in itself.

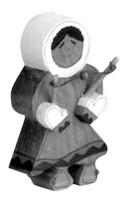

LILIA SHEVCHENKO

RUSSIA

Realizing that three-dimensional crèches are a Western tradition not common to Orthodox Russia, I knew the search for our first Russian crèche would not be easy. However, aware of how common wood-carving is in Russia, I hoped one might be commissioned. Eventually we succeeded, via the internet—a tool not available when Emilia and I began collecting so many years ago.

I found a website for the Most Holy Mother of God Catholic Church in Vladivostok, in the far east of Russia, and was delighted to learn that the pastor was an American priest, Father Myron Effing. I contacted him, and he kindly agreed to make inquiries on our behalf. I did not receive a reply to a follow-up e-mail months later, so it was with much surprise that, almost two years later, I received a message from Father Effing saying that he was in California and had a crèche in his suitcase! I called him immediately and discovered the crèche's story.

paying her, but ultimately Father Effing and I decided that a contribution to the church would please her.

The figures are made of papier-mâché, evidently the medium that Shevchenko uses in her puppet-making. The animals are made from carefully chosen fabrics. The figures' clothes are all sewn or knitted, as are the small blanket and pillow for the Infant Jesus. The shepherd's vest appears to be made of lamb's wool.

Receiving this crèche as a gift was a powerful lesson in generosity for us. Lilia Shevchenko was obviously not a person of great means. Yet she offered her painstaking work, her time, and materials as a gift to a total stranger in a foreign country—someone made known to her only through a third party. We were also touched that Father Effing—while toiling in a difficult area with concerns of his own—kept my request in mind for a period of years, and even troubled himself to bring the piece to us in his luggage.

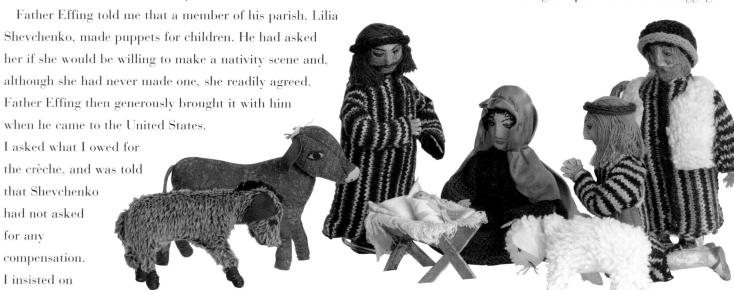

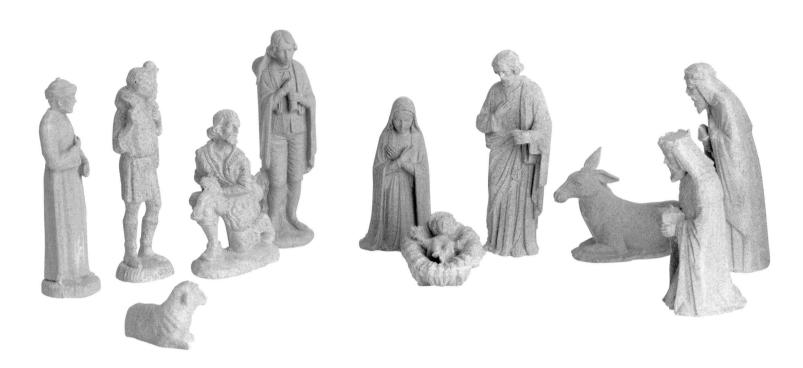

THE CARLOS FAMILY

THE PHILIPPINES

This crèche was a gift from Salvador and Gigi Carlos of Manila, leading crèche collectors in the Philippines. We first contacted the family to make general inquiries into how the nativity tradition had developed in the Philippines, and their response was very generous. Over the course of several years, they kindly gave us three crèches, including this one, which was created by the family.

Crèches in the Philippines are made from many different materials. This one is made in one of the more unusual media in the collection: "ash ware," which is volcanic ash (from an eruption of Mount Pinatubo in 1991) and resin. The late Salvador Lichauco-Carlos had a trading business that involved resin and fiberglass products. Salvador Carlos and his family gathered three drums of the ash from their

roof. Salvador began experimenting with the ash by mixing it with resin and pouring the blend into molds. One of the first objects he made in this way was a crucifix that was presented to the country's then president, Corazón Aquino. Salvador trained one of his former employees to make this crèche set, using molds for the figures. According to Gigi Carlos, the molds were either Italian or Spanish in origin. Several of the figures here resemble those in our first crèche, an Italian piece that Emilia and I acquired in 1962 (see page 8).

MITSUKI KUMEKAWA

JAPAN

Finding a crèche from Japan had been a challenge for many years. Father John Burger, regional director of the Columban Fathers based in Nebraska, found two commercially made Japanese examples for me. Another in the collection, a plastic scene with a music box that plays the carol "Silent Night," is of great sentimental significance since it belonged to my mother. She bought it in a Woolworths store in Chicago during the 1950s. Finding a crèche made by an artist, however, proved more difficult. Luckily, in 2001, I made contact with an American ceramist, Tom Morris, who lives in Japan. He had a ceramics studio and school, the Agape Ceramic Studio, in Kamakura (which he has since relocated to Yokohama). On my behalf, Tom asked Professor Mitsuki Kumekawa, one of his former students, to make a crèche. As in other cases of working with an intermediary, I developed a warm, friendly association with Tom.

Born in Kyoto in 1932, Mitsuki Kumekawa is a distinguished professor emeritus of Japanese literature and culture who now engages in writing, oil painting, and ceramics. He taught in the United States at Princeton University and at universities in Singapore as well as in his native Japan.

This crèche combines two traditions: its form reflects a Western and Christian style, while its Japanese ceramic technique pays homage to honored and longstanding Asian influences. Kumekawa says, "I am pleased by the idea that I am learning the traditional Japanese ceramic technique from an American artist. This is something exciting and

encouraging in terms of cultural history." He sought "to give the figures a tinge of oldness like an excavated relic." This "antique" touch is seen in the lines or cracks that appear in the figures, which are the result of Kumekawa's glazing and firing technique. Tom says this traditional Japanese style "often creates a rough, textured and earthy look compared to the smooth, clean, bright colors associated with many European ceramic wares." The gotomaki clay used in the crèche is best known for making bowls for the traditional Japanese tea ceremony. The glaze is called *shino*. The pieces were "reduction-fired" in an electric kiln using charcoal, a method of firing that gives the pieces their white, burnished, and aged appearance.

The touching aspect of this scene is that it was created by a scholar who is steeped in the traditions of his own culture but open to creating a religious expression of another tradition. Kumekawa had never made a crèche before this. There was no compelling reason for him to accept my request. He did so, however, with dedication,

and worked extremely hard in perfecting the pieces with his recently learned skills. When he gave me some information about himself, Kumekawa included material on the history of Christianity in Japan. On making the crèche, he wrote, "Though I am not a Christian, I feel very much honor."

> MITSUKI KUMEKAWA

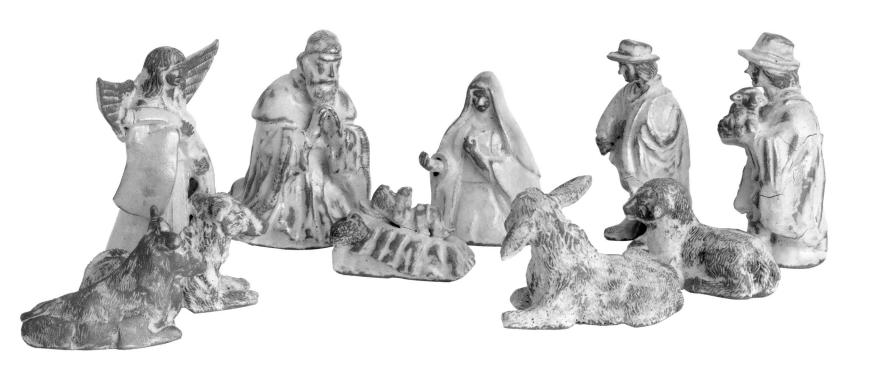

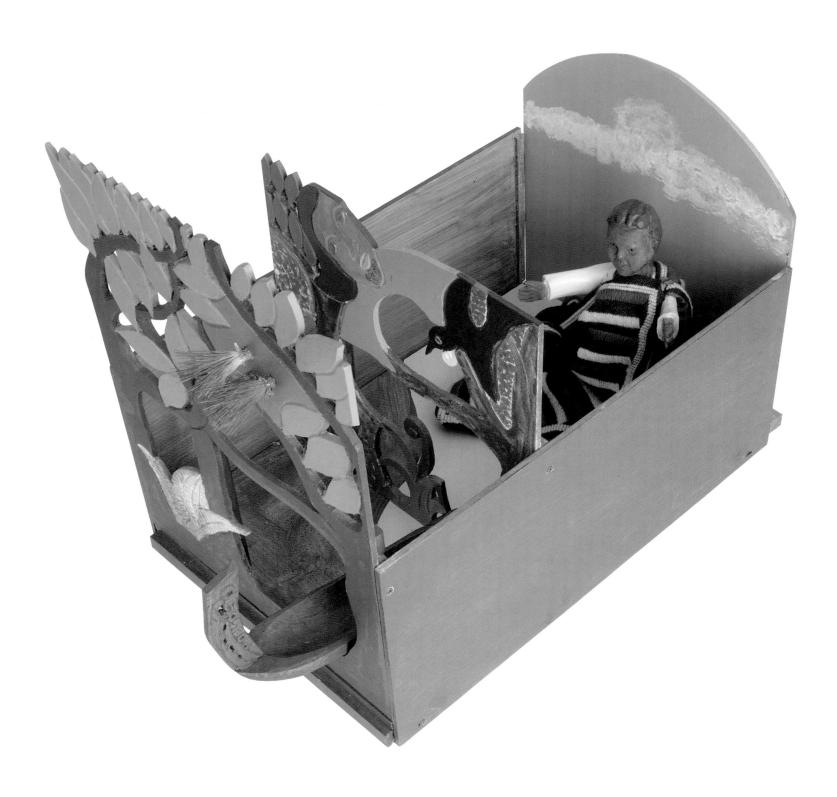

GEOFF PRYOR

NEW ZEALAND

A far-reaching network of people has played its part in making the collection so special to Emilia and me. This beautiful Maori interpretation of the Nativity, made by Geoff Pryor in New Zealand, is another reminder of the kindness and faith that extend across the world (see also pages 50–51).

Geoff Pryor was born in Louth, England, in 1934 and moved to New Zealand in 1952. He now lives in Paremata. His late wife, Marilyn, was a descendent of the Maori tribe of Ngai Tahu. Pryor spent most of his career in public service and describes his interest in carving as "more a passion" than an avocation. His interest in the sculpture of Henry Moore, and the likeness of Moore's forms to traditional sculpted Maori figures, stimulated his desire to create and to carve. Pryor spent six years training with a Maori carver. Among several pieces he carved for churches is a large cross with a Maori Madonna and Child at its foot for the entrance of a Maori church near his home. He has also carved items for New Zealand government officials to offer as gifts on official foreign travels.

Pryor notably carved a memorial to American troops to honor their service in New Zealand during World War II. He told me that when visiting his son, who was working at a golf course on the site of a former U.S. Marine campground, he noticed that there was nothing to indicate the marines' former presence. He wrote, "After a bit of background reading, I realized what a sacrifice these young men had

made, so I took a totara log with my chisels and carved a memorial to them. Something like fifteen years later, the carved *pou* (totem pole) still stands as a reminder of their commitment."

This crèche came to me through the generosity of many people, and with special blessings. Several Maori women helped Pryor complete it. The Christ Child wears a cloak, or *korowai*, which represents authority, and was made by Leone James and Hilary James. The cloak bears a Maori motif designed by Shirley Kelland, who also offered a final Maori prayer over the scene. The priest of the local parish asked that it be displayed on the church altar during Sunday Mass before it was shipped, and he then asked Pryor to make a similar one for the church, which he did with Kelland's help. Our crèche was brought to the United States by Dr. Erlinda Punongbayan, who was returning to

California after staying with the Pryors. It arrived in time for Christmas 2001.

From the beginning, I sought to negotiate a price for the artwork, but Geoff deflected each inquiry. Finally, he told me that he wanted to present it as a gift—a touching final gesture to a touching experience.

⇒ GEOFF PRYOR

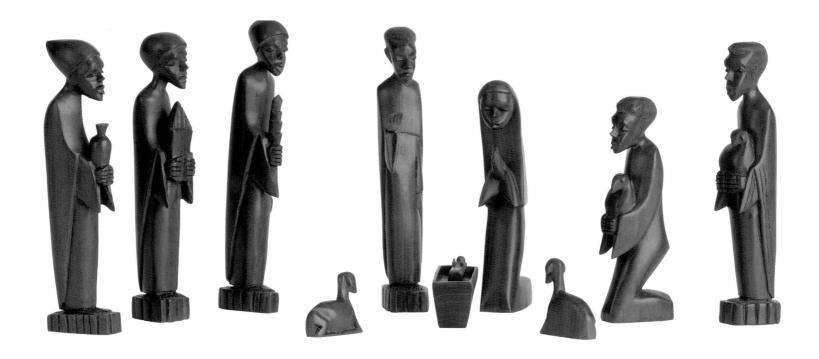

CARLOS JOAO ANTONIO

ANGOLA

In recent times, an independent Angola has suffered through civil war, so crafts are sparse. Nevertheless, through a USAID colleague and his friend, Father Agustin Escelera, this crèche was commissioned for the collection. The priest located the carver, Carlos Joao Antonio, whose work is another fine example of the unheralded talent of so many carvers throughout Africa. When the crèche was completed, Father Escelera and Joao Antonio both offered it to me as a gift. This gesture is a humbling example of charity from people who have few material resources to spare. In return I sent a box of school supplies to Father Escelera.

Born around 1957, Joao Antonio has subsisted as a farmer. He began carving in the early 1990s, and his work includes other religious art as well as crèches. The pieces in this scene, beautifully crafted from Angolan blackwood, conform to a traditional format while reflecting indigenous characteristics. The kings bear gifts in elaborate vessels, and their caps recall those of the wise men from Phrygia who appear in some of the earliest depictions of the Nativity in the catacombs of Rome. Although Mary is simply sculpted, her youthful face expresses deep devotion.

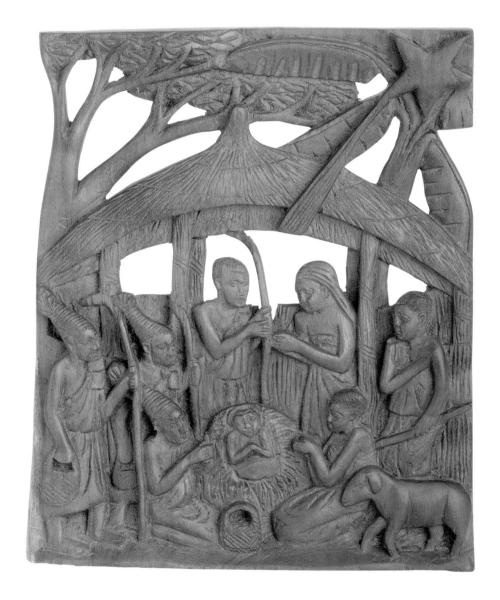

NYANGI-BOSCO

UGANDA

While the collection consists largely of three-dimensional carvings, it does include a few attractive plaques or relief carvings, such as this handsome crèche scene, a gift from a USAID friend. The artist, Nyangi-Bosco, is developing a reputation for his fine carving. Working just outside

Kampala, this relatively young man has begun to employ others, whom he teaches. The scene is a rural village setting with a thatch-roofed hut, tropical trees, and people in native dress. The three kings carry their gifts in baskets. The wood is mavulu, an African hardwood often used in carving.

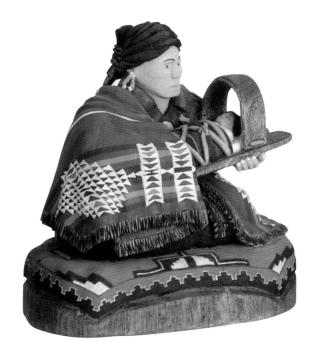

FELIX YAZZIE ARIZONA, UNITED STATES

Through the help of a kind priest we were able to acquire a Navajo crèche—a considerable feat, since Navajo artists rarely make crèches. Unlike our long-standing interest in the santos tradition, our interest in Navajo art is fairly recent. During a trip to the Southwest in 1998, we saw several fine carvings by Navajo artists. The works were of people and animals in secular contexts. I learned that carving—as part of Navajo art tradition—has developed and gained recognition mainly during the last two decades. The Navajo are better known for their weaving and pottery work.

Christian imagery among the Navajo is very limited, since only a small proportion of the people have adopted Christianity. Also, Navajo religious and cultural beliefs tend not to encourage the representation of figures. Nonetheless, some Navajo began to make carvings of figures in the latter half of the twentieth century. Many depicted Navajo pursuing their daily lives, but a few artists carved crèches.

During our search for a Navajo crèche, we had inquired through shops and galleries in the region, without success. Eventually, I read an article mentioning a Catholic priest,

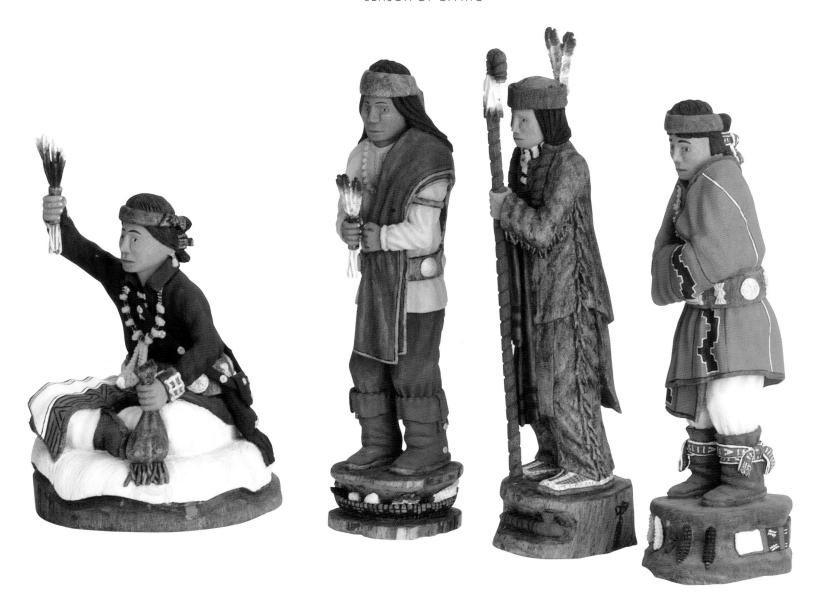

Father Blane Grein, in Chinle, Arizona, who worked with the people of the Navajo Nation. I contacted him to ask if he knew any Navajo carvers who might make a crèche, and luckily, a local artist, Felix Yazzie, had recently created a religious carving for the church. He lived in a somewhat remote location north of Chinle, and Father Grein saw him only occasionally, but next time they met he asked Yazzie on our behalf if he would carve us a crèche. Happily for us, Yazzie agreed, and the result is one of the finest works of art in our collection.

The crèche took well over a year to make. Yazzie delivered the figures to Father Grein a few at a time whenever he went to Chinle. Eventually, there were six painted figures, each exquisitely carved in great detail. The Holy Family is in the style of the *Dine* ("the people"), as the Navajo call themselves. Mary and Joseph wear typical attire, such as the conch belt, and their hair is styled in Navajo buns. The kings represent the Apache and Ute people. The clothing of one of the kings is so finely carved, you could mistake it for velvet.

HANNEKE AND LES IPPISCH

MONTANA, UNITED STATES

I had always wanted an Alaskan nativity for the collection. After various unsuccessful attempts to find one, I eventually saw one advertised on the internet by a shop in Juneau. Since I seek the work of local artists, I was disappointed to learn that this nativity was made by artists who lived in Montana, but I acquired the set anyway. My disappointment quickly turned to humility and awe after I contacted the people who made the crèche, Les and Hanneke Ippisch. Hanneke's heroic story is one of the best examples of how the collection is enriched beyond the cultures and art it represents.

Hanneke Ippisch was born in 1925 in The Netherlands, the daughter of a Protestant minister. She was still in high school when the Germans occupied her country during World War II. Shortly after high school, she decided to join the underground resistance to the Nazi occupation. In her memoir of those years, *Sky*; Hanneke describes the harrowing times she experienced. She writes: "My first assignment was to bring some identification papers and food coupons to a Jewish family hidden in an old house ... On that day my life changed completely." Later, she would secretly meet Jewish people and sneak them to safer places in the Dutch countryside. Sometimes she would bring them food. In January 1945, when she was nineteen years old, she was captured while attending a clandestine meeting, and imprisoned by the Nazis. With other women, she shared a small cell, where she endured cold, darkness, and hunger. She struggled "to stay alert and strong," gaining strength

from the small patch of sky she could see from the cell. She sustained herself for several weeks until she was released at the end of the war.

Hanneke left The Netherlands for Sweden, and then settled in the United States in 1956. She lived first in California—where she became a graphic artist—and then moved to Montana. There, she and her husband, Les, undertook several enterprises, including organizing an annual Christmas market in their village, for which they made wooden ornaments and toys as well as crèches. A few years ago, the couple moved to another location in Montana, where they continued to make crèches until Les became ill and died in 2005.

Both Hanneke and Les created the designs for their

crèches, and sometimes their daughter helped. They preferred to create crèches that were ethnically or culturally representative. Hanneke says, "We tried to express Christmas to the people where they come from rather

than in the traditional form of nativity," although they also made a traditional nativity scene. The couple traveled frequently and, as they did, observed local cultures. As a result, they designed about forty nativities with various geographic and ethnic themes. Hanneke liked to include

> LES AND HANNEKE IPPISCH

historical figures in some scenes, such as the one set in Washington, D.C. Over the years, the couple depicted the cultures of North Carolina with a tobacco farm, the American Southwest, Florida with senior citizens, Ukraine, Tibet, and Africa, among many others.

Les was a retired forester. His role in making the nativities was to prepare the wood, which was often pine, and to cut and plane it. Hanneke often did the sanding with machines. The couple created a prototype, painted it, and then usually employed local villagers to reproduce more of each type. At times as many as twenty-five people worked for them, making crèches and other carvings. Even so, Hanneke described their work as "play," and their art form as "just folk art."

Hanneke generously offered to me, as a gift, my choice of several nativities they had made. Among them was a Washington-themed crèche. Living in the capital area, I could not resist this one, which she happily gave me. This unique crèche captures the attention of local viewers. The stable structure is the grand Lincoln Memorial, with an eagle atop it:

Betsy Ross and Ben Franklin with the Infant represent the Holy Family; and the three kings are George Washington, Abraham Lincoln, and Teddy Roosevelt. Paul Revere arrives on a horse with his lantern. Rosebushes symbolize the White House rose garden, and a cherry tree recalls the George Washington legend as well as the capital's renowned cherry blossoms. The Washington theme is completed with the inclusion of a donkey and an elephant, for the Democratic and Republican parties.

In the Alaska scene, the stable is an Alaskan cache, a storage structure placed on poles to keep items safe. Mary, holding Baby Jesus, is in Eskimo dress; Joseph in Cossack dress. The three kings are a kayaker bringing fish, a dog-sled driver with furs, and a fisherman with a crab.

On the surface, these crèches are attractive and even amusing. They also become powerful expressions when one realizes that they were created by someone (assisted by a spouse) who has witnessed the depths to which humanity can sink. Yet Hanneke

smiles to people today, smiles that were so very rare during her wartime experiences.

sought to create something that brings

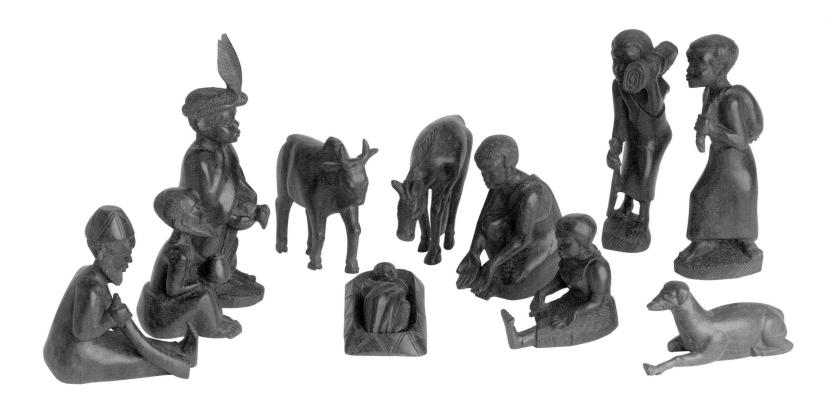

SUWEDI BIGULA

MALAWI

This scene by Suwedi Bigula reflects in so many ways the hope, love, and unity the crèche came to represent to Emilia and me (see also page 99). Exquisitely carved, it represents the indigenous people of Malawi, yet speaks to all peoples. The scene transcends particular religious beliefs, in that the baby in the manger can be understood as the Incarnation by Christians, or, by others, in terms of the birth of a child that unites all humanity. The crèche's universality is exemplified by the fact that it was carved by a Muslim artisan under the auspices of a Catholic art center, and was found and given to us by a Jewish friend.

ART OF THE CRÈCHE

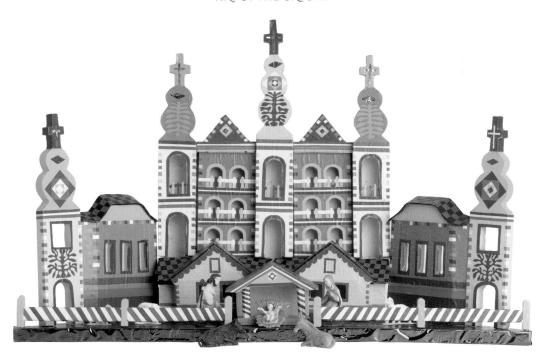

STANKO BUNIĆ

CROATIA

This striking, colorful crèche was commissioned for me with the kind assistance of Josip Barlek, senior curator of the Ethnographic Museum in Zagreb, who at the same time commissioned one for the museum. I have since visited Josip, who kindly treated me to a tour of Croatian nativities in Zagreb and the surrounding countryside.

This scene is the work of Stanko Bunić. He was born in 1936 in the small village of Plemenšćina, northwestern Croatia, where he still lives. A folk artist in the naïve

> STANKO BUNIĆ

tradition, he is among the last of the artists in Croatia to work in this style. As with the *szopka* tradition in Krakow, these Croatian scenes are dominated by the fantastic distinctive settings inspired by the architecture of the region.

Bunić created the setting of this nativity, which includes manufactured plastic figures. He is self-taught and makes all his work by hand. He describes his interest in crèches thus: "In 1961 I was seriously ill and unable to move ... recovery was very slow. I then decided to model a crèche and turn to God in prayer Crèches bring God closer to me; I give them to other people, and in this way I wish them peace and prosperity, which every Christian needs." Bunić gained his knowledge and skill for making crèches from his great-grandfather, who made them in the nineteenth century. Bunić's poor health now limits his ability to make crèches, and he is sad that there is no one to carry on the tradition, which he considers "a gift."

This nativity setting is formed of wood with colored paper carefully cut and applied to create a decorative building façade. In times past, the crèche figures were also painted paper, ceramic, or wood, rather than the plastic pieces in this scene. It is indeed sad that there are so few artisans left who make these delightful, fanciful scenes.

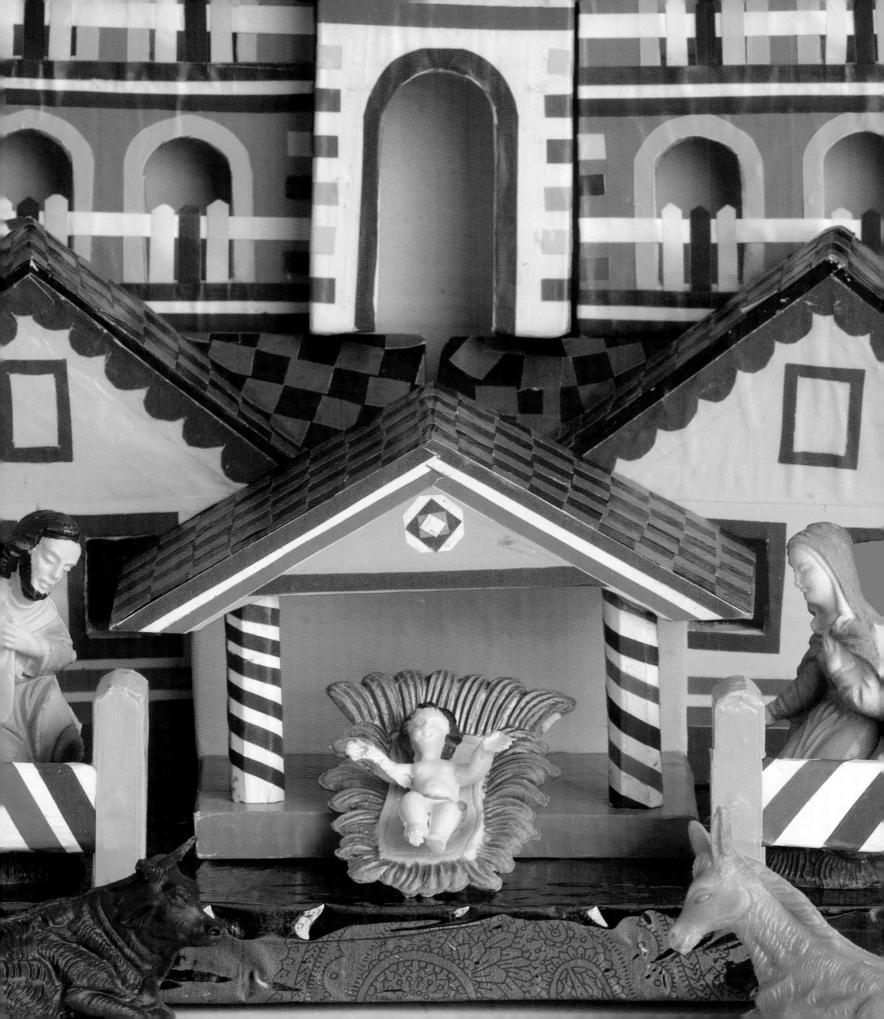

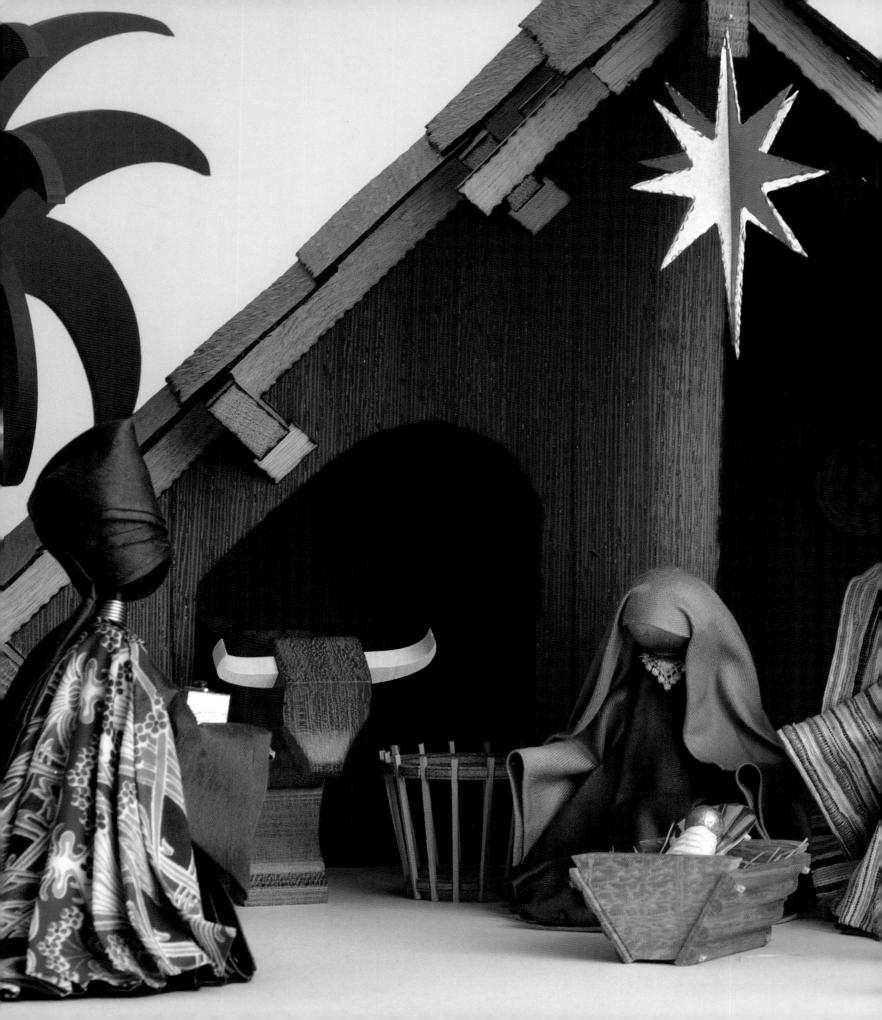

ALL IN THE FAMILY

FAMILY LEGACIES

crèche is a treasured possession and heirloom in many families. Our family collection, however, includes many examples in which the crèche-making tradition itself, together with its legacy of faith, have been shared between generations.

WACLAW SUSKA

POLAND

Waclaw Suska, like many carvers, has passed on his skill to his family—in his case, his son and son-in-law. I first saw his carving on the cover of the book *Contemporary Polish Folk Artists* by Hans-Joachim Schauss. When Emilia and I traveled to Poland, I went armed with a list of carvers described in Schauss's informative book, hoping to find a crèche by at least one of them, and since an appealing crèche by Waclaw Suska was on the cover of the book, he was number one on our list. In a shop in Warsaw we bought a crèche by Stanislaw Suska, his son (see pages 144–45), and with some help from the staff, we acquired one by Waclaw Suska the next day. Years later, we also bought a crèche by Adam Wydra, Waclaw's son-in-law (see page 146).

Waclaw Suska was born in Dąbrówka in 1922. Since he taught his son and son-in-law to carve, it is not surprising that there are many similarities in their styles. Both Stanislaw and Adam belong to the Lukowski Center of Folk Sculpture, established in 1965. The center is renowned in Poland for the outstanding work of its carvers, many of whom make their living from farming.

Schauss describes Waclaw Suska as a "jovial and congenial man" who gives his works "a rich and cheerful coloring." In his book he includes Waclaw's story of how, at twenty, he was sent into a forced-labor factory in Germany. He returned home three years later, in 1945, and worked as a carpenter building houses. Over the years, he observed that nearby villagers were earning a good wage from carving. In 1971, when he was almost fifty years old and without formal training, Waclaw says he "started to carve to have something to do, to make myself feel better." Surprisingly, he discovered, "I was good right away." Before his death in 1999, he won a number of prizes and sold his work in Europe and the United States. He liked carving religious themes, but he also created such subjects as weddings and village life. He wrote, "Every year I try to do it better, better and better, you see."

This crèche embodies a sort of primitive realism. While the facial expressions are somber, perhaps out of respect or devotion, the color of the scene gives it warmth. The Christ Child, placed on a white blanket looking out, lies with arms extended, as often seen in Italian crèches, symbolizing his reaching out to humanity.

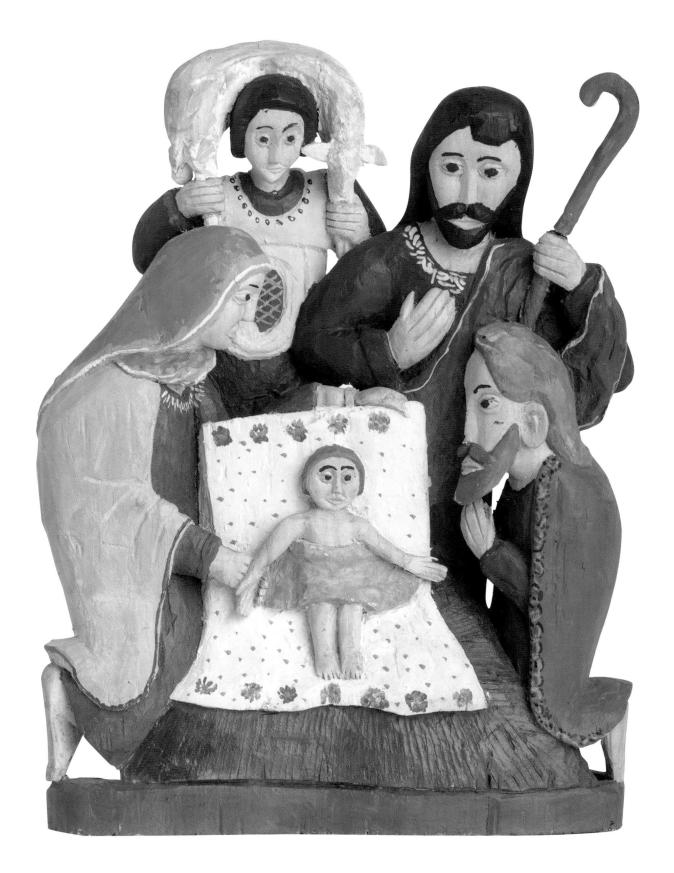

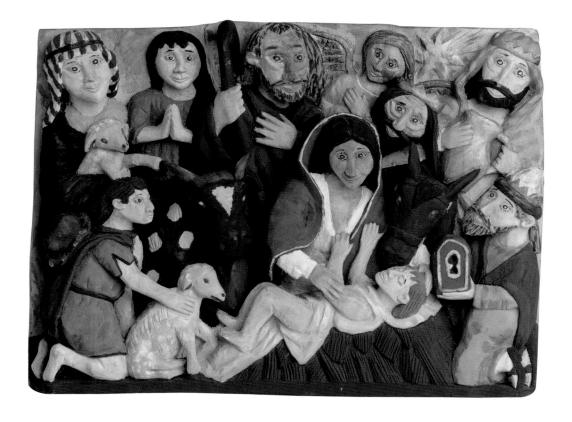

STANISLAW SUSKA

POLAND

Stanislaw Suska was born in 1959 and graduated from technical school as a stonemason. Growing up in a "poor farming family," he really enjoyed and was encouraged by his father's sculpting. "My father was my teacher," he says. At the age of fourteen, Stanislaw created his first sculpture, a carving of a sorrowful Christ figure. Having now carved for more than a quarter of a century, Stanislaw sees it as "his mission and lifelong passion." Sacred themes—especially biblical stories—dominate his work. He carves single figures, particularly angels; some historical figures, such as the Polish astronomer Copernicus (1473–1543); and bas-reliefs. He usually paints his works, favoring such

colors as antique gray and shades of brown and green.

Stanislaw's lively carvings are sometimes in triptych form,

and his scenes are crowded with many figures. In this compact presentation, the figures' facial expressions exude energy. This crèche conveys the excitement at the birth of Christ, who appears to be a little older than in many crèches, with the gesture of a young boy tugging at his mother's garment.

> STANISLAW SUSKA

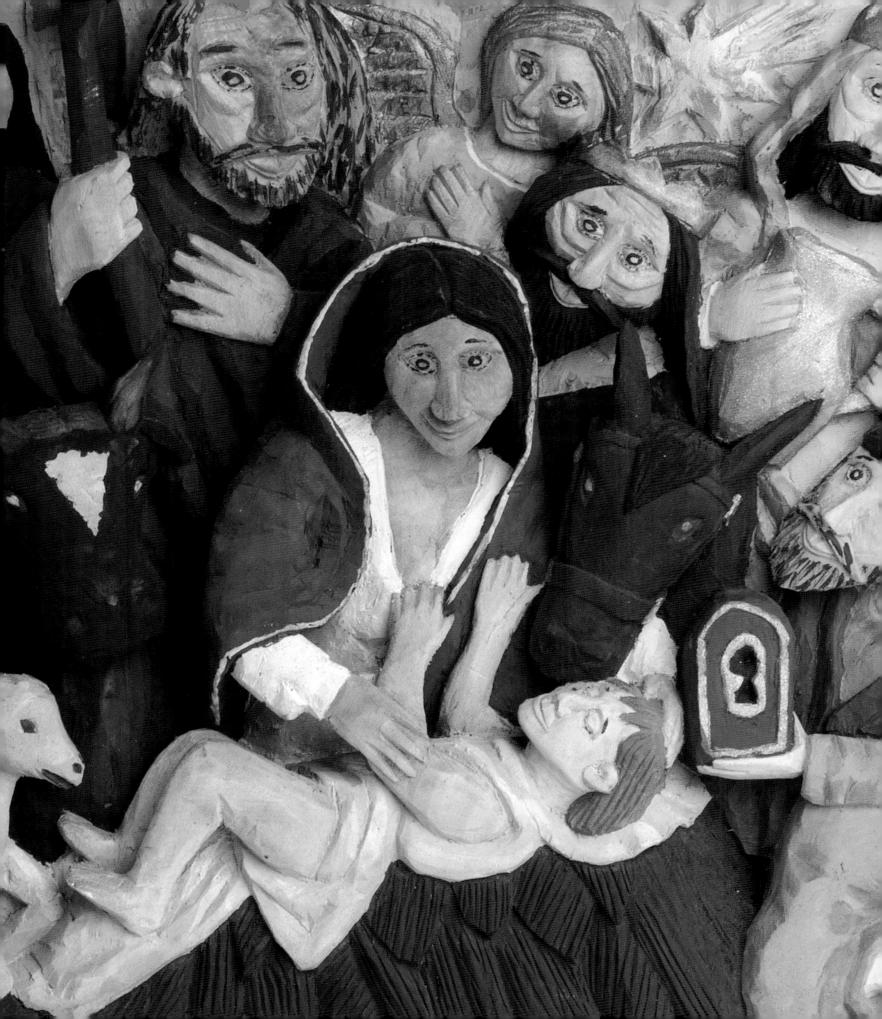

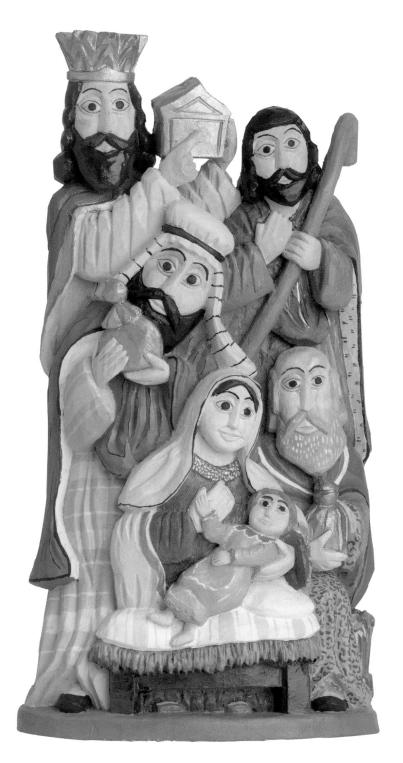

$\frac{\text{ADAM WYDRA}}{\text{POLAND}}$

Born in 1953 in Lukow, Adam Wydra married Jadwiga, the daughter of distinguished artist Waclaw Suska (see pages 142–43). After a time, the couple moved to Waclaw's farm, where Wydra observed and learned from his father-in-law's carving. Wydra began to carve when he was twenty years old. His first piece was sold a year later, and in a short time he developed his own style.

Wydra carves both religious and secular-themed relief sculptures, triptychs, and single figures, using only three carving implements and no machinery. He also creates large outdoor sculptures that can reach 10 feet (3 m) high. His

work has earned many awards and is exhibited widely.

Wydra carved crèches from the beginning of his career and says the Nativity is his favorite subject, giving him the most pleasure and satisfaction. In this scene, Wydra's figures are similar to Waclaw's but appear softer or, in his own words, "more gentle."

> ADAM WYDRA

GOVAN COSTA RICA

This charming miniature scene within an egg-shaped container is made by GOVAN. That name obviously gives this crèche a special place in the Govan Collection. However, in this case, GOVAN is not a surname but the name of an enterprise formed by the combined names of a husband and wife team Juan José Gómez and Alexandra Vanolli de Gómez.

Juan José is a dentist who also teaches at a university. He enjoys painting and sculpting, and particularly likes to make miniatures. For Juan José and Alexandra's first Christmas as a couple, he created a miniature nativity in a sphere for his wife. This was the seed for their enterprise. They decided to make more nativities, a little larger and enclosing them in egg-shaped shells with a light inside.

Initially Juan José created typical scenes of Costa Rica without people or animals; later, he began to include figures. He enjoys creating images of daily life, such as a woman washing clothes, and scenes with environmental themes, such as endangered turtles coming ashore to lay their eggs. A "person of strong religious beliefs," Juan José sees his nativities as occupying a special place among his works, each of which is unique. In the beginning, his portrayal consisted of only miniature Holy Family figures made of papier-mâché. Now other figures are included and are made of clay. This appealing landscape scene, which is lighted, shows the kings approaching the Holy Family while sheep graze peacefully under a nearby tree.

THE ENGELSEN FAMILY

NORWAY

Henning Engelsen is one of Norway's leading carvers. He started a workshop, Henning Woodcarvers, in Toten in 1947, hoping "to create a world of figures that radiate joy and humanity." He carved such subjects as Vikings, fishermen, trolls, and—his favorite—horses. Now retired, his work is continued by his daughters, Christl and Angelina, and Angelina's husband, Bjorne Espedal (as well as a few non-family employees).

The family wanted to create a Norwegian crèche

"characterized by distinctive medieval features." In 2000, Angelina and Christl designed and began to construct this piece. Angelina and Bjorne carved; Christl determined the colors; and the other artisans assisted in the carving and finishing of the pieces. The wooden figures in this elegant presentation were shaped by machine, completed using knives and air tools, and then painted by hand. Wearing a crown, Mary is seated holding the Infant on her lap. The depiction of the Virgin as a queen is rare in a crèche.

JOAN AND DAVID KOTTLER

UNITED KINGDOM

This appealing scene is the result of Joan and David Kottler's search for a nativity that would convey "the true mystery and wonder of Christmas" to their children. Disappointed with crèches they had seen in shops, Joan decided to create her own. In 1976, she began making crèches to sell to help the family earn money. In a few years, she developed the style represented here. Some figures have been added and others have evolved, but the scene has essentially remained the same.

Making these crèches is very much a family industry. At one time, two of the Kottlers' sons assisted with the effort, and, briefly, a few other workers were hired to help make the stables. Now, Joan and David decide at the beginning of each year how many sets are to be made, and they make them themselves. Joan, trained as a teacher, does most of the work. David, a civil engineer, makes the animals.

Neither has had any training in woodwork. Machinery is used in the making of some of the wooden pieces, but not for the figures of the people. David says the endeavor "has become a way of life for us."

This scene, with its Moorish arch, includes both the exotic and humble elements of the Nativity story. The kings' rich

costumes contrast with those of the simply attired shepherds and Holy Family. All the clothing is made of stiffened natural fabrics, including burlap, silk, and velvet. The animals are made of polished hardwood. The stable, made by both Joan and David, is of oak and oak veneer.

> JOAN KOTTLER

he four Aguilar sisters may well be the most famous ceramists in Mexico today. Their work is documented in several books; museums have acquired their sculptures and honored them. The women live near each other in Ocotlán, a village near Oaxaca. Three of them learned their craft from their mother, but Concepción, the youngest sister, learned primarily on her own. All four are represented in the collection.

My research on the Aguilar sisters derives from *Oaxacan Ceramics*, a book by Lois Wasserspring that features the art of Oaxacan women. Wasserspring notes that the sisters' mother, Doña Isaura Alcántara Díaz, was the first of the family to achieve success, but her husband, Jesús, initially signed her work. Only years later was the appropriate attribution established. Her recognition gave opportunity to the daughters, who followed in her steps.

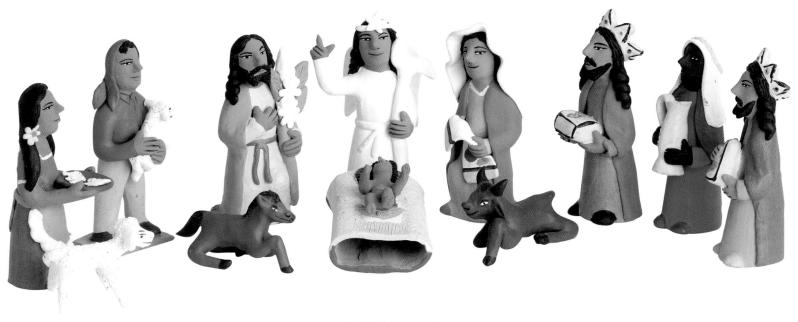

JOSEFINA AGUILAR

MEXICO

Josefina, the second oldest of the four Aguilar sisters, was the first to gain fame for her ceramics and is probably the best known. Working on her own while very young, she first received recognition in her early twenties. In just a few years, she attracted attention in both Europe and the United States, and she continues to be one of the most

prominent folk artists in Mexico.

Josefina's crèche is vividly colored. As Wasserspring notes, her figures tend to reflect the features of the local people, the Zapotecs. Joseph clutches a large flowering plant that appears to be his staff. Other elements add a touch of whimsy, such as the star that rests on the angel's head.

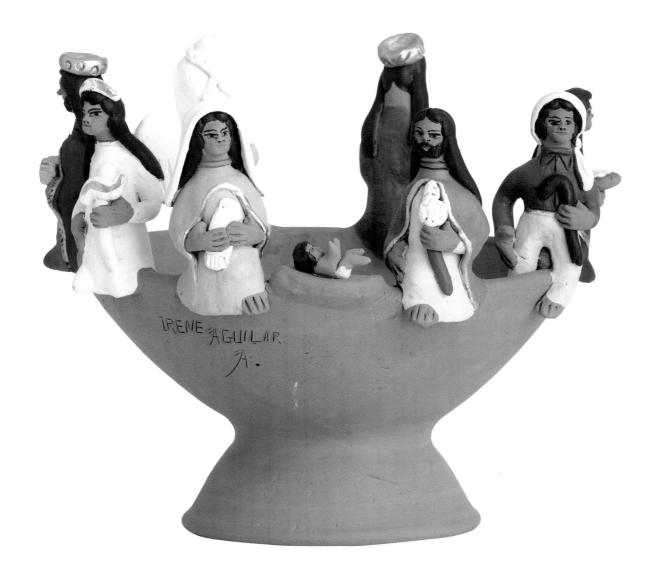

IRENE AGUILAR

MEXICO

As a young girl, Irene Aguilar attended less than a year of school before she was needed at home to care for one of her brothers. She remembers playing with clay as a small child, and sculpting figures when she was eight. By the end of her teenage years, she was creating group scenes to make money to pay for medicine for her

mother. In time she would receive national recognition for her work.

Irene's piece in the collection might be described as a nativity fruit bowl. The traditional figures, facing outward, are placed around the rim of the bowl. Irene's palette—like that of her sisters—comprises varied and vivid colors.

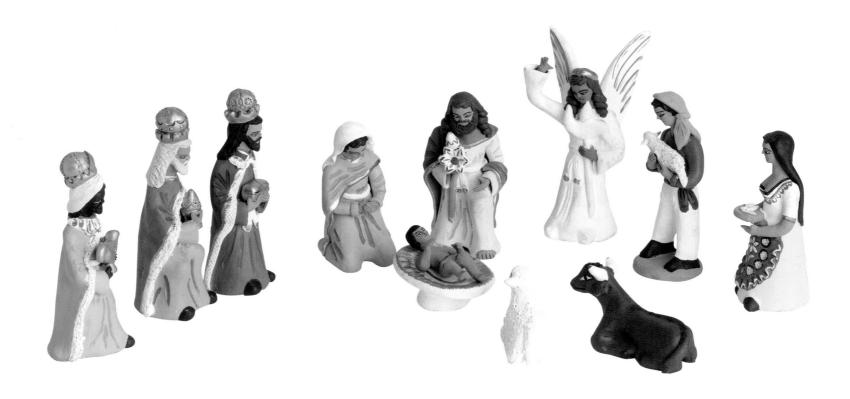

GUILLERMINA AGUILAR

MEXICO

Guillermina Aguilar is the eldest of the four Aguilar sisters, but she began her career after her sister Josefina. While growing up, Guillermina worked with clay with her mother. In 1968, almost as an act of desperation to provide for her growing family, she turned to ceramics. Ten years later, she began to gain recognition. She has exhibited internationally and, according to Lois

Wasserspring's book, *Oaxacan Ceramics*, "has even, on occasion, acted as Mexico's 'folk art ambassador abroad.'"

Guillermina's crèche features the vibrant colors seen in so many of the sisters' works. The kings have colorful beards, and the angel, with a staff, is similar to the one depicted in Concepción's crèche (see opposite). Joseph holds a lily, and the Christ Child reaches out.

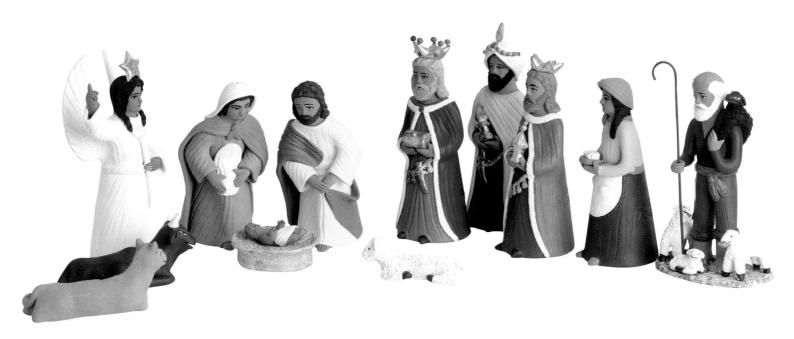

CONCEPCIÓN AGUILAR Mexico

Despite the Aguilar sisters' successes, Lois Wasserspring notes in her book *Oaxacan Ceramics* that life has not been easy, especially for Concepción, the youngest of the four. Concepción was only ten when her mother died, after which she spent much of her time caring for her younger brothers. She did not turn to ceramics until 1978 and not in a dedicated way until 1988. Two years later, she too gained recognition with a national award.

Concepción's colors are strong and exuberant, like those of her sisters. The commanding angel, crowned with a star, points heavenward while announcing the birth of Jesus. The kings are resplendent in their bright robes and jeweled crowns, while the shepherdess looks on with a serene expression that exudes piety. The shepherd injects a touch of humor and earthiness, holding a black sheep across his shoulder while a white sheep happily chomps on grass.

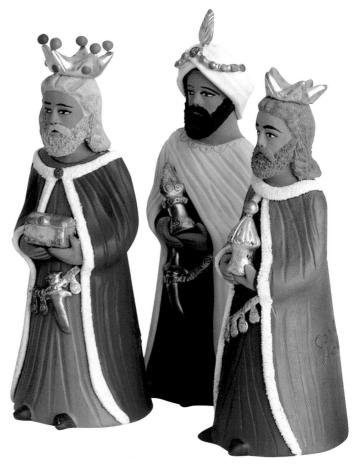

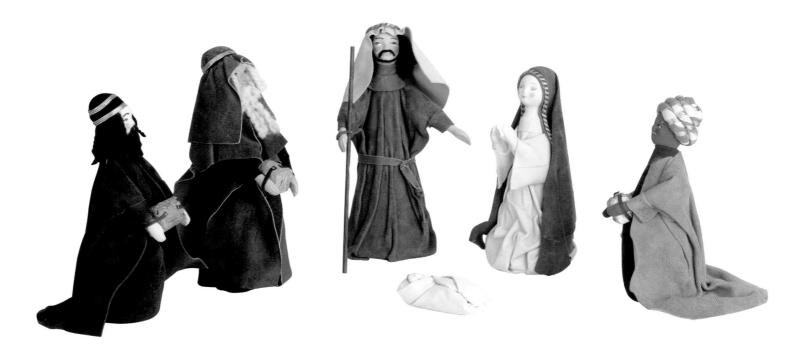

$\frac{\text{PAULA CUELLAR}}{\text{COLOMBIA}}$

This colorful crèche was created by artist Paula Cuellar of Personitas de Colección, a family enterprise in Bogotá. Cuellar's artistic career began with her making dolls. People's reactions to her work encouraged her to initiate a family business in her grandmother's house. Much of the work is undertaken by the family, including Cuellar's mother, who is also an artist. Other women artisans are hired when needed.

The figures are richly clothed in suede and leather, a characteristic of Cuellar's creations. The faces and hands are ceramic, and are hand-painted.

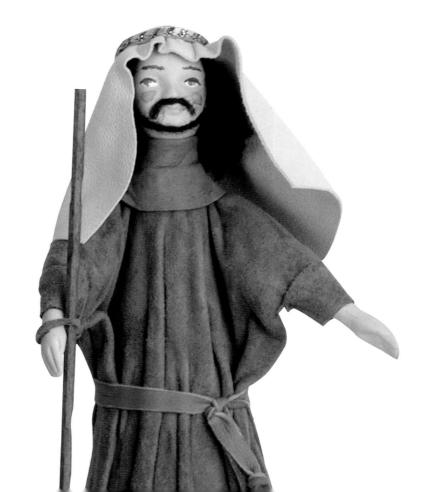

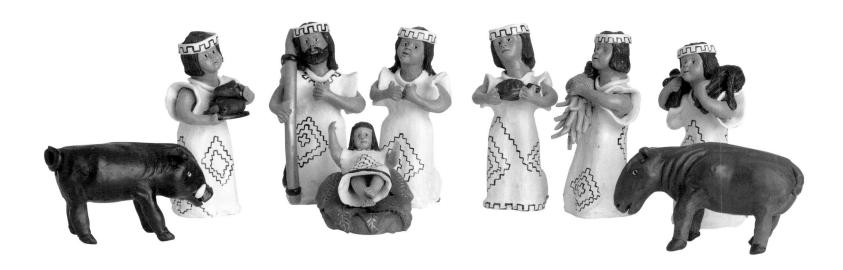

THE MAMANI FAMILY

PERU

Cristóbal Mamani, who has worked in ceramics for nearly forty years, learned his craft from his grandparents. He passed it on to Melchora, his wife, and their seven children. Today they work together in a family enterprise. They now live in Lima, although the family roots are

in the Cuzco area of the Andes, where they often return for visits. They typically make religious sculptures but also create pieces illustrating Andean life.

In their art, the family like to reflect the various cultures of Peru, and this crèche

represents the Shipibo people. The tribe, numbering perhaps 35,000, lives in the jungle region along a tributary of the Amazon. Most Shipibo are Christian, but they retain their strong preconversion cultural identity and way of life. In this clay scene, the figures' clothing is decorated with a traditional

Shipibo design. The people bring gifts from the jungle: fruits and vegetables, a turtle, and a monkey. A tapir and a wild pig join the gathering. The Christ Child's exaggerated size is an example of the custom that uses proportion to signify relative importance.

>THE MAMANI FAMILY

RUTH TEWKSBURY AND FAMILY

MAINE, UNITED STATES

This is one of the most delightful scenes in the collection. Its appeal derives from its creativity, exquisite craftsmanship, and inherent family tradition. Emilia and I first discovered the Tewksbury crèche, as we referred to it, during a vacation trip to Maine in 1979. We found it in a shop in Kennebunkport. The crèche is a small world in itself and suggests that all of creation was present at the divine event. Pieces continue to be added, and we have acquired new figures every year. In this picture there are over 120 miniature clay pieces.

Conceived and begun by the late Ruth Tewksbury of Maine in the 1970s, the presentation continues to grow through the sustained involvement of her family. The Tewksbury crèche is truly a family cottage industry. All the work is done by hand in the family homes. I had the pleasure of learning more about the crèche and the family tradition directly from Ruth before she died; Ruth's granddaughter, Yvonne Chick, helped me gather more information.

Ruth Tewksbury was trained as a medical technologist, but needed to find a channel for her artistic interests. "Four of my children are artists and maybe so am I," she wrote. She began to work with clay and made small pottery items. She was inspired to create a crèche after seeing a picture of an ornately painted Mexican one in the 1970s. After some experimentation, she settled on a style for her figures. She added more to her scene each year, accepting suggestions from customers and a shopkeeper friend, who provided an outlet for her work.

For years, Ruth made the pieces with her daughter, Deborah Dunham. Ruth made the people, and Deborah sculpted the animals by hand. Ruth said she tried "to make everyone look happy—except maybe the innkeeper." Deborah had had two years of studying fine art and found that she could create animals that fitted into her mother's folk-art style. She sees the crèche in a "magical sense" as the "peaceable kingdom," and included a unicorn, which she sees as "pure and mystical."

By 1988, another of Ruth's daughters, Marie Cole, had begun working with her, as had Marie's own daughter, Dawn Wheatley. The two of them soon became Ruth's principal partners. Dawn assumed Deborah's former role in making all the animals. Yvonne Chick writes, "The Tewksbury house was always filled with creativity of

some sort, always a group doing some kind of art or craft, and each finding their own special talents along the way." In 1998, Dawn's husband, Dan Wheatley, joined the family enterprise.

Ruth became ill and died in 1991. One of her last innovations was to introduce black figures for characters other than the black king. She designed six new pieces, including an angel holding a star. She very much wanted to present multiethnic ideas in the crèche; Dawn later encouraged the introduction of Asian figures. Marie and Dawn, "feeling a strong need to continue Ruth's legacy," instigated planning sessions, biblical research, and the sculpting of "idea figures" in clay to help them decide what to add each year.

Each figure in the Tewksbury assemblage is individually made. The miniature pieces—of exquisite detail—range from bluebirds at ½ inch (6 mm) high to the stable at 4½ inches (114 mm). They are made from a special formula of parian clay. Each piece is then hand-painted with underglazes before being fired. Gold enamel, when used, is applied after firing.

The scene includes elegant kings with their attendants,

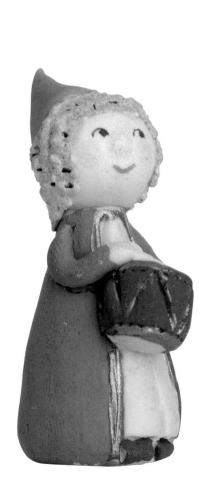

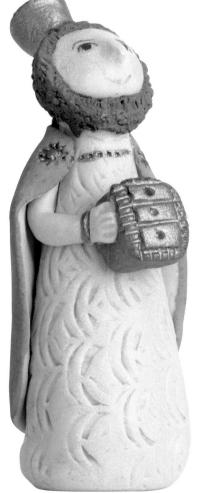

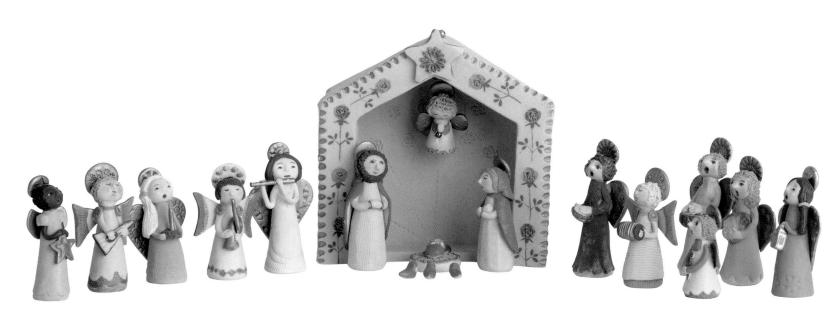

including a drummer boy. Many shepherds and shepherdesses share the stage with whimsical characters. A choir of angels with instruments heralds the Infant's birth; a black angel holds a star. Children carry cats, rabbits, and wood; some of the people carry pails from the well. One figure clutches an apron full of chicks. Besides the more traditional ox and donkey, other creatures—including an owl, a leopard, a lion, a fawn, and some pigs and dogs—abound.

According to Yvonne, "The pageantry and grandeur of Ruth's early religious years ... left her with a special love of the Christmas season and its magic, something that would be with her throughout her life and that she shared with all around her." Marie and Dawn feel the crèche "represents the best of what human potential is—the goodness of what we can all be." Yvonne concludes: "The crèche is a labor of love for both of these ladies, and has deep meaning for them, both artistically, and in connection with Ruth."

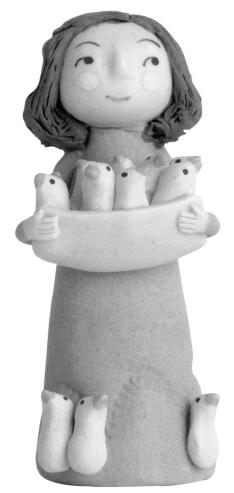

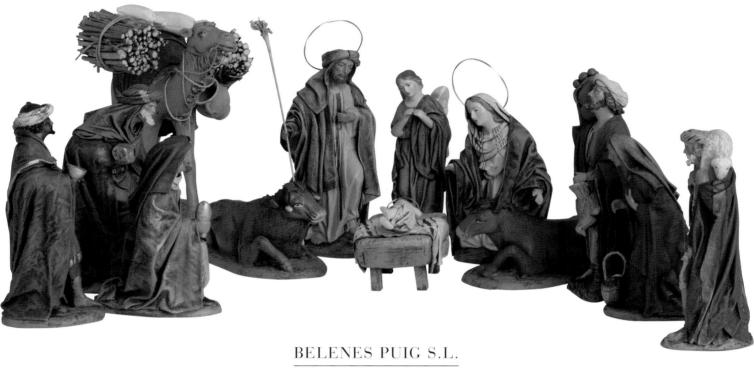

SPAIN

The Puig family's nativity-making began more than half a century ago. José Puig started to make cork stables and other elements of crèche scenes in 1933, and in 1945, he began to make terra-cotta figures. José's son and daughter-in-law, Francisco and Mercedes, now carry on the family business with their own sons. "Born among nativity figures," they are committed to continue the family tradition. They oversee the design of the classical figures and, Mercedes notes, "we choose how the fabric is glued on the figures and which colors must be used for the painting." They create a range of figures, including the Holy Family, villagers, and animals.

The Puigs have made this form of crèche, with some variation, for more than twenty years. They consider this version one of their "classics." It was influenced by the style of Francisco Salzillo, a renowned sculptor who created one of Spain's most famous crèches in the eighteenth century. Salzillo's crèche reflects the Italian Baroque style of his father, Nicola, a Neapolitan who moved his family to Spain. Salzillo's crèche, in the Museo Salzillo in Murcia, consists of more than 500 pieces. The Puig figures are made of terra-cotta. Their various parts are made from molds, sun-dried, and then hand-painted. Clothes made of stiffened fabrics lavishly adorn each figure.

MAKİNG A DİFFERENCE

CRÈCHES AS INSTRUMENTS OF SOCIAL CHANGE

he demand for crèches has created opportunities for skills training and employment where they might not otherwise exist. Supported by Catholic and Protestant missionaries, local government programs, and private individuals, these opportunities often arise in places and among peoples not normally associated with the crèche tradition.

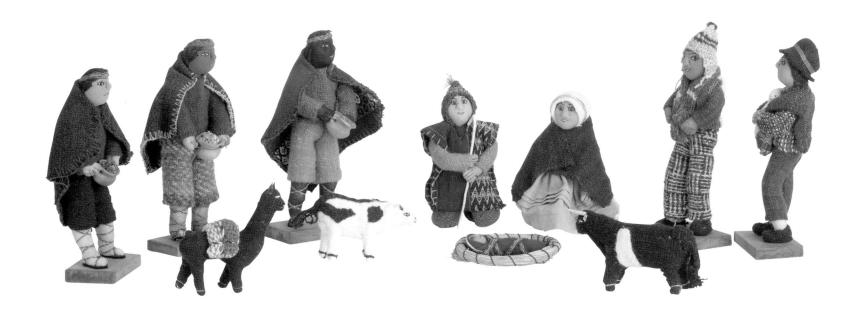

ARTESANIA SORATA

BOLIVIA

Artesania Sorata is an artisan group of several hundred people, most of whom are women. The group, founded in 1978 by Diane Bellomy from the United States, aimed to revive the traditional textile arts while improving family incomes and the standard of living of the native people on the eastern slopes of the Andes. Handmade cloth dolls have been one of the principal creations, and these have been used in crèche scenes for more than ten years. The idea of the crèche was introduced by a priest in La Paz. Diane Bellomy suggested the use of the traditional costume for what is called the "Inca dance" for the kings. The rest of the design comes from the artisans and represents the style of clothing worn by the Aymara people, especially for festivities.

This crèche was made by artisans from either the Adelio Quispe or Pastor Mendoza family, who live in the community of Pocobaya in northern Bolivia. The kings' capes are made of old traditional cloths (perhaps thirty to forty years old) called *aguayos*, which the local women use for many purposes, including carrying their infants. The fabric is hand-spun and hand-woven on traditional indigenous looms. The other materials used for the figures are factory-made cotton muslin and hand-spun, hand-woven wool. This attractive scene includes a baby llama. One shepherd holds a panpipe, another a sheep. The kings bring the traditional gifts of gold, frankincense, and myrrh—the frankincense and myrrh here are real.

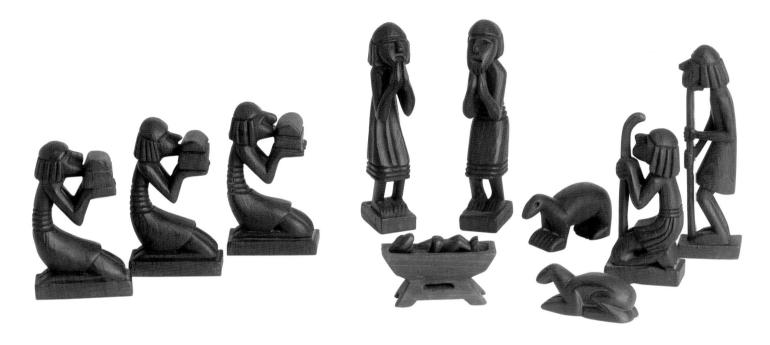

SUKODONO MENNONITE WOOD-CARVERS

INDONESIA

The wood-carvers of Sukodono, Indonesia, receive support from the Mennonite Central Committee (MCC) to enable them to earn income. The purpose of the carvers' group is to help provide employment, but also to sustain cultural traditions. Taman Petra is a cofounder of the Sukodono carvers. As a fourth-generation carver, Petra represents the strong cultural attachment to carving that exists in the Japara region. A master carver, he trains young apprentices

on the front porch of his home. This crèche reflects the culture of the Asmats, who, numbering fewer than 100,000, live in the province of Irian Jaya. The Asmats were largely unknown to the rest of the world until the mid-twentieth century. Many have accepted Christianity but blend it with their ancestor worship and animist beliefs. This stylized crèche conveys both reverence and the tribal character of the Asmat people.

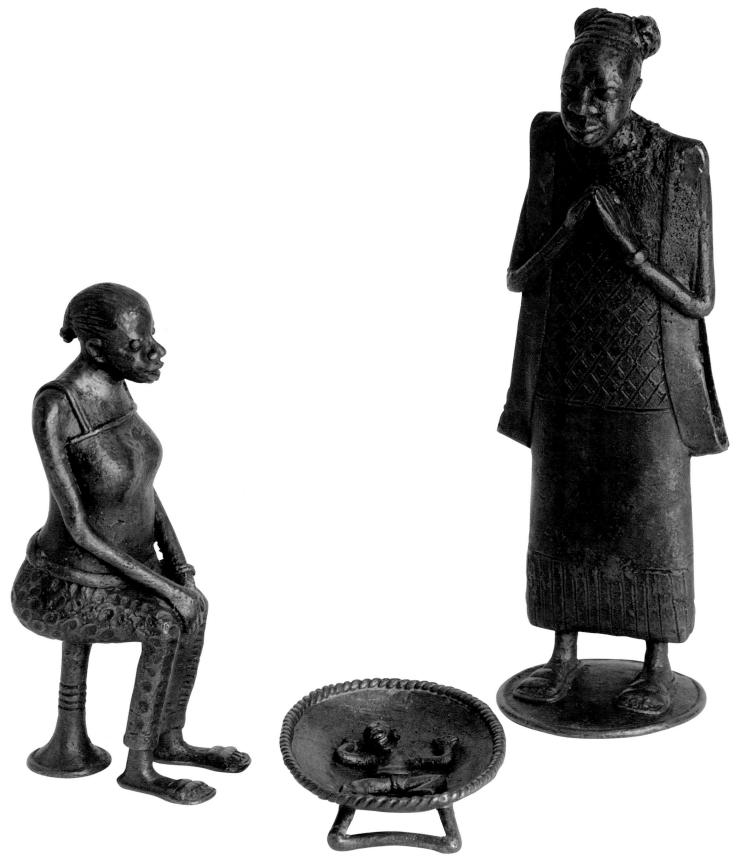

ARTISANS OF PRESCRAFT

CAMEROON

This crèche was made by artisan Emmanuel Che working with the Presbyterian Handicraft Center (Prescraft), which was founded by a Swiss missionary but is now managed locally in Cameroon. Nearly six hundred artisans, mostly women, practice crafts—including making crèches—in three rural production centers. These brass pieces are produced by a method known as the lost-wax process. While the figures are made from a mold, at Prescraft the mold is destroyed each time. Each piece is therefore unique.

Emmanuel Che, trained by Prescraft, has worked for the organization as well as for himself since 1978, and lives in Bamenda. He produces a variety of articles in brass, including candleholders, animals, and decorative items, and he sometimes also works with copper.

In this Holy Family scene, Mary, simply clad, sits on a stool, and Joseph is represented deep in prayer.

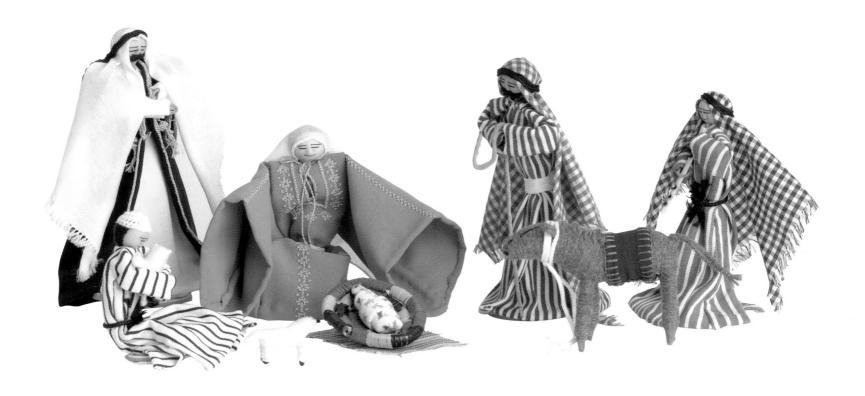

$\frac{YWCA}{\text{WEST BANK}}$

Women artisans supported by the Young Women's Christian Association (YWCA) of Jerusalem created this colorful scene. It was made by a group of about twenty young Palestinian women in the Jalazone Refugee Camp. The women also produce dolls dressed in national costumes. The Holy Family and shepherds are clothed in traditional Palestinian garb: Mary and Joseph are especially attractively adorned. This crèche was a gift from a Jewish friend who was a colleague at USAID.

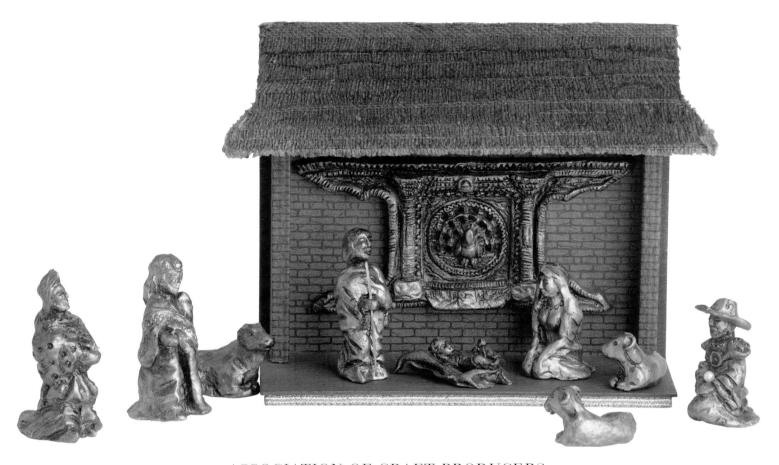

ASSOCIATION OF CRAFT PRODUCERS

NEPAL

The nonprofit Association for Craft Producers has existed in Kathmandu since 1984 to assist low-income artisans with skills training and to provide a marketing outlet. The association works with about one thousand artisans, most of whom are women. The organization obtained guidance for a crèche design from outside buyers and created a prototype in its workshop. Women in Kathmandu then produced the crèches in their homes.

The most striking feature is the stable, which is made

to resemble a traditional Nepalese house. It includes a sculptural centerpiece of a peacock. Peacocks are often included in Nepalese carvings and other designs: the feathers, used in religious ceremonies, are considered auspicious and protective. The figures are made of clay. Two kings bear gifts modeled in gold; the third brings a pearl. The Baby Jesus lies in the manger with arms outstretched, as in many classic Italian presentations. Like several others, this crèche was a gift from USAID friends.

BANTEAY PRIEB PRODUCTION

CAMBODIA

This crèche, made especially for the collection, comes from Banteay Prieb Production, also known as the Center of the Dove, which is part of a Jesuit-supported program in Cambodia. The center provides skills training for disabled people in several disciplines, including sculpting, agriculture, and tailoring. Some of the students have been disabled by land mines, others by such diseases as polio. Their ages range from nineteen to forty-five, and all of them are Buddhist.

I learned about the center through contact with a Maryknoll missionary in Phnom Penh, Father Charles Dittmeier. He put me in touch with Jesuit Brother In Young Cho, a Korean who was affiliated with the

workshop. The Center of the Dove had previously made two or three nativities with only the Holy Family figures. This crèche

> CHAY SARON

is the first that included other figures and animals. The scene is accented with indigenous elements, especially evident with the two Khmer-style angels. All the figures are hand-carved from a wood known as daikla. The carvers even help make their own tools—the wooden handles for their chisels!

These figures were carved by at least six carvers. The Holy Family figures, with a smiling Infant, are carved by Chum Samon and Chay Saron. The youthful kings are carved by Nem Da, Sueh Nduen, and Rottana; and the Khmer angels by Yan Thoun. Some figures, such as the boy cowherds, are unsigned. The carvers took several months to complete the scene for me, especially to perfect

> CHUM SAMON

the Khmer figures. Their commitment adds yet another special dimension to the experience of the collection.

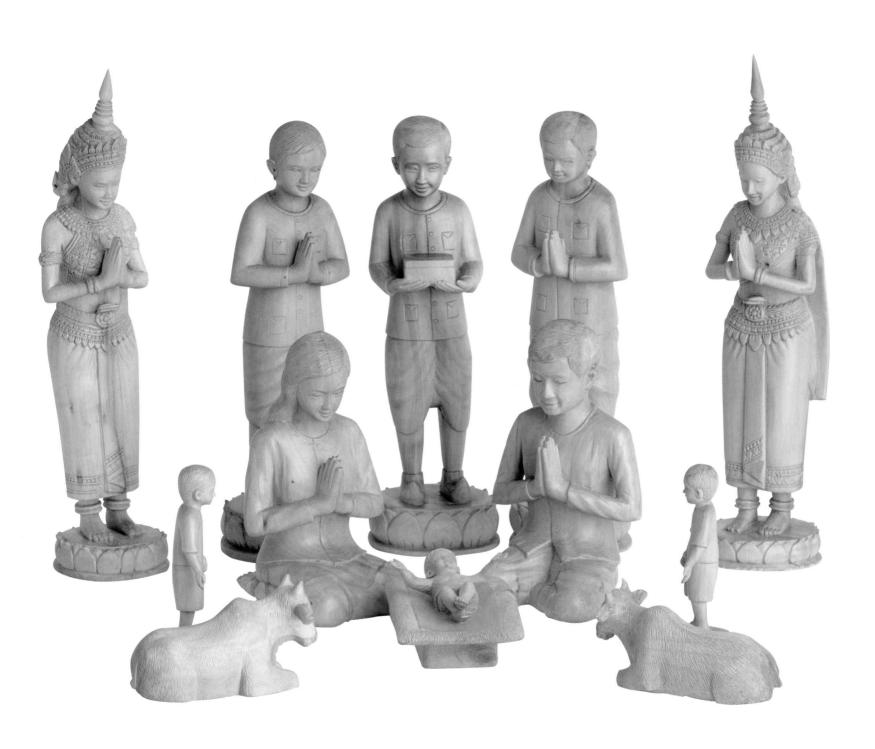

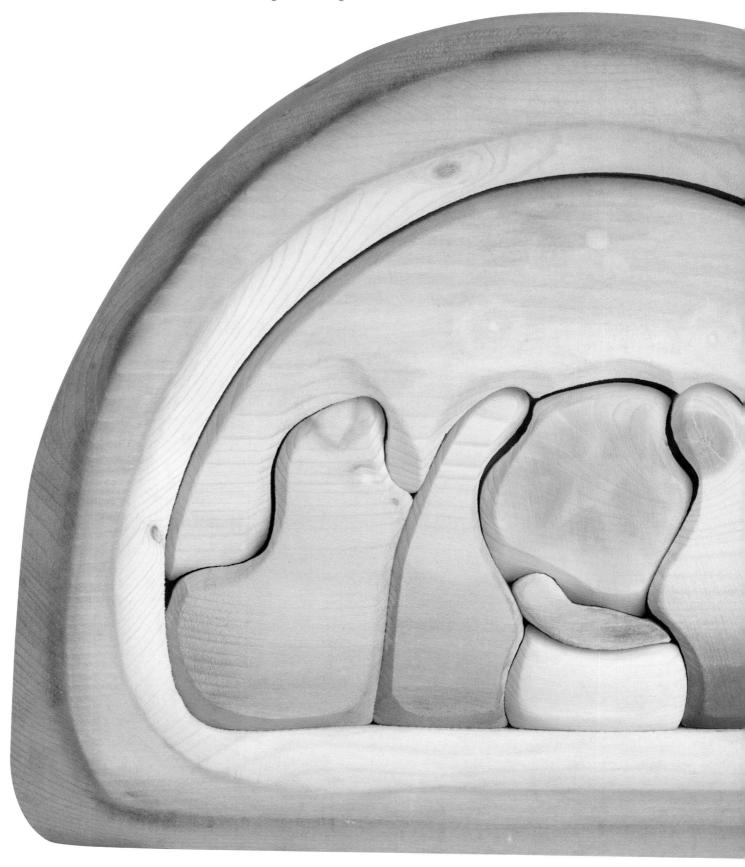

$\frac{\text{SOLHEIMAR CRAFTS CENTER}}{\text{ICELAND}}$

This gaily painted abstract scene, which is also a puzzle, comes from Iceland, where crèches are rare. It was created by learning-disabled people. The small community lives in Sólheimar, not far from Reykjavik, where they grow vegetables, make jams, and produce crafts, including woodwork. Those with special needs work alongside those without such difficulties. In the wood workshop, established in 1998, a group leader guides the work of community members. The work is divided by the stages of the process: one individual sands, another paints, and so on. The individual tasks may change from day to day, making this colorful crèche truly a group effort.

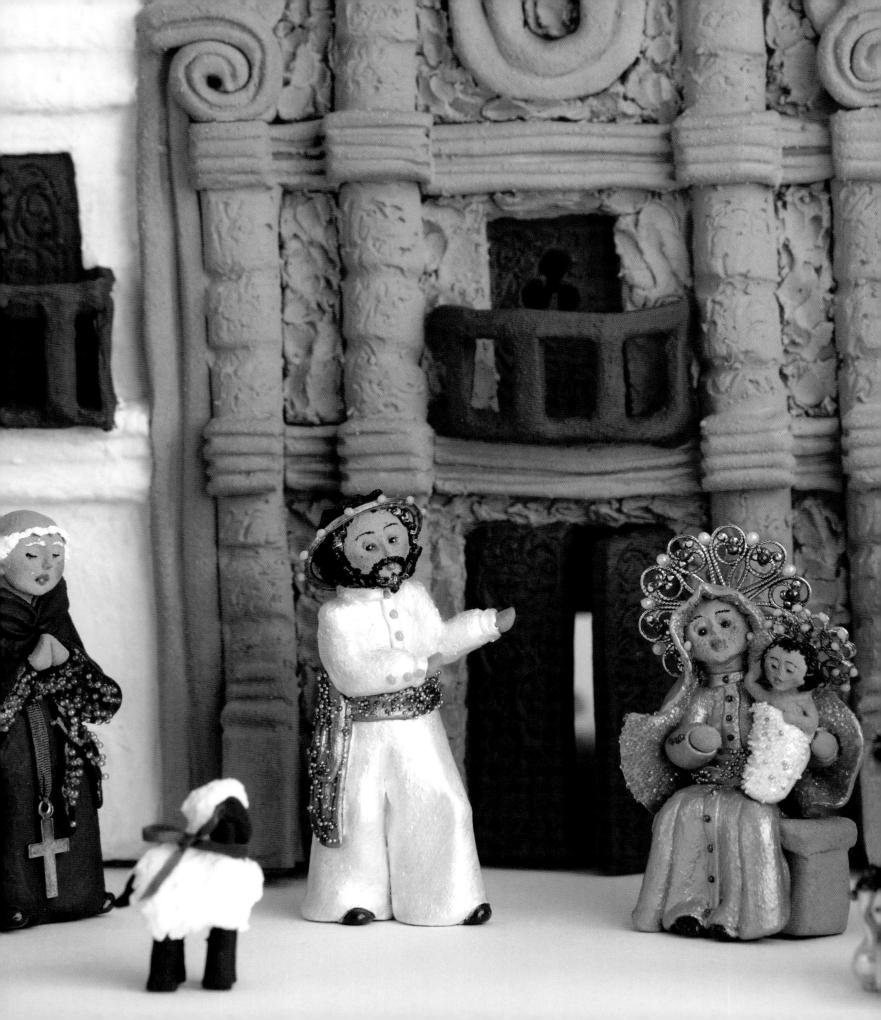

A WORLD OF CRÈCHES

SEEING OURSELVES

he truth of legends comes from the fact that we recognize in them our own stories and ourselves. This is how the story of Christ's birth has been embellished and elaborated throughout the centuries. The words of the Gospels supply the facts, but art and culture—and faith—the world over provide the details.

ADRIAN HUNT (turner) JILLI ROBERTS (painter) AUSTRALIA

This crèche comes from the wood-turning workshop the Deeping Dolls, which Adrian and Roslyn Hunt established in 1983 in Nicholls Rivulet, Tasmania. Adrian is the wood-turner; Roslyn handles the marketing. Inspired by traditional European wooden dolls, Adrian has developed his own artistic style. In the late 1980s, he added crèches to his wood-turning creations. Initially, he worked in three styles: rustic, naïve, and elaborate. In 2001, he introduced an Australian pioneer style, and he occasionally makes crèches described as "Byzantine." He uses only Tasmanian white

sassafras, a light-colored soft wood once used to make clothespins. His figures are painted by professional painters.

This crèche, turned by Adrian, is painted in the rustic style by Jilli Roberts, the first artist to paint crèche scenes for the workshop and to research ideas for early designs. Her colors for the rustic nativity are based on images in stained-glass windows, including those of Wells Cathedral in Somerset, England. In this scene, Joseph holds a dove, the traditional symbol of peace. Mary holds the Infant Jesus, and they are flanked by two small angels dressed in blue.

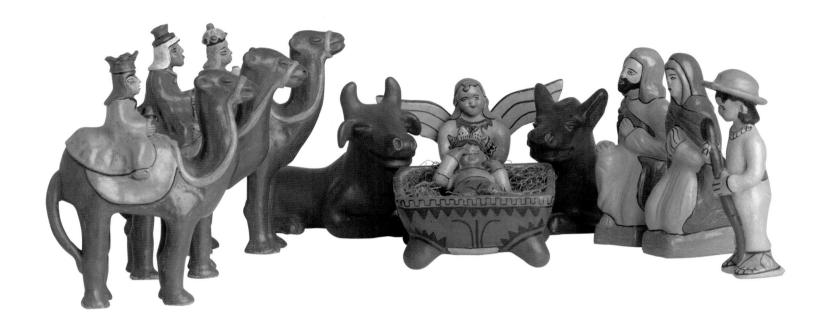

UNKNOWN ARTIST

NICARAGUA

This crèche was found for the collection by a USAID colleague. The clay scene was made by a young artist (whose name unfortunately is unknown), who won an award for it in an exhibition in Managua. A notable feature of the composition is the disproportionately large Christ Child, who wears a crown. The crown symbolizes Christ as King; the Infant's exaggerated size also reflects his central importance.

JOZEF STACHURA

PENNSYLVANIA, UNITED STATES

This crèche was acquired in 1982 at an exhibition of the artist's work in a gallery in Alexandria, Virginia. Jozef Stachura described it as "unique, made for that show only." Though it bears some resemblance to his earliest crèches in Poland, it is on a much larger scale. The warm and varied tones of the wood give the crèche a feeling of depth, despite its linear grouping.

Stachura, born in 1923, received most of his education as a sculptor in Poland. He studied at the Academy of Fine Arts in Warsaw (1949–55). He joined the Polish resistance movement as a youth during World War II, and was imprisoned under the Nazis. Opposed to Communism, he moved from Poland to the United States in 1962, arriving with the equivalent of only five dollars—all that he was permitted to take out of Poland. After further study in

New York City, he developed a successful career as a sculptor, living and working in Queens. In 1978, he moved to Pittsburgh, where for a time he taught at the Ivy School of Professional Art and the Pittsburgh Center for the Arts. He died in 2001.

More than 260 of Stachura's works are held in public and private collections throughout the United States and Europe, and many of his sculptures have been exhibited throughout North America. He generally created large-scale pieces, some larger than life-size. He worked in many media, but especially stone, marble, metal, and wood. His major work consists of forty large sculptural pieces for the Wethersfield Garden in New York State. Some of his sculptures reflect the sadness and torment of his wartime experiences.

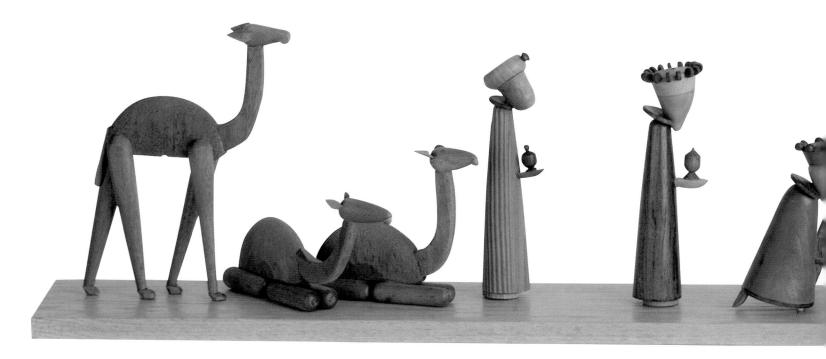

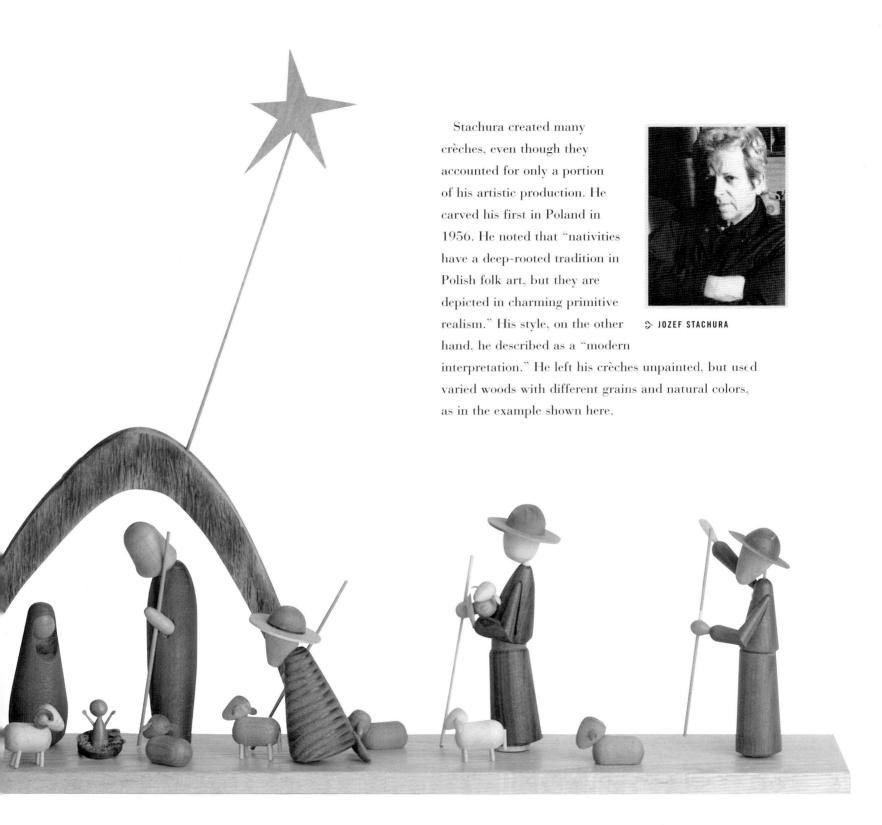

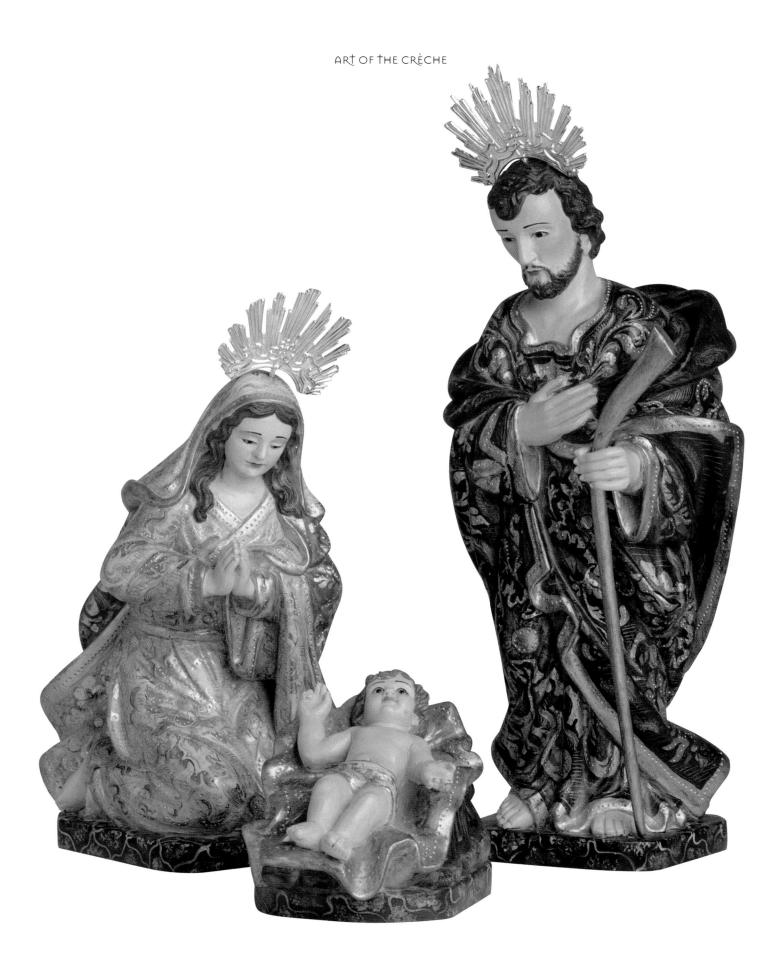

MIGUEL AVILA AND SEBASTIÃO DE AVILA

BRAZIL

This striking Holy Family grouping, commissioned for the collection, reflects the Portuguese Baroque style of the eighteenth century. The statues are the work of the Avila brothers, both of whom are *santeros* living in the Brazilian state of Minas Gerais. Sebastião designed the figures and did most of the carving, and Miguel worked on such details as the faces and hands, inserting the glass eyes, and guiding the polychrome work. Once carved and coated with plaster, the figures received an application of gold leaf and decorative incisions. They were then painted, and, while the paint was still wet, a stylus-like instrument was used to create delicate decorations by scraping away the paint to reveal the gold underneath.

Both brothers work primarily in wood but also sculpt from stone and work with concrete. Miguel Avila is self-taught. He began working with clay—including making nativities—when he was only eleven or twelve years old. He learned much from observing noted *santeros* in his town, and he taught Sebastião. Miguel has completed a major work consisting of seven statues—Our Lady of Aparecida and six saints—for a tourist company. The statues are for the railway line that takes visitors to the top of Rio de Janeiro's Corcovado, crowned with its famous figure of

Christ the Redeemer. Miguel also sculpted the crucifix for the cathedral in Brasília as well as statues for several churches. His latest project, in concrete, involves producing twelve Old Testament figures for a church in São Paulo.

Sebastião de Avila has carved a statue of Saint Jude for the University of Belo Horizonte, but his works tend to be on a smaller scale than those of Miguel Avila. In addition to accepting private commissions, Sebastião has undertaken restoration work for churches. Both brothers carve mostly religious figures, but they also make secular pieces.

This opulent portrayal of the Holy Family echoes the rich heritage of religious art in Brazil, evident in the lavish collections of churches throughout the country.

> MIGUEL AVILA

> SEBASTIÃO DE AVILA

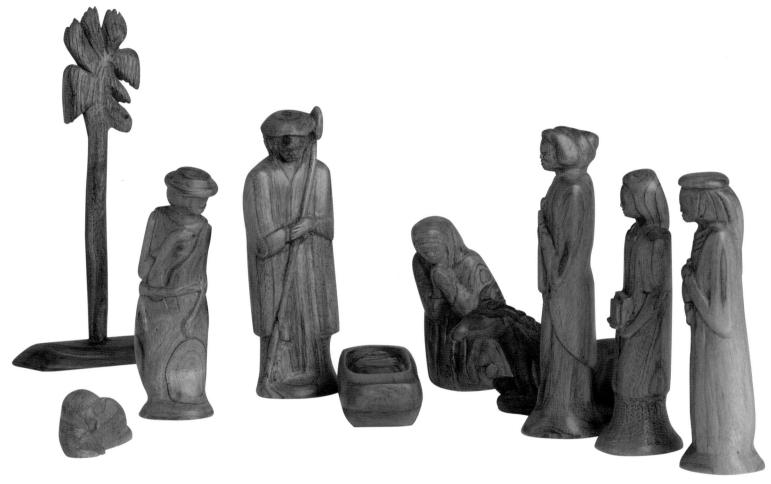

KEITH SWANSTON

TRINIDAD AND TOBAGO

Keith Swanston, from Trinidad, is an art teacher who carves, sculpts, and paints. His skills derive from a fine-arts education in the United States and perhaps from his family heritage—his father worked occasionally with crafts. Swanston considers his own work "a mix of traditional and contemporary." He sculpts in many media—wood, stone, concrete, plaster, and clay—and paints in many media, too. He likes working with the subject of the human figure, in a "semi-abstract or abstract form." In 1971, he was named "Best Emerging Artist" by the Trinidad Art

Society. His largest sculpture is on display at the country's international airport.

Swanston carved this nativity, his first, on commission, and took delight in the challenge of creating it. He "let the figures flow naturally out of the shape of the wood" and allowed "one piece to influence the other" as he worked through the composition. The nativity, carved from beautiful Trinidad mahogany, is a traditional scene, yet it also reflects Swanston's interest in semi-abstract forms.

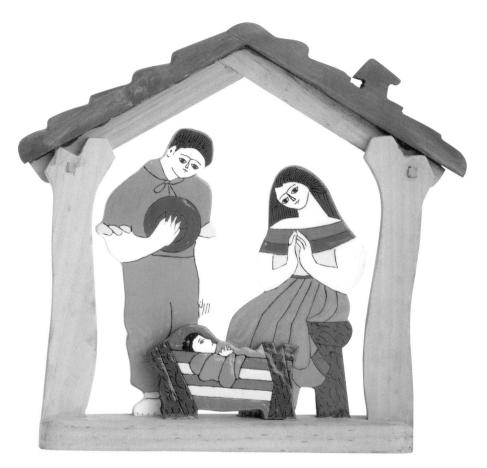

TALLER SAN FRANCISCO DE ASIS
EL SALVADOR

In the early 1970s, the artist Fernando Llort arrived in La Palma, El Salvador. As a young man developing his own painting style, he created a center for the study of art and began a workshop to teach his style to artisans of the area, creating a tradition that made this town, near the country's northern border, an arts and crafts center. The first product of his workshop was a small nativity painted on a copinol seed. The style he developed was one of simple designs and bold colors. Llort referred to his craft, which creates an effect similar to enameling, as a "temple" technique.

Even though Fernando Llort left La Palma in 1979, artisans in the region have continued to work in this unique style of folk art. Brightly hand-painted wooden pieces—including crèches—have now become synonymous with La Palma and the nearby area. This simple but typically gaily painted scene depicts the Holy Family as *campesinos*, or country people. This presentation was derived from an image in a Puerto Rican cultural publication in 1987, and has been produced since then by the San Francisco de Asis workshop.

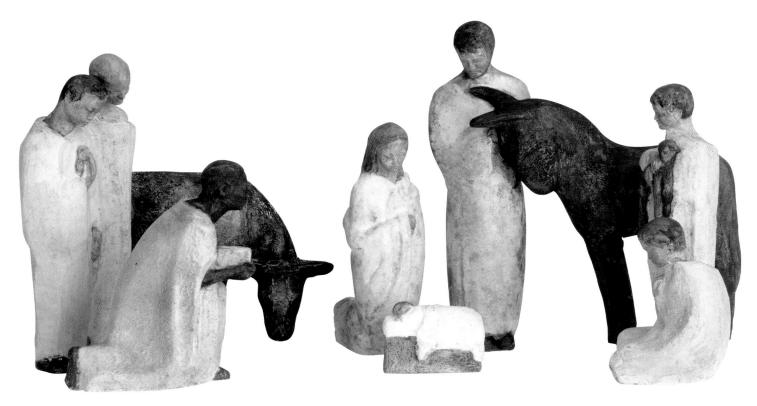

NOËLLE FABRI-CANTI FRANCE

One of the most impressive crèches in the collection was created by Noëlle Fabri-Canti, and acquired from Monsignor Michael di Tecchia Farina in Washington, D.C. A sculptor born in Corsica, Fabri-Canti is one of the most celebrated crèche artists in France. From the late 1940s, she received government and church commissions for her art, which includes Stations of the Cross, many Virgin with Child sculptures, and other religious pieces. Now in her eighties, Fabri-Canti has created a legacy of crèches throughout France and especially in Paris, where she has made pieces for such historic churches as the Madeleine, St. Germain des Près, and St. Marcel. Her scenes are also in the cathedrals of Clermont-Ferrand, Tours, and Versailles.

In this clay crèche, typical of Fabri-Canti's style, the simplicity of the figures and their humble expressions create a sense of peace and stillness. The figure of Mary conveys meekness and gracefulness. Some of the wise men and shepherds seem to have a Far Eastern character. The donkey nuzzles Joseph, adding warmth to the scene, and, most unusually, the Infant Jesus is depicted sleeping peacefully on his stomach.

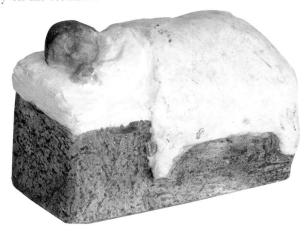

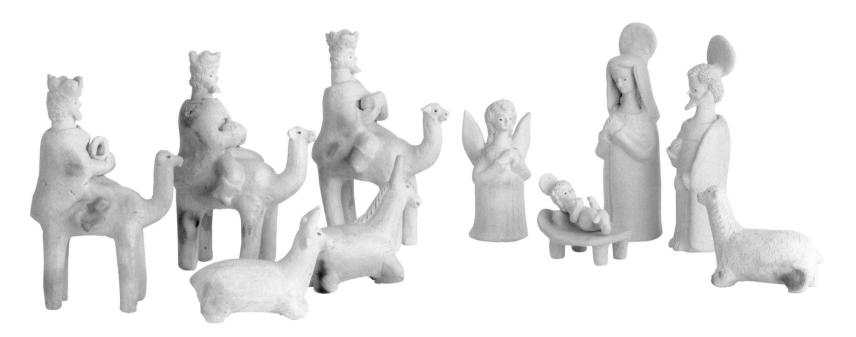

UNKNOWN ARTIST

GUATEMALA

Guatemala is rich in folk-art traditions. This crèche comes from Chinautla, one of the country's leading pottery centers. White pottery dating from the time before Christ has been discovered in the region. Mayan artisans in this town continue the tradition of white pottery works, but the clay is now scarcer. Today the pieces are generally made from red clay and then covered with the white.

This finely crafted scene is one of the favorites in the collection. Acquired in the 1970s, it was made by an unknown artisan from Chinautla's "old school." Such potters carry on traditional techniques, such as molding all pieces by hand, but this one is made according to the more recent technique of covering reddish clay with white. A llama-like animal, perhaps a sheep, joins the ox and donkey, and the Infant is in the typical pose of holding out his arms.

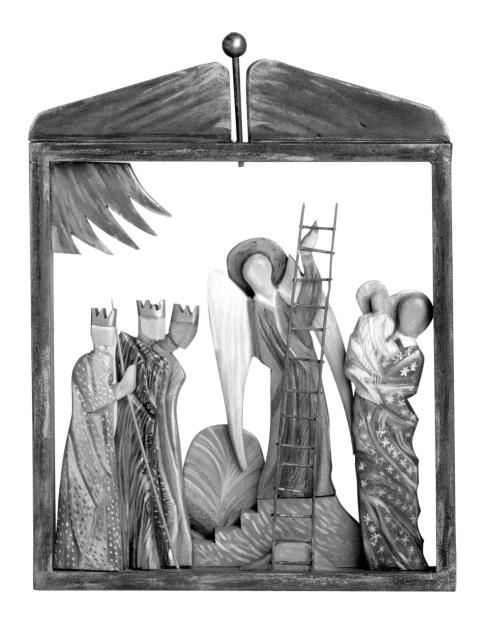

 $\frac{\mathrm{IMRE\ A.\ VARGA}}{\mathsf{HUNGARY}}$

"Medieval church paintings affected my art very much; I use their forms and symbolism in an altered way," explains self-taught artist Imre A. Varga. Born in 1953, Varga considers himself primarily a painter and sculptor. His characteristic works are what he calls *lada kep* (box pictures), of which this unusual crèche is typical. He has placed the richly painted scene in a box frame. The figures have no facial features, a device Varga uses to draw attention to

their full form. The ladder represents a connection between earth and sky, and symbolizes how the angel arrived. It is reminiscent of the biblical story of Jacob, who saw a ladder that extended between heaven and earth, by which angels descended and ascended. Another unusual aspect of this composition is the absence of Joseph, recalling the earliest depictions of the Nativity, in which Joseph was not included with Mary and the Infant. Friends acquired this crèche for me.

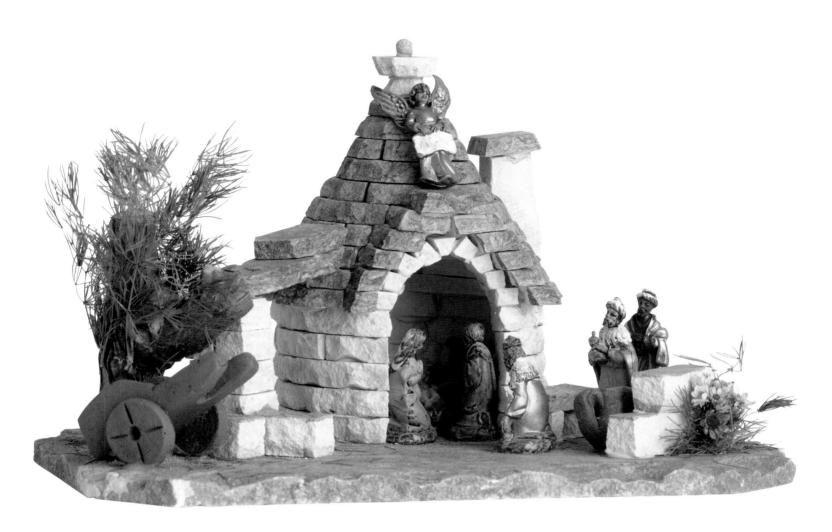

CAVALIERE GIUSEPPE MAFFEI

ITALY

Depictions of the birth of Christ in local settings are common, but this small nativity is among the more

unusual. Cavaliere Giuseppe Maffei presents the Nativity in a structure known as a trullo. (An artist associate creates the clay figures.) Trulli are stone buildings with conical roofs found in the Puglia region of Italy and especially in Alberobello, and Maffei was born in such a house in 1958. He has devoted his life to creating miniature trulli, including nativities, as a way of preserving and spreading

> CAVALIERE GIUSEPPE MAFFEI (LEFT), WITH THE AUTHOR

knowledge of *trulli* architecture. For his dedicated efforts, especially in traveling to schools throughout Italy to teach

children about the tradition, the Italian government has bestowed on him the distinguished title of Cavaliere, Knight of the Republic of Italy.

Emilia and I visited Maffei in his studio in 1995. Because of the weight of his nativity scenes, we were able to acquire only a very small one to remind us of this unusual corner of the world.

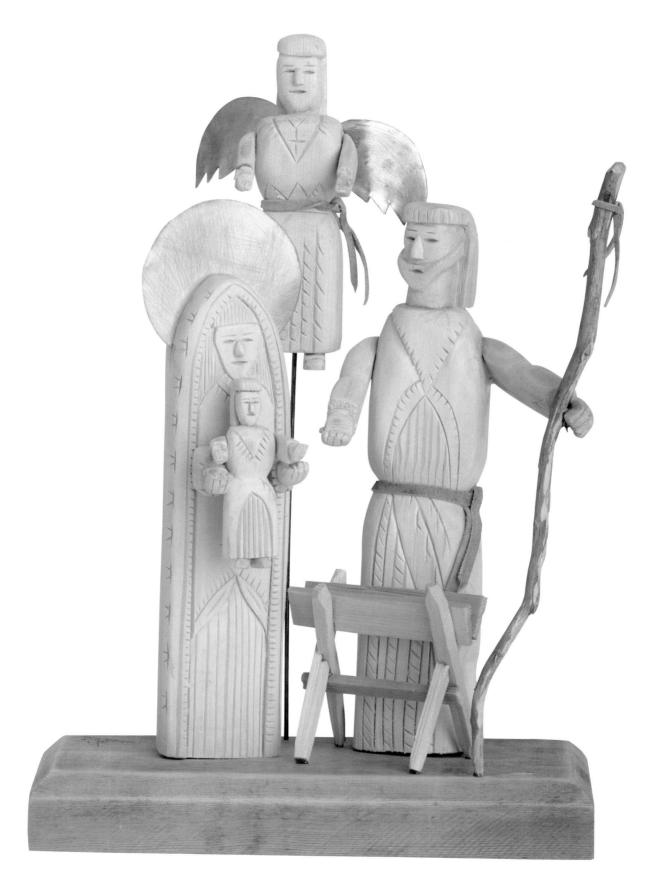

ELUID LEVI MARTÍNEZ

NEW MEXICO, UNITED STATES

Artist Eluid Levi Martínez is the grandson of José Dolores López, a carver who was known for establishing the Cordova style and reviving interest in Spanish Colonial carving (see also pages 82–83). Martínez, born in 1944, did not begin to carve until after he had completed his education and developed a career as a water engineer. In the 1990s, he served as New Mexico's state engineer and later served in the Department of the Interior in Washington. He considers himself self-taught, though he often observed the work of his uncle, George López, who gained wide acclaim for his carving. Martínez has carved *santos* since 1968, and created his first crèche in 1978. He has carved at least twenty other nativities since then.

This crèche, carved from aspen wood, reflects the family style. The artist sometimes adds touches of tin or brass, as he has here with the hovering angel's tin wings. The placement of the angel creates a triangular composition, which, Martínez feels, creates an interesting perspective on the Infant, whom the Virgin is holding.

Martínez dedicates himself to preserving and documenting both the art of the *santo* and his family's artistic heritage. Realizing that the family owned none of his uncle George's acclaimed carvings, Martínez commissioned twelve pieces from him. Martínez also wrote a small booklet, *What is a New Mexico Santo?*, to describe the history of the tradition. The Smithsonian National Museum of American History holds one of his crèches. Martínez has become an innovator in the family, and has encouraged Spanish American artists not to be restrained by the market's desire for reproductions of traditional images, but to apply innovative concepts. Besides his carvings, some of which he has painted, he has made lithographs and paintings. In recent years, owing to the demands of his engineering career, Martínez has not been able to carve, but he hopes to resume his art in the future.

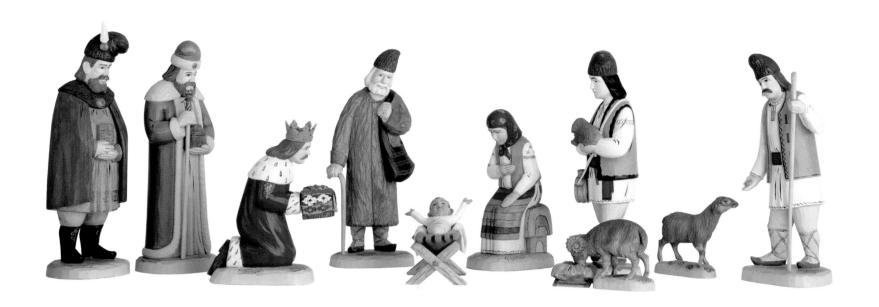

STEFAN CIUMASU

MOLDOVA

Stefan Ciumasu created this Moldovan three-dimensional nativity scene. The work is a rare example because Moldovans are predominately Orthodox, as is Ciumasu

himself, and religious imagery traditionally takes the form of icons. Born in 1969 in a small village, Ciumasu now lives in Chisinau, the capital of Moldova. He graduated from a well-known carving school in Bogorodskoye, Russia, a village where the carving tradition dates to the seventeenth century. His specialty is making wooden animal toys with moving parts, but he began creating nativities in 1996. Now he earns his living from carving, and

> STEFAN CIUMASU

belongs to the Handicraftsmen's Union of Moldova. In this crèche, Ciumasu has created a traditional Moldovan presentation, with Mary, Joseph, and the

shepherds appearing in traditional peasants' clothing. Joseph holds a *traista*, a traditional bag, a version of which is still used today. One shepherd is feeding a sheep. Two of the kings resemble Moldovan knights of the fourteenth and fifteenth centuries. The kneeling king is in the image of a fifteenth-century Moldovan king, Stefan Cel Mare. The Christ Child, with arms raised, seems especially joyful.

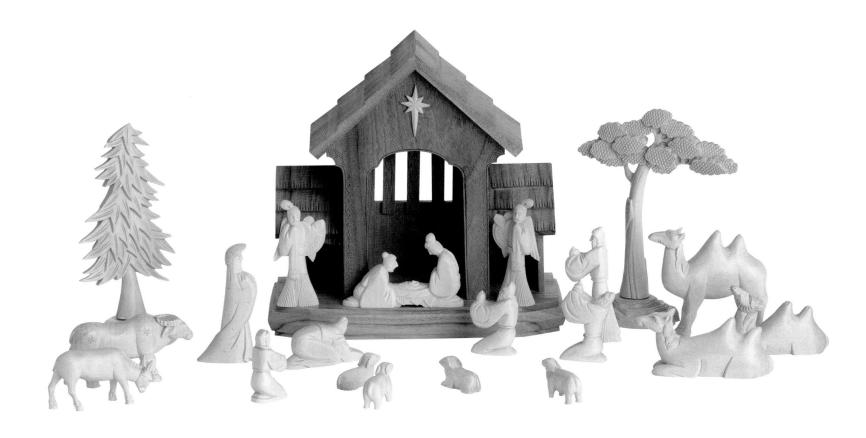

WANLONG ZHANG

CHINA

Wanlong Zhang is a Christian living in southern China. He began carving in 1966 and, twenty years later, gave up making traditional Chinese carvings in favour of Christian-themed ones. Initially he adopted a Western style in his works, but he was encouraged by a Protestant minister stationed in Beijing to carve Christian subjects in his native Chinese style. Now he designs Christian art pieces to be carved by the artisans in his workshop, which he founded in 1986.

One of Zhang's most important projects to date is a work

on the life of Jesus that contains more than one thousand figures in seventy-six biblical scenes. It took more than three years to complete, and was exhibited in Hong Kong in 2004. Zhang's carvings have also been included in several exhibitions in Europe and the United States.

Although the scale is small, with the delicately carved figures ranging in size from approximately 2 to 4 inches (5–10 cm) high, the indigenous character of Zhang's work is strongly evident in this charming nativity, especially in the figures' detailed costumes.

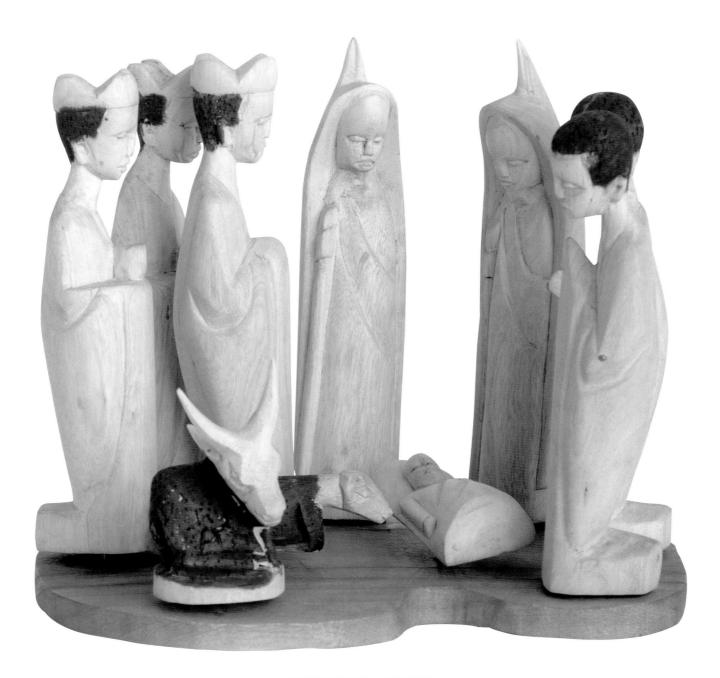

$\frac{\text{UNKNOWN ARTIST}}{\text{rwanda}}$

This crèche from Rwanda is a sign that faith and hope are being renewed in this poor country that suffered so tragically in the 1990s. It is another gift from a USAID colleague.

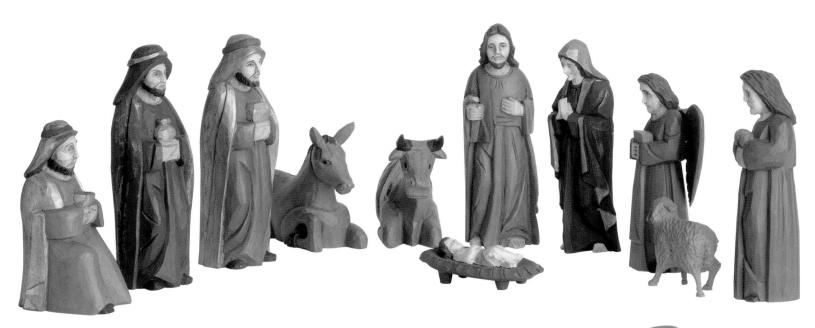

UNKNOWN ARTIST

THE PHILIPPINES

This traditional wooden scene was probably made by wood-carvers in the town of Paete in the Philippines.

Founded in 1580, Paete, like San Antonio de Ibarra in Ecuador, is one of the world's leading wood-carving centers and home to several thousand carvers. Early in the town's history, Franciscan monks helped develop the skills of Paete's artisans, and between them they established a reputation for religious carvings, especially of santos.

Today carvers continue to make religious images, but they also make furniture and other wooden products.

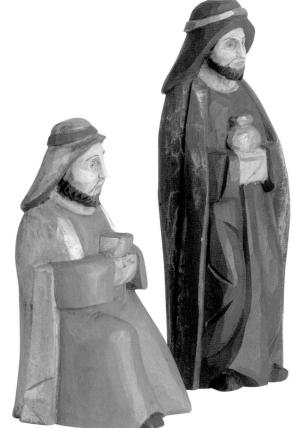

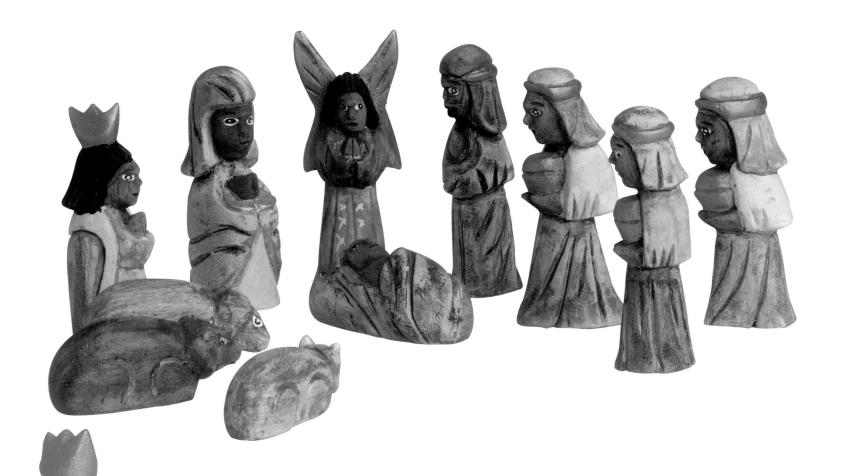

OWEN GRANT (painter)

JAMAICA

The boldly painted animals of this scene evoke the vibrant culture of Jamaica, and an intriguing aspect is the ominous presence of Herod, who wears a crown. The figures were carved by Lincoln Jarrett and painted by Owen Grant. Born in 1956 in St. Mary, Jamaica, Jarrett started carving when he was eight years old. He trained as a primary school teacher, but has worked as a self-taught

carver since 1983. Now living in Manchester, in west-central Jamaica, he continues to carve, inspired by Jamaican country life and his religious beliefs. When not carving, he likes to write songs and poems, and he has also tried painting. Grant has worked for years with the Gallery of West Indian Art in Montego Bay, where he trained as a painter.

Jarrett carved these figures from Jamaican cedar. His concern for the environment leads him to "encourage the farmers to plant more cedar."

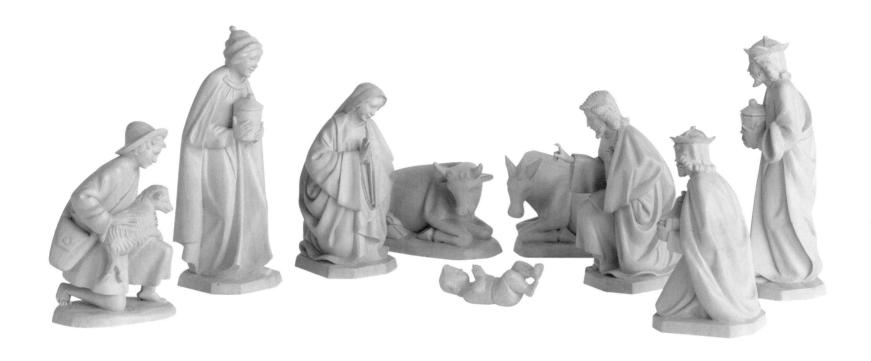

UNKNOWN ARTIST

ECUADOR

This traditional crèche comes from San Antonio de Ibarra. Settled by Spanish craftsmen in the sixteenth and seventeenth centuries, San Antonio remains the most important wood-carving center in South America. The similarity of the style of this crèche to European traditions is clear. The identity of the artist is not known, but the quality of the work suggests that it might have been carved by the late Miguel Herrera, a noted master carver. The light-toned wood is naranjillo.

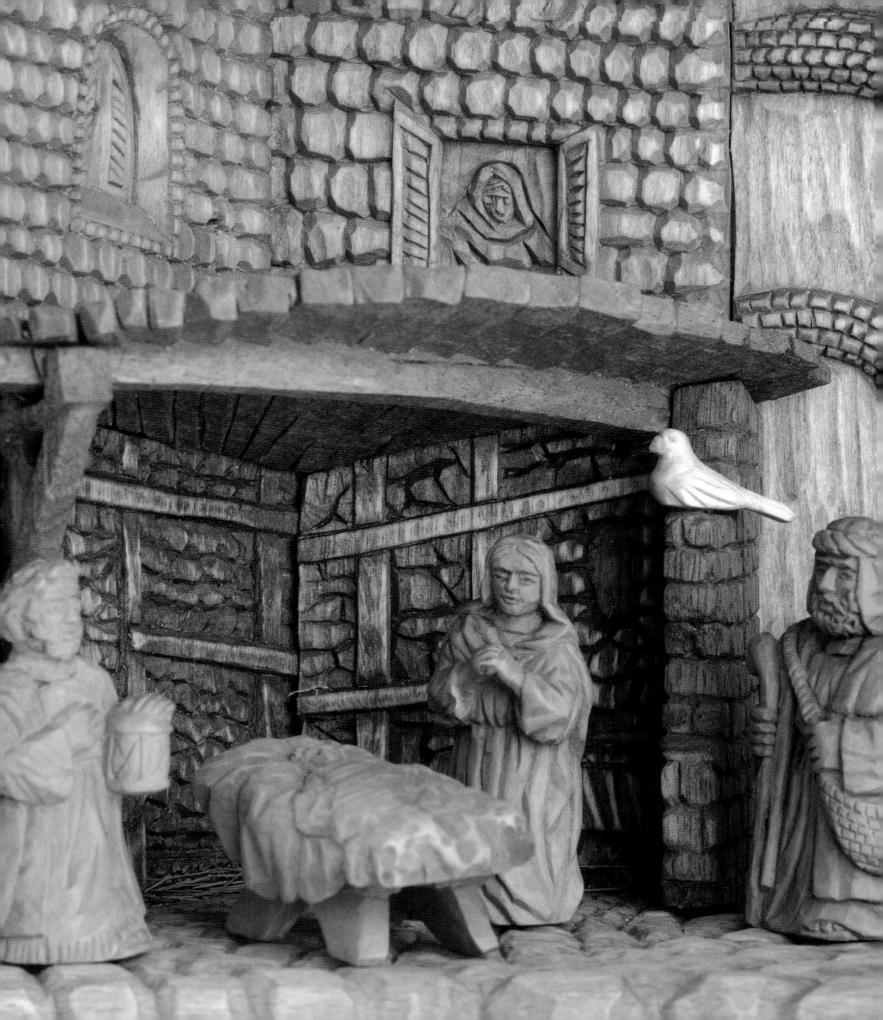

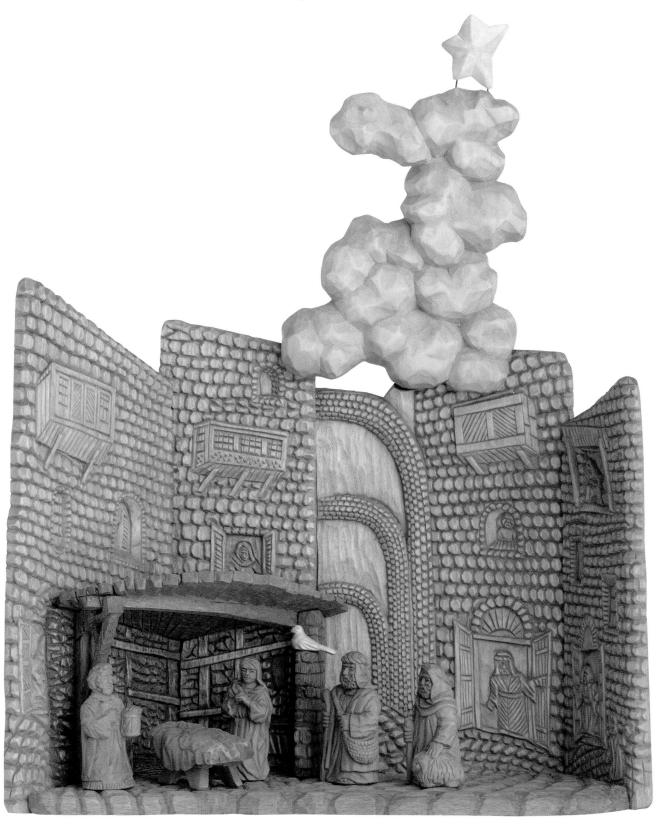

> ELENA URALOVA, UKRAINE

ELENA URALOVA

UKRAINE

This is one of the most intriguing crèches in the collection. It was carved to special commission by the skilled miniaturist Elena Uralova of Lviv, Ukraine, who was born in Barnaul in Siberia in 1954. Uralova specializes in figures that range from ½ inch to 1 inch (12–25 mm) high. In addition to works on Christian themes, she carves chess sets, relief sculptures, and historical figures, although she has had no training in carving. She is a retired tunnel-and-bridge engineer, and for nearly twenty years, she has carved in her

free time. She says, "I have my own peculiar style of craft. Probably the way I hold my chisel is incorrect and far from the classic technique."

Uralova began carving crèches in the mid-1990s, when she read the Bible and, as she explains, "came to understand God is great." Descending from "old Orthodox ancestors," she claims no specific religious affiliation. Instead, she seeks to use her Christian carvings to promote religious harmony and peace, and aims her message particularly at children.

This unique crèche was made specifically for the collection. The Holy Family, shepherds, and stable are similar to the nativity she commonly carves, but the town scene is inspired from her carving of Christ carrying the cross through the streets of Jerusalem. Amid the finely carved details of the buildings, people peer from the windows to witness the Nativity. The cloud nestling above

the buildings is adapted from another carving depicting Christ's resurrection. The star is a new addition to the usual scene. A dove rests near the Christ Child. The varied colors of the wood, especially the orange tone in the buildings, give this exquisite crèche warmth. As Uralova says, "I love to create interesting compositions that carry warmth to the people."

> ELENA URALOVA

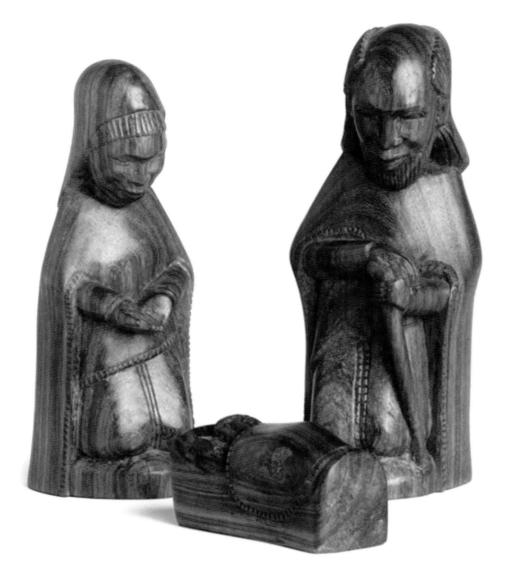

$\frac{\text{UNKNOWN ARTIST}}{\text{zimbabwe}}$

Little is known about this marvelously carved Holy Family scene, other than it comes from Zimbabwe. The rich wood gives it a luxuriant feel. Emilia and I first saw the figures of Mary and Joseph one evening as we walked past a shop in Victoria Falls. Joseph—portrayed as an old man with a balding head—particularly caught our notice. The shop was closed, so we returned early the next morning. Looking

again at the two figures, we were surprised to realize that there was no Baby Jesus. The clerk understood very little English and seemed unaware of the concept of a nativity scene, but permitted us to search through the piles of crafts crammed into his shop. After a considerable and intense search, we found the Christ Child in a corner, buried under many other objects. The Holy Family was reunited.

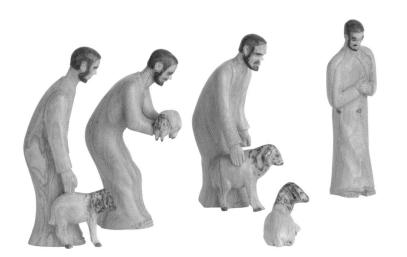

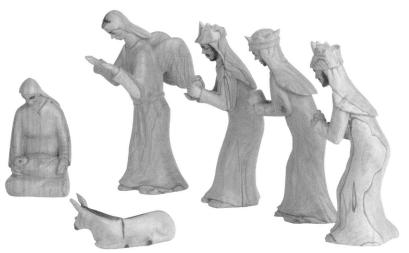

PHAKEDI JETA Botswana

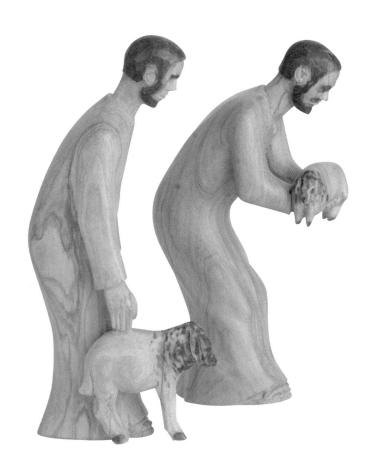

This commissioned piece, described as "stunning" by the individual who helped arrange for it to be made, is only the second nativity scene Phakedi Jeta carved. Born in 1963, Jeta, a bushman, lives in Marulamantsi in northwest Botswana. When he carved this nativity, he was the chair of a group of carvers known as the Serowe Woodcarvers, who were trying to establish a successful venture. An adviser had suggested the idea of making a crèche to the carvers, who already made bowls, animals, bushmen figures, and other objects. Jeta has since left the group, but still earns his living from his carvings, supporting his five children.

The figures are carved from an attractive wood, modumela, or white syringa. The grain suggests a flow to the garments, adding to the feeling of movement in the kings and shepherds. The angel gestures, as if calling attention to the newborn Infant. The painted facial features of the figures and what seems to be a star on the angel's head are highlighted details in this sensitive scene. "Stunning" indeed seems an appropriate way to describe this crèche.

$\frac{\text{IVARS KALNINS}}{\text{Latvia}}$

Crèches are not easy to find in Latvia. This one was acquired through the help of a USAID friend and her relatives there. Eventually, her cousin found this scene, carved by Ivars Kalnins. The artist lives in Saulkrasti on the Baltic coast, but occasionally sells his carvings from a street stall in Riga.

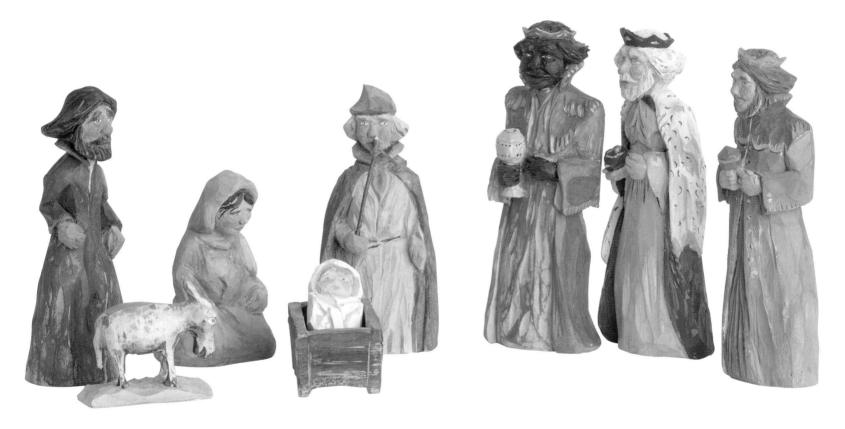

JIL GURULÉ NEW MEXICO, UNITED STATES

When I commissioned my first crèche from Jil Gurulé (see page 90), I was also aware that she liked to create replicas of the historic mission churches found in the American Southwest. I have always been especially attracted to the lovely mission church of San Xavier del Bac, just south of Tucson, Arizona. A Jesuit missionary, Father Eusebio Francisco Kino, established the first San Xavier mission in 1700. The present structure, initiated by Franciscan missionaries, was built in 1783–97, probably by the Tohono O'odham Native American people, whom the church serves to the present day.

After acquiring the first crèche, I asked Gurulé if she would make a nativity scene with the mission as the setting. She enthusiastically agreed. Joseph gestures toward Mary, who is seated with the Infant at the entrance to the church. The Holy Family is joined not only by the wise men but also by two priests, one in black to represent the Jesuits, and one in blue to represent the Franciscans, and by Native Americans representing the Tohono O'odham, Apache, Hopi, Navajo, and Zuni peoples. There is also a Mexican figure. The animals include the donkey on which Mary traveled, as well as a camel, elephant, and horse, on which the wise men arrived.

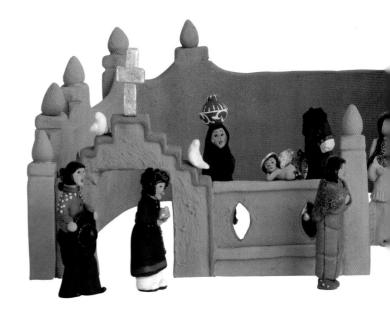

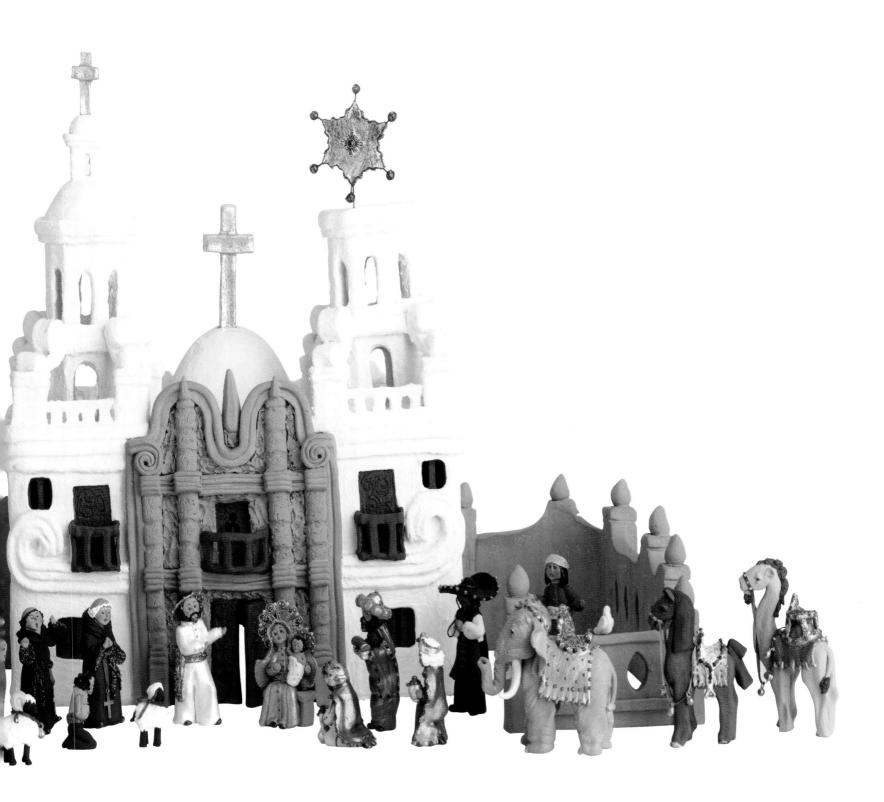

oday the universal existence of crèches goes far beyond the expression of faith and devotion that is evidenced in their placement in churches and homes at Christmas time. Certainly, they are made by artists to reflect their faith. They are also made for the market as a means of earning a livelihood by people who, in some places, do not hold the Christian faith. Some artists make crèches primarily to express their culture; others make them as an artistic endeavor.

Out of this varied environment, a rich tapestry of crèche art has emerged. The devotion, creativity, diversity, and skill with which crèches are created have stimulated a renewed interest in the tradition in recent decades. It is an art form that can be appealing as a matter of faith, as an aesthetic creation, or as a familiar cultural expression. Depicting the birth of a child brings all humanity together to share a universal experience. And depicting the birth of the Christ Child brings much of humanity together to share a profound belief in the future.

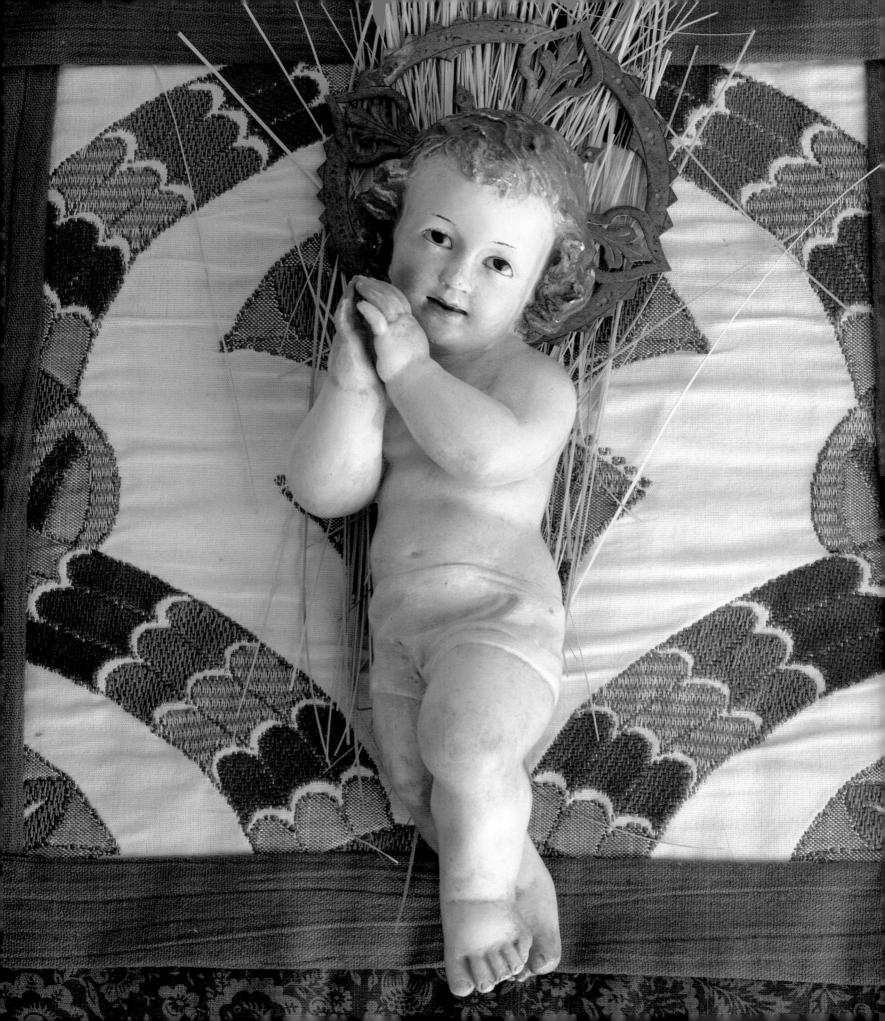

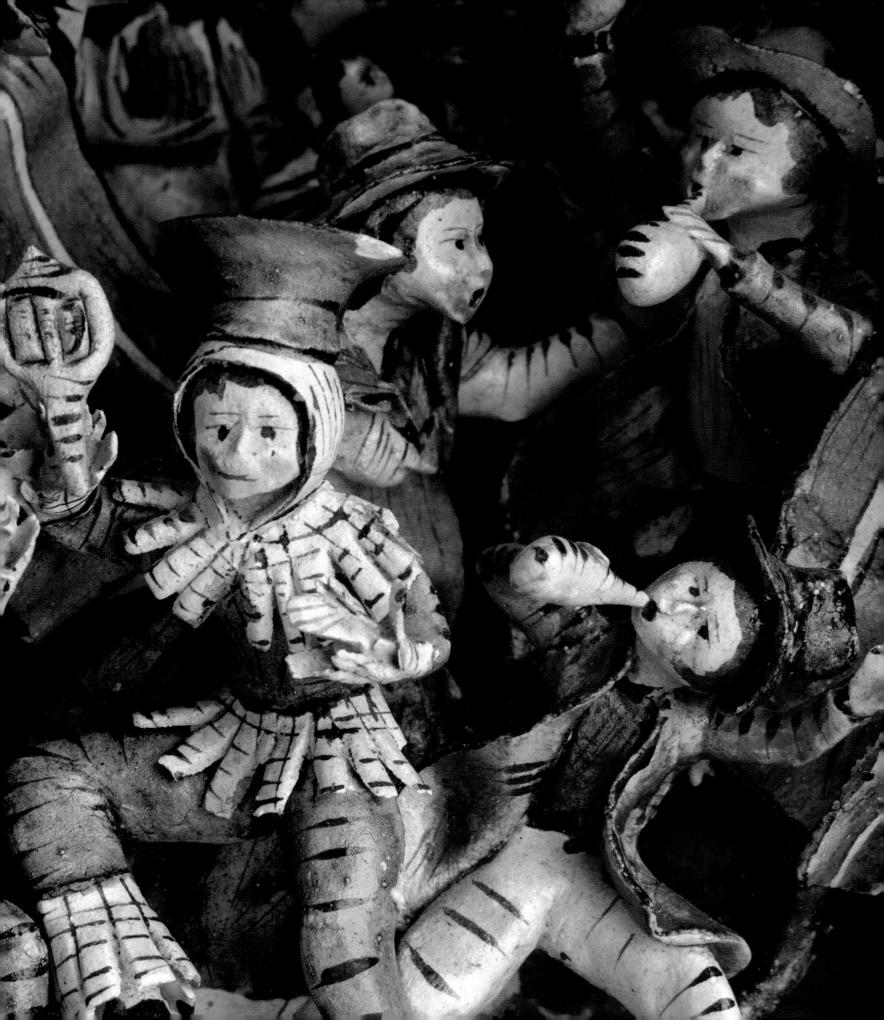

ACKNOWLEDGMENTS

A long-cherished goal is achieved with the publication of this book. The initial purpose of the project, which is based on our Govan family crèche collection, was to celebrate the worldwide crèche tradition. But, with the passing of my beloved wife, Emilia, my desire also became to complete it in her memory. Therefore, first and foremost, I acknowledge her loving partnership in building the collection and initiating the writing. The times we shared each Christmas enjoying the crèches displayed in our home remain among my most cherished memories.

With love, I wish to thank my sons, Michael and Stephen, for their contributions to the collection, and for their support of this project.

I am enormously grateful for the many contributions of Daniel G. Callahan, former Director of Publications and Exhibitions at the Pope John Paul II Cultural Center, which initially supported my effort. Dan's wise guidance and enthusiastic support, as well as his contributions to the structure and content of the book, are deeply appreciated. His steadfast encouragement and determination to assist me in gaining publication of the book were critical to my efforts.

I express much gratitude to Cade Martin for his skillful photography and most cooperative support. I am also most grateful to Gary Ridley of Smarteam Communications Inc., Washington, D.C., whose dedicated technical support in compiling the final text and photography files for submission to Merrell Publishers was indispensable. I thank Shauna McPherson for her fine editing work when the project was under the auspices of the Cultural Center. I express appreciation to the Cultural Center for its early support of the initial editing, crèche photography, and development of the photographic files. I especially thank former Deputy Director Penelope Fletcher, and, again, Daniel Callahan.

I also wish to thank my agent, Jim Fitzgerald of the James Fitzgerald Agency, New York City. Jim's immediate and successful support of my proposal is very much appreciated.

I extend my profound gratitude to Merrell Publishers for their enthusiastic support of this project, especially Joan Brookbank, U.S. Director, and Claire Chandler, Managing Editor. I am greatly indebted to Helen Miles at Merrell and to the copy editor, Diane Pengelly, not only for their invaluable editing of the text but also for their substantive

comments and questions that improved the content of the book. For the book design, I express appreciation to Merideth Londagin, 3+Co., New York City, and to Nicola Bailey and Michelle Draycott of Merrell for their caring and creative presentation of the text and crèches. I deeply appreciate both the considerate manner in which all staff at Merrell Publishers worked with me throughout the process and their genuine sensitivity in retaining the personal character of this book that describes the wonderful journey that Emilia and I shared.

I am grateful to the many, many friends who gave us crèches, and to new acquaintances all over the world who assisted us in acquiring these wonderful works of art. My heartfelt appreciation goes to all the artists who responded to my requests to make a crèche for the collection. Last, but certainly not least, I wish to thank all those who have been a part of the effort to create and sustain our new national society, Friends of the Creche: wonderful colleagues who have inspired and taught me so much.

FURTHER READING

The author wishes to acknowledge the countless e-mails, letters, articles, and other sources, including those listed here, used in compiling this text.

Bennett, Monica Klein, "The Art of Nicario Jiménez, Peruvian Retablista," *A Report*, vol. 14, no. 3, San Francisco Craft and Folk Art Museum 1997 (unpag.)

Berliner, Rudolf, "The Origins of the Crèche," *Gazette des Beaux Arts*, vol. 30, October–November–December 1946, pp. 249–78

Bilz, Hellmut, Erzgebirgische Volkskunst: Popular Arts and Crafts from the Erzgebirge Mountains, Schwarzenberg, Germany (Ingo Beer Verlag) 1997

Briggs, Charles L., The Wood Carvers of Cordóva, New Mexico: Social Dimensions of an Artistic Revival, Albuquerque (University of New Mexico Press) 1989

Carandente, Giovanni, Rome: Architecture, Sculpture, Painting, New York (Holt, Rinehart & Winston) 1971

Coles, William A., "Jozef Stachura," August 25, 1990 (unpub.)

Damian, Carol, "The Peruvian Retablo," Southeastern Latin Americanist, vol. 37, no. 1, Summer 1993, pp. 9–13

De Robeck, Nesta, *The Christmas Crib*, Milwaukee, Wis. (Bruce Publishing Co.) 1956 Dowlaszewicz, Wanda, *Rzezba Antoni* Kaminski, Plock, Poland (Muzeum Mazowieckie w Plocku) 1998

Egan, Martha, "The Retablos of Nicario Jimenez," *Artspace*, Summer 1987, pp. 11–13

Ippisch, Hanneke, Sky: A True Story of Courage During World War II, Mahwah, N.J. (Troll Communications) 1996

"Marcel Carbonel's Santons: The Tradition—A Few References," santonsmarcelcarbonel.com

Mulyran, Lenore Hoag, Ceramic Trees of Life: Popular Art from Mexico, Los Angeles (UCLA Fowler Museum of Cultural History) 2003

Ott, Martin, African Theology in Images. Kachere Series, Blantyre, Malawi (Christian Literature Association in Malawi) 2000

Powell, Matthew, *The Christmas Crèche:* Treasure of Faith, Art, and Theater, Boston (Pauline Books and Media) 1997

Powell, Matthew; Utro, Umberto; Finizio, Alberto; and Salvatori, Antonella, Christmas in Miniature: Crèches from Around the World, New Haven, Conn. (Knights of Columbus Museum) 2005

Rosenak, Chuck and Jan, Navajo Folk Art: The People Speak, Flagstaff, Ariz. (Northland Publishing) 1994 Schauss, Hans-Joachim, Contemporary Polish Folk Artists, New York (Hippocrene Books) 1987

Szalapak, Anna, Cracovian Christmas Crib, Olszanica, Poland (BOSZ) 2002

Wasserspring, Lois, Oaxacan Ceramics: The Traditional Folk Art by Oaxacan Women, San Francisco (Chronicle Books) 2000

Zemanová, Zita; Vojíř, Miloš; and Matuška, Pavel, *Třebechovický Proboštův Betlém*, Hradec Králové, Czech Republic (Fotografo) 2004 First published 2007 by Merrell Publishers Limited

Head office 81 Southwark Street London SE1 0HX

New York office 740 Broadway, 12th Floor New York, NY 10003

merrellpublishers.com

Text copyright © 2007 James L. Govan Photography copyright © 2007 the copyright holders; see right Design and layout copyright © 2007 Merrell Publishers Limited

All rights reserved. No part of this publication may be reproduced, stored in a retrieval system, or transmitted, in any form or by any means, electronic, mechanical, photocopying, recording, or otherwise, without the prior permission in writing from the publisher.

British Library Cataloguing-in-Publication Data: Govan, James L. Art of the creche: nativities from around the world 1. Creches (Nativity scenes) I. Title 704.9'4856

ISBN-13: 978-1-8589-4402-9 ISBN-10: 1-8589-4402-3

Produced by Merrell Publishers Limited Designed by 3+Co. Edited by Shauna McPherson Copy-edited by Diane Pengelly Proof-read by Charlotte Rundall

Printed and bound in China

Photography Credits

All crèche photography and author's portrait: Cade Martin Photography

p. 5: photograph by Junior Bridge

Artists' portraits have been reproduced courtesy of the following: p. 19: Jaroslav Frencl; p. 31: Claudio Riso. Photograph by Emilia Govan; p. 45: Alfredo Rodriguez; p. 48: Gregor Rychlik; p. 54: Vladas Rakuckas; p. 61: Hanni Lüthi; p. 62: Boo Ho Kim; p. 64: Africancraft.com; p. 69: Brian Camilleri; p. 72: Carmélia Rodrigues da Silva; p. 75: Juan Cruz Avilés and his wife, María; p. 81: Trayan Gabrovski; p. 83: Sabinita López Ortiz; p. 86: Mohammed Amin; p. 89: Alberto Finizio; p. 93: Pavel Matuška; p. 99: Suwedi Bigula and his wife, Esther Aphia; p. 101: Roger Bawi; p. 104: Francesco Scarlatella; p. 107: Elsie and Thomas Franco; p. 111: Albert Tay; p. 120: Nicario Jiménez Quispe. Photograph by Emilia Govan; p. 126: Mitsuki Kumekawa; p. 129: Geoff Pryor; p. 135: Les and Hanneke Ippisch; p. 138: Stanko Bunić; p. 144: Stanislaw Suska; p. 146: Adam Wydra; p. 149: David Kottler; p. 155: Novica.com; p. 168: Chay Saron and Chum Samon; p. 177: Irene Stachura; p. 179: Miguel Avila and Sebastião de Avila; p. 185: Giuseppe Maffei. Photograph by Emilia Govan; p. 188: Stefan Ciumasu; p. 196: Simon Uralov

Front jacket

unknown artist, see pp. 38 and 40

Back jacket (from top, left to right)

Stanko Bunić, see pp. 138–39; Waclaw Suska, see pp. 142–43; unknown artist, see p. 117; Ruth Tewksbury and family, see pp. 156–58

Details

p. 2: Vladas Rakuckas, see pp. 52–54; p. 16: Jaroslav Frencl, see pp. 18–19; p. 28: Juan Hernández Arzaluz, see pp. 39 and 40; p. 46: Denis Moyo, see p. 57; p. 58: Hassa Pascal Mounkoro, see p. 64; p. 66: unknown artist, see pp. 70–71; p. 84: Alberto Finizio, see p. 89; p. 94: unknown artist, see p. 96; p. 102: Francesco Scarlatella, see pp. 104–105; p. 122: Hanneke and Les Ippisch, see pp. 134–36; p. 140: Joan and David Kottler, see p. 149; p. 160: Sólheimar Crafts Center. see pp. 170–71; p. 172: Jil Gurulé, see pp. 200–201; p. 204: Nicario Jiménez Quispe, see pp. 118–21